100
DRESSES

Front cover: *"Propaganda" Dress.* Vivienne Westwood, British, b. 1941. Silk satin, Fall/Winter 2005–06. Purchase, Friends of The Costume Institute Gifts, 2006 2006.197a–d.

Back cover: *Dovima wearing Molyneux Evening Dress* (C.I.42.33.3) (detail), February 1953. Cecil Beaton, British, 1904–1980. Photograph: Sotheby's Picture Library/Cecil Beaton Studio Archive

Published by The Metropolitan Museum of Art in association with Yale University Press

Copyright © 2010 by The Metropolitan Museum of Art

Produced by the Department of Special Publications, The Metropolitan Museum of Art: Robie Rogge, Publishing Manager; Linda Falken, Senior Editor; Atif Toor, Designer; Victoria Gallina, Production.

Photography by The Metropolitan Museum of Art Photograph Studio, unless otherwise noted in the credits.

First Edition
Printed in China
19 18 17 16 15 14 13 12 11 10 5 4 3 2 1

Library of Congress Cataloguing-in-Publication Data

100 dresses : The Costume Institute, The Metropolitan Museum of Art. — 1st ed.
 p. cm.
 ISBN 978-1-58839-377-7 (MMA; pbk. : alk. paper)
 ISBN 978-0-300-16655-2 (Yale Univ.; pbk. : alk. paper)
 1. Dresses. 2. Women's clothing. 3. Costume. 4. Costume Institute (New
York, N.Y.) 5. Metropolitan Museum of Art (New York, N.Y.) I. Title: One
hundred dresses.
GT2060.A15 2010
391'.2—dc22
2010013932

The Metropolitan Museum of Art
1000 Fifth Avenue
New York, NY 10028-0198
212.570.3894
www.metmuseum.org

Yale University Press
302 Temple Street
P.O. Box 209040
New Haven, CT 06520-9040
www.yalebooks.com

100 DRESSES

THE COSTUME INSTITUTE
THE METROPOLITAN MUSEUM OF ART

THE METROPOLITAN MUSEUM OF ART, NEW YORK
YALE UNIVERSITY PRESS, NEW HAVEN AND LONDON

Introduction

The idea for *100 Dresses* originated not with the staff of The Costume Institute, but with our colleagues in the rest of the Museum. Over the years, we have heard a number of them express a desire for a publication that would sample the rich holdings in our department's vast archives. Because of the well-known constraints associated with the display of costume and textiles—their tendency to wear in the stresses of dressing and mounting for display and their susceptibility to light damage, especially—The Costume Institute collection, though available online and to students, scholars, and design professionals on research visits, is seen by the larger public only intermittently and selectively in the department's annual exhibitions and attendant catalogues. Despite the effort on the part of the Museum to establish a running sequence of installations representing the breadth of holdings of The Costume Institute, only a relative few of the more than 35,000 costumes and accessories spanning five continents and as many centuries can, in fact, be seen on display at any given time.

The extraordinary and, in many instances, exceptionally rare examples of dress in this compilation are a diverse representation of women's clothing from the late seventeenth century to the present. While The Costume Institute, today, is among the preeminent museum collections of dress in the world, its precursor was the Museum of Costume Art, a relatively modest aggregation of historic and regional costumes acquired in the 1920s for the use of New York City's Neighborhood Playhouse in dramatic productions. Over the years, the small but burgeoning collection of dress came to be deemed too historically important to subject it to the wear and tear of theatrical use. In 1937, the Museum of Costume Art was established and immediately benefited from gifts by Irene Lewisohn, the founder of the Neighborhood Playhouse; her sister Alice Lewisohn Crowley; theatrical designers Aline Bernstein and Lee Simonson; and others. In 1946, with the financial support of the fashion industry, the Museum of Costume Art merged with The Metropolitan Museum of Art, and in 1959, The Costume Institute became a full curatorial department in its own right.

At its inception as the Museum of Costume Art, the collection was intended to comprise an encyclopedic survey of fashionable Western European dress, augmented by a smaller, subsidiary collection of regional examples. When it became a part of The Metropolitan Museum of Art, however, a new mandate, to collect "masterworks" in the field of dress, was added to its original mission to provide a timeline of costume. Therefore, the selection of dresses in this book attempts not only to suggest the amazingly comprehensive nature of The Costume Institute's holdings but also to include some of the most iconic examples of fashionable dress to survive in any collection, public or private.

Because the Museum's costume collection is mostly composed of women's dress and accessories, with much smaller numbers of menswear and children's wear, the reductive editing to only 100 dresses from the thousands of choice examples was fraught with debate and, on occasion, good-natured contention. Truth be told, establishing a standard for inclusion of one beautiful or elegant dress over another presents, whatever its date and provenance, the same subjectivity that operates whenever we judge others by what they are wearing. Despite the curator's ability to apply objective criteria and recognized methodologies to identify the historical significance, rarity, or technical virtuosity of one gown when compared with another, in the end, it must be confessed, the 100 dresses in this book are often simply the special favorites of one or another of The Costume Institute staff. This bodes well, however, for another publication, *Another 100 Dresses*.

—Harold Koda
Curator in Charge of The Costume Institute

The Dresses

Mantua
Late 17th century

British

The great French costume authority Maurice LeLoir (1853–1940) once pronounced the Museum's earliest complete European costume the finest example of its kind extant. Made of striped wool embroidered in silver gilt, the dress dates from the very end of the seventeenth century, about 1695.

The open robe is drawn away from the front and draped at the back to reveal the richly decorated petticoat. The embroidery is worked perfectly along both sides of the border of the robe and train so that when the skirt is draped, its beauty is uninterrupted.

Thread of silver gilt wound on a yellow silk core was used for the embroidery, adding sparkle to an otherwise sedate costume.

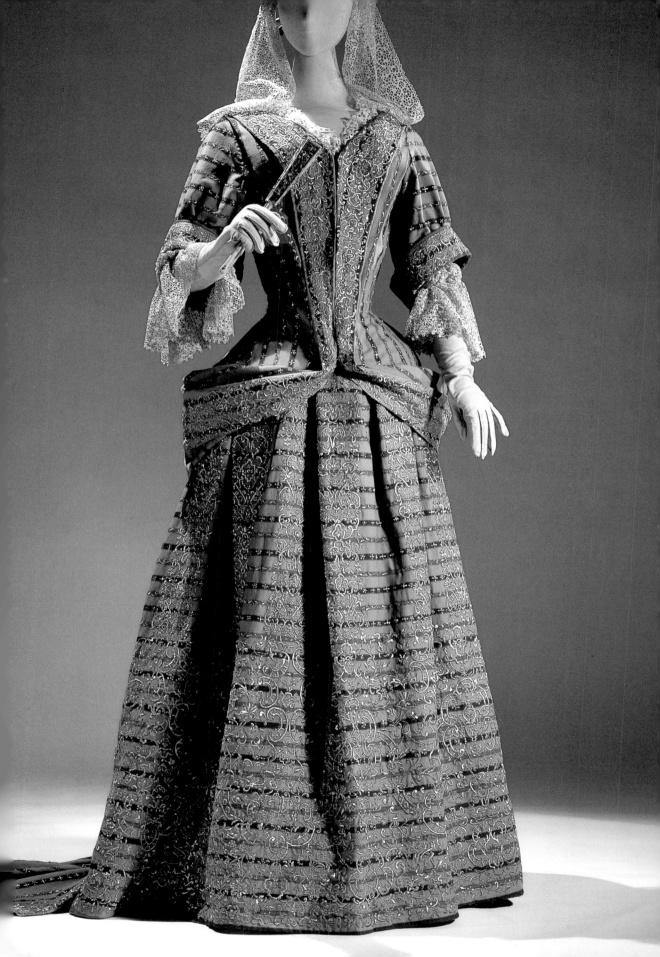

Robe Volante
1735–40
French

This opulent dress in tobacco brown silk damask reveals both the airy amplitude of 1730s style, just before the flattening out of the skirt by midcentury, and the luxury of extraordinary silk damask, with its tone-on-tone design in pronounced relief. In fact, the sumptuous fabric itself, with its large floral and lace pattern, is enough to warrant interest in and satisfaction from this gown. Elbow-length sleeves end in pleated wing cuffs, and in the back, double box pleats start at the neckline and splay in a widening flow down the dress to the hem.

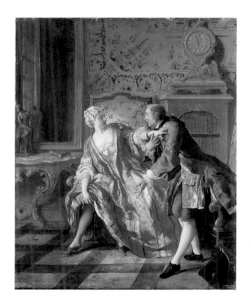

In *The Garter*, painted in 1724 by Jean François de Troy (French, 1679–1752), a woman wearing a *robe volante* seems to be gently restraining her suitor while, at the same time, removing a garter to give to him. Garters, usually silk ribbons tied just above the knee to hold up the stockings, were often embroidered with amorous sayings.

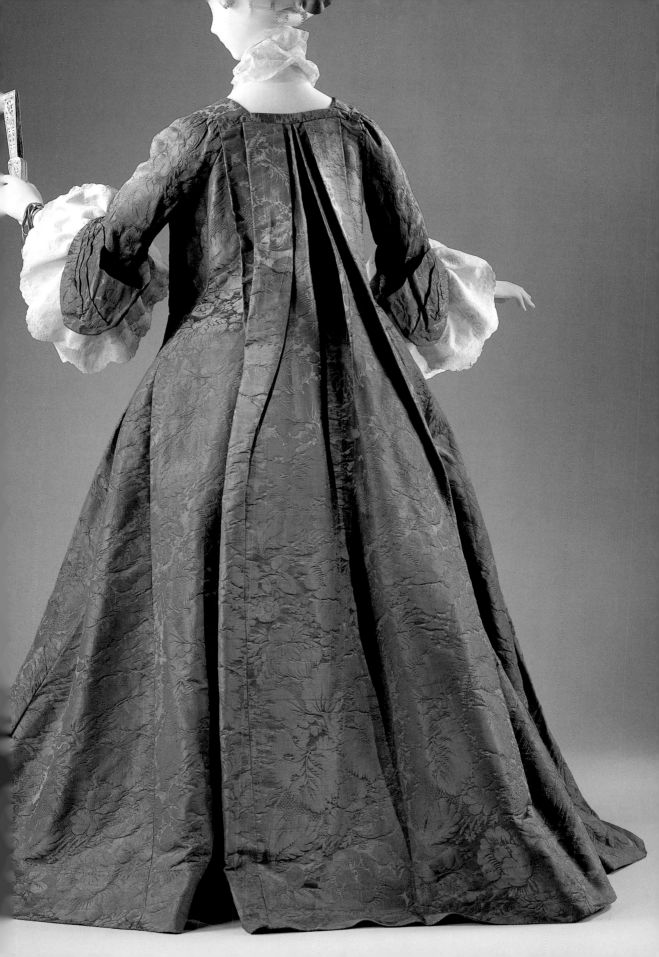

Court Dress (Robe à la française)
ca. 1750
British

In the mid-eighteenth century, formal court dresses—called *robes à la française* for their close association with the French court—presented a wide and flattened silhouette. Panniers, constructed of bent wands of willow or whalebone and covered in linen, were worn under the skirt to hold it out. Seen from the side, the skirt of this court dress was barely wider than the wearer's body, but seen from the front or back, it extended nearly five feet.

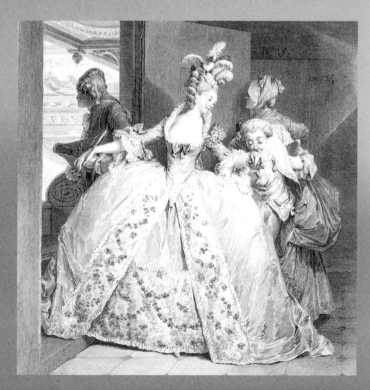

When wearing a *robe à la française*, a woman had to turn sideways to get through most doorways, as shown in this 1777 etching and engraving.

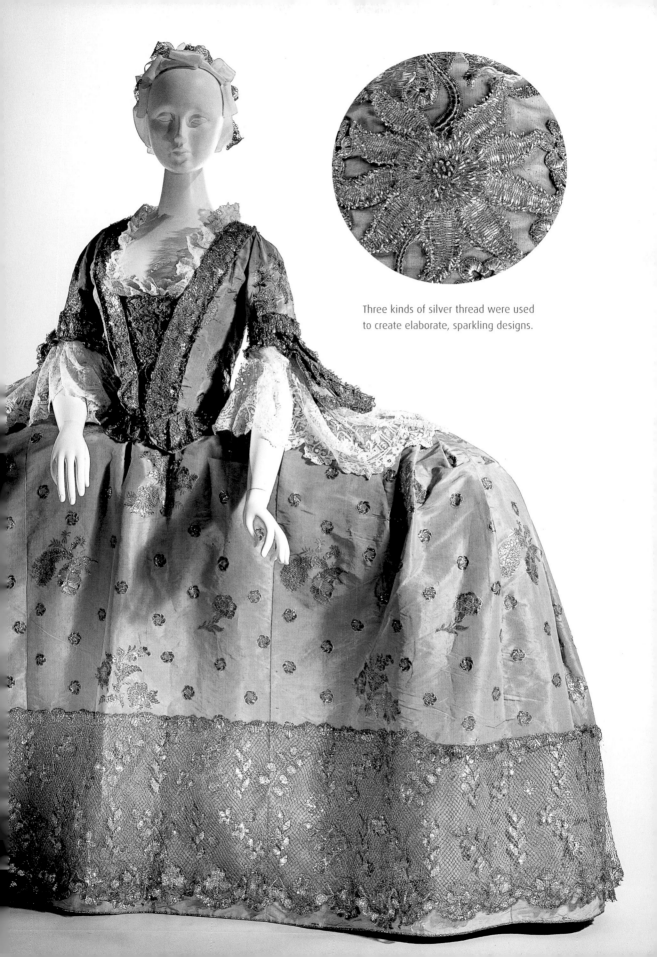

Three kinds of silver thread were used
to create elaborate, sparkling designs.

Robe à la française
1760–70

French

Fashionable dress of the eighteenth century reflected a changing world influenced by textiles and textile techniques from Asia and the Middle East. The warp-printing of the fabric used in this dress emulates *ikat* (from the Malay), a technique in which yarns are tie-dyed before weaving. The softened edges of the design, caused by the slippage of the warp threads as they are stretched taut on the loom and during weaving, do not detract from the bold textile design.

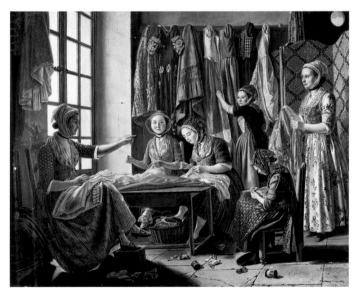

Seamstresses' Workshop in Arles by Antoine Raspal (French, 1738–1811) is thought to depict his wife's dressmaking shop in about 1760. The fabric of the petticoat hanging at the left end of the row of dresses is remarkably similar to that of the dress shown at right.

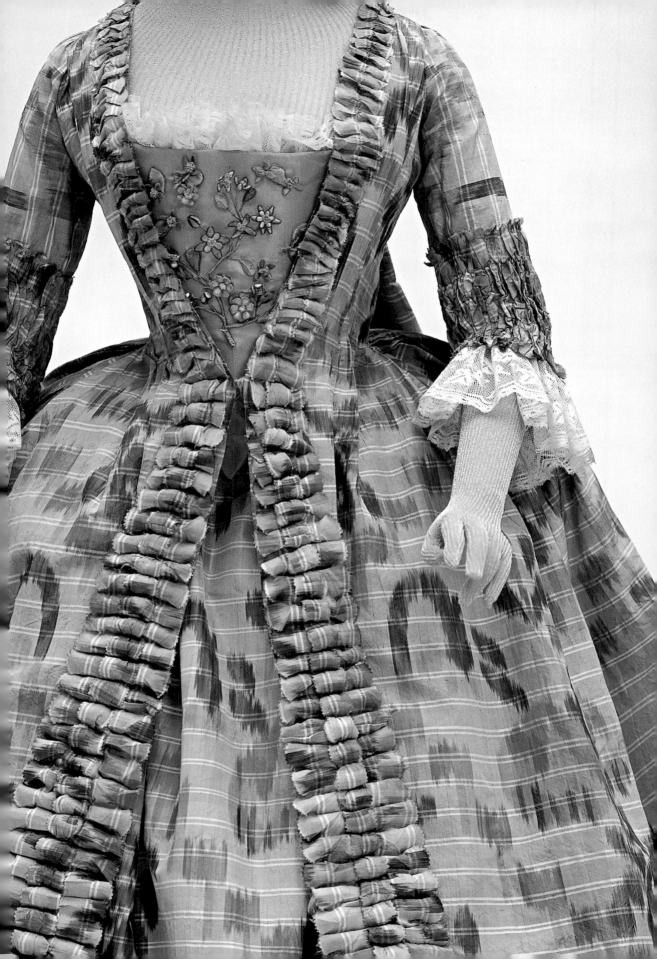

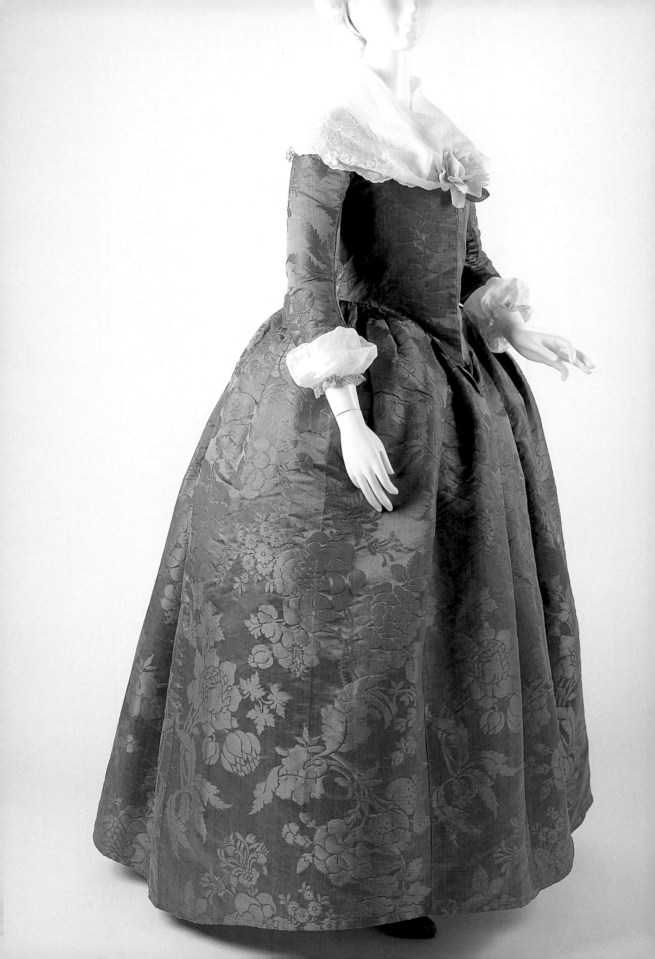

Robe à l'anglaise
ca. 1775

American

This dress is considerably less gaudy than European clothing of the period, yet its imported green Spitalfields silk damask lends an air of sumptuousness. Spitalfields, in London's East End, became renowned for its fine dress silks after French Huegenot weavers, fleeing Catholic persecution in their home country, settled there.

The floral design of the damask is attributed to Anna Maria Garthwaite (1690–1763), an Englishwoman who began creating textiles when she was in her thirties. It is not known how she learned the art of designing for silk weaving, but her efficient use of materials and her gracefully scaled brocades and damasks show her mastery of the craft.

Fabric designer Anna Maria Garthwaite's family was acquainted with several naturalists, which may account for the skilled rendering of flowers in her work.

Robe à la polonaise
1780–85
American

The *polonaise* gown first came into fashion in the 1770s. It had a close-fitting bodice and a skirt with a back that could be gathered up into three puffed sections to reveal the petticoat below. The method of suspending the fabric varied. Most often, the dress had rows of little rings sewn inside the skirt through which a cord ran from hem to waist. Alternatively, ribbon ties were used. In some instances, the skirt was held in place by simple cords sewn to the inner waist of the dress and looped over buttons attached to the outside waistline. All three methods allowed the wearer to adjust the length of the fabric to achieve different looks.

Hand-painted Chinese silks, like this one, were among the most coveted materials for eighteenth-century dresses.

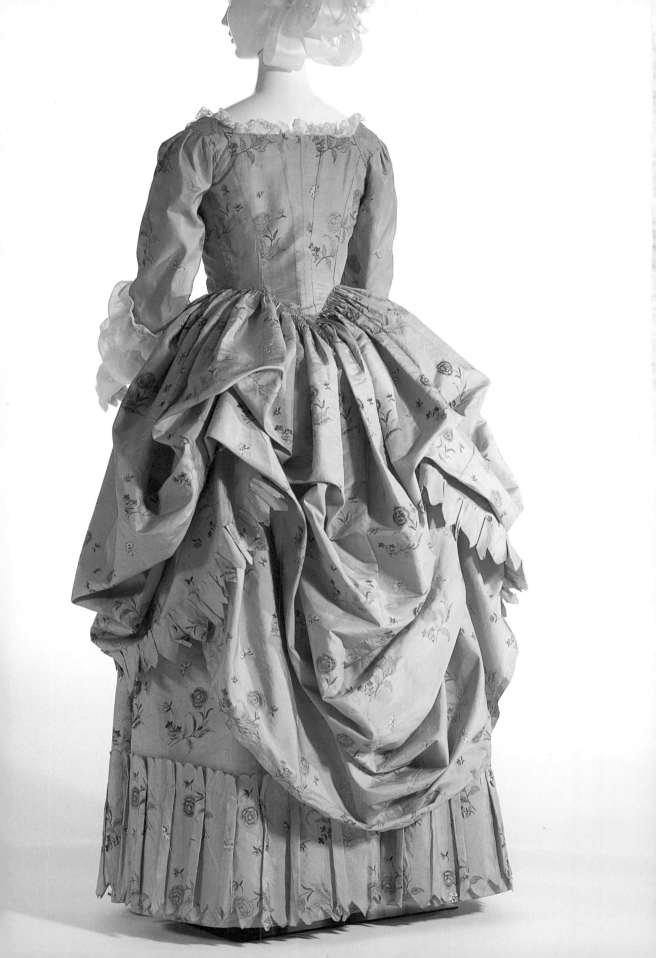

Dress
ca. 1798
European (probably)

After the French Revolution (1789–99), traditional court styles were abandoned. Most clothing was constructed in an increasingly cylindrical silhouette, often in light muslins that suggested the chemise, or undergarment, of earlier styles. The combination of elements within this one dress makes it particularly interesting. Made of fine Indian mull with a rare matching fichu, the dress's train and tiny bodice, only two and one-half inches from neckline to waist, preclude any date earlier than about 1798. Yet its form, though simplified, alludes to the components of the *robe à la française*—the ancien régime open-fronted robe with matching underskirt of the 1760s to 1780s.

Each piece of the dress is embroidered with variations on the floral designs rather than mere duplications, suggesting creative handwork, not pattern book repetitions.

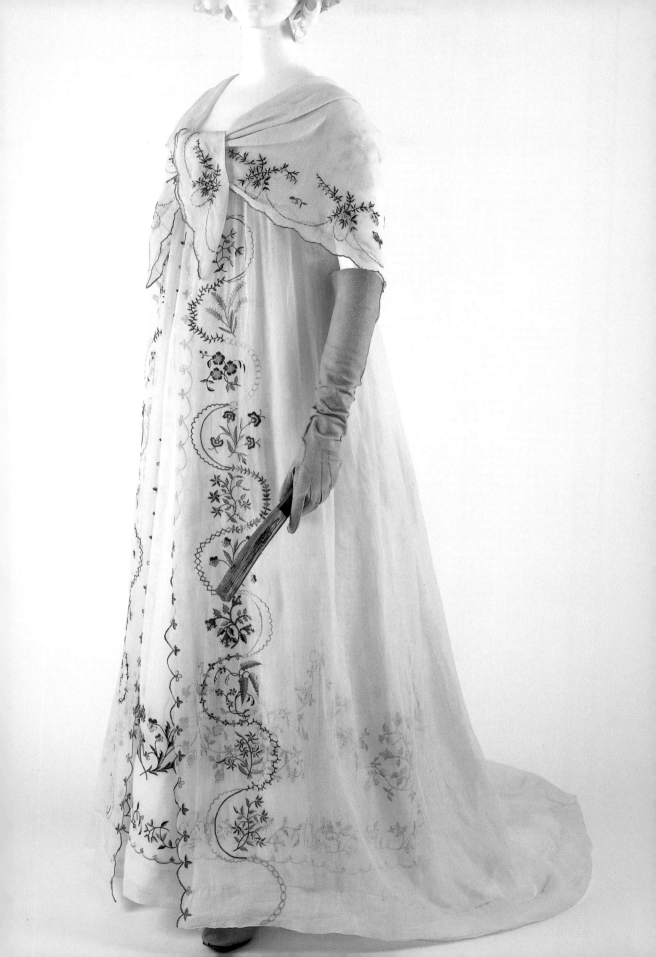

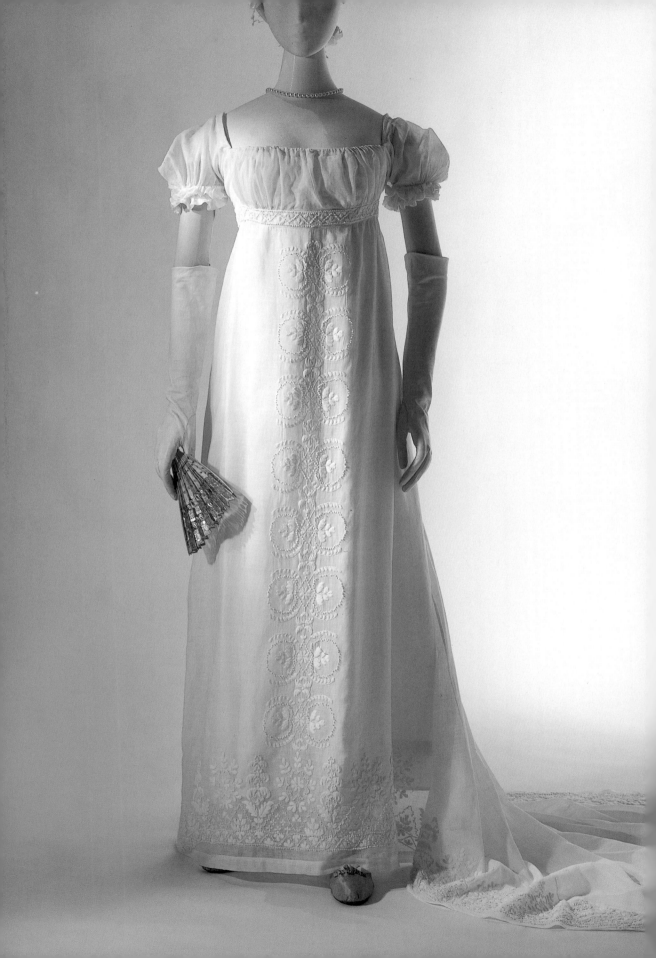

Evening Dress
1804–05

French

O n December 24, 1803, Jérôme Bonaparte, brother of Napoléon, wed Elizabeth Patterson of Baltimore, Maryland. The fashionable young American wore a dress that, according to a contemporary, "would fit easily into a gentleman's pocket."

Although originally thought to have been Patterson's wedding dress, the neoclassical gown pictured here probably dates from after 1804, when this type of vertically disposed white embroidery became fashionable. Under the very sheer cotton mull were worn the chemise, corset, and underdress that only a daring few had briefly abandoned in imitation of "Grecian" naturalism—the first of many fanciful nineteenth-century allusions to costume in earlier historic periods.

As for the Patterson-Bonaparte union: Napoléon had the marriage annulled in 1805.

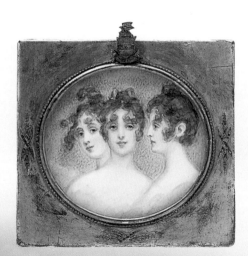

This miniature triple portrait of Elizabeth Patterson Bonaparte, created between 1805 and 1810, is attributed to Thomas Sully (American, 1783–1872).

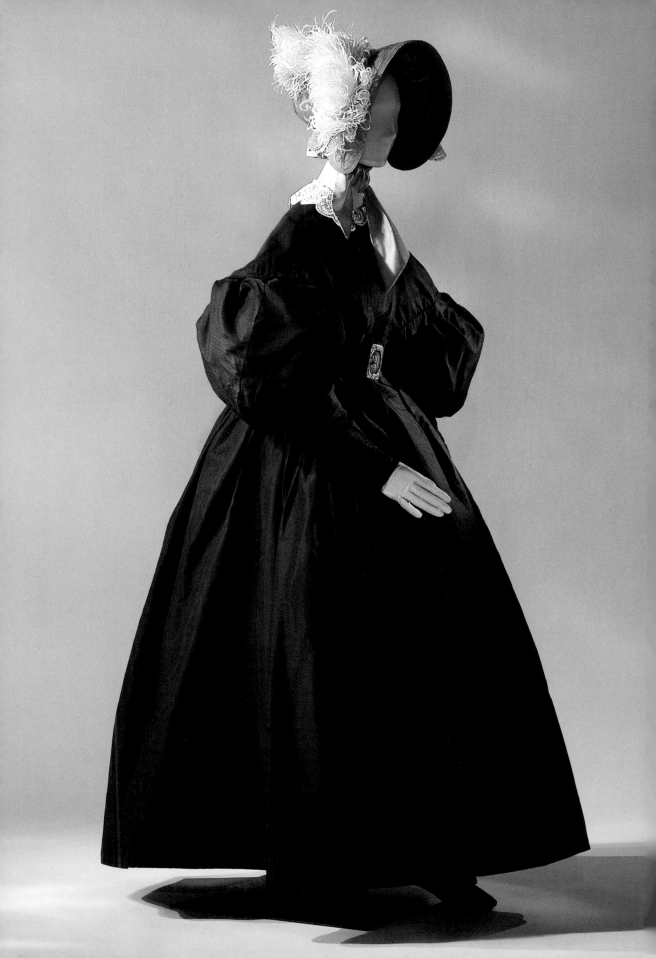

Walking Dress
ca. 1835

American

T he 1830s silhouette was created by a corseted, raised waistline and a bell-shaped skirt revealing the lower ankle. The wide triangular shape at the top of the dress was imposed by the stays worn underneath, which had straps to hold the shoulders down and away from the neck. Puffed sleeves in the 1820s and '30s were sometimes supported with sleeve extenders and pads made of various materials. By the late 1830s, however, the gigot sleeve was collapsing at the sleeve cap. A detachable pelerine was used to maintain the triangular silhouette. The waist, still not quite at its natural position, is made to appear small by the expanse of the dress above and below.

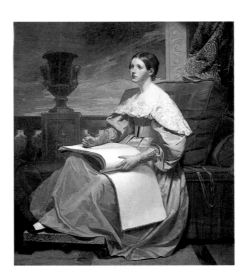

Susan Walker Morse wears a similar dress in this ca. 1836–37 painting by her father, Samuel F. B. Morse (American, 1791–1872), artist and inventor of the telegraph.

Ensemble
ca. 1855
American or European

E quipped with two interchangeable bodices, one for day and one for evening, this costume, for all its frothy romanticism, introduces a sensible pragmatism. Less practical are the splendid ruffles of organza in high-maintenance profusion. Research in The Costume Institute's Woodman-Thompson Collection of Fashion Plates confirms the date. The country of origin is considerably more difficult to determine because, with the popularity and proliferation of fashion plates, ideas and modish textiles were carried fast and far.

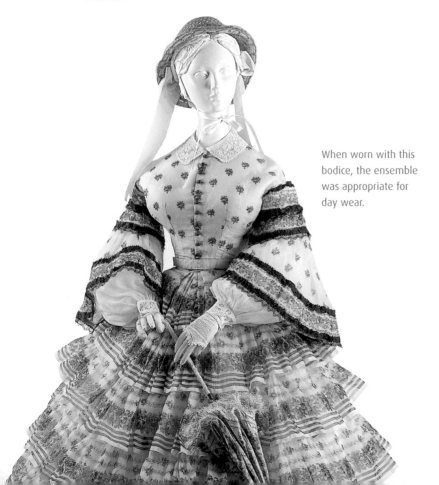

When worn with this bodice, the ensemble was appropriate for day wear.

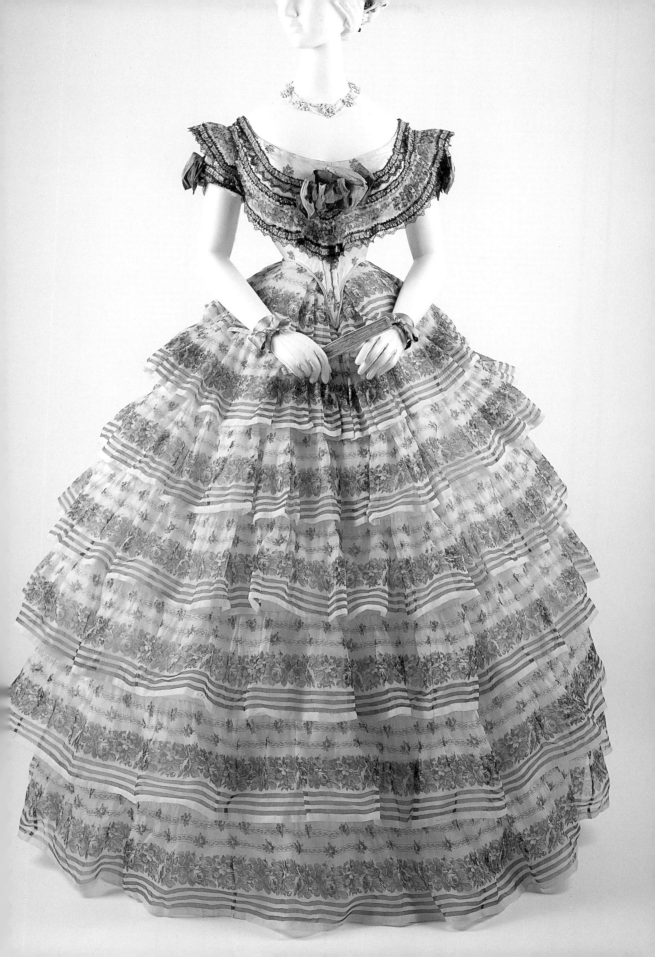

Day Dress
ca. 1857
American

By the 1850s, the ballooned sleeve had disappeared completely, as had any hint of women's feet and ankles. The waistline was at its natural position, emphasized somewhat by a corset but even more so by the expansion of the skirt. Still supported by starched and corded petticoats, the skirts of the early 1850s were often pleated at the waist, rather than gathered. This allowed for a crisp, highly concentrated volume of fabric and retained the narrowness of the waist.

The dress-silk plaid reflects the period's vogue for tartanlike patterns, whether or not with clan associations. It was a fashion fueled by the affection Queen Victoria and Prince Albert had for Scottish dress, the Highlands, and Balmoral, their Scottish retreat. But for all the ostensible nostalgia and historicism implicit in the wearing of the plaid, its bold colors were the result of the Industrial Revolution and the invention of chemical dyes in the mid-1850s.

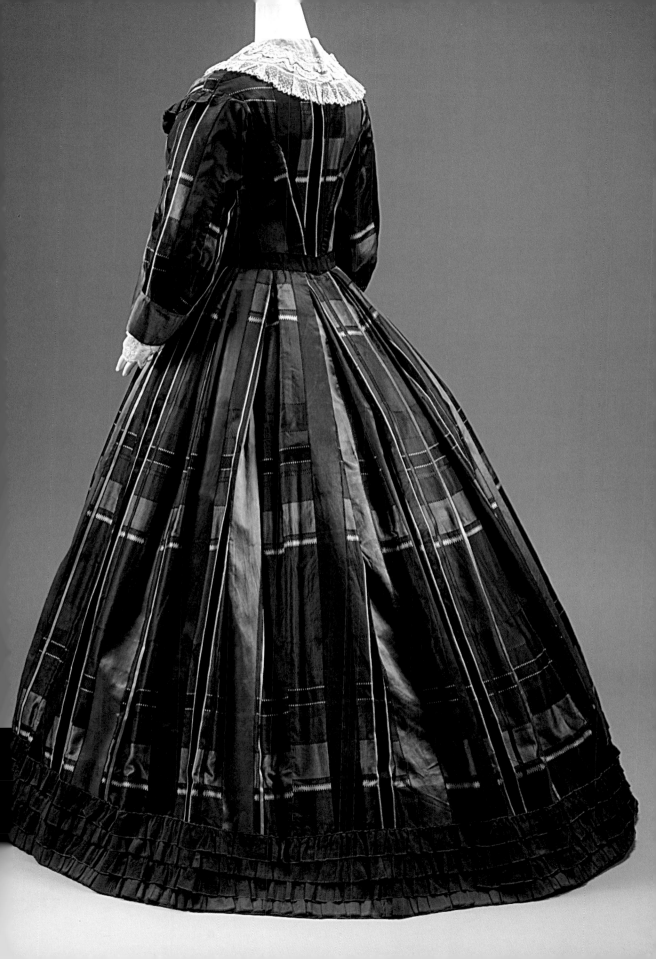

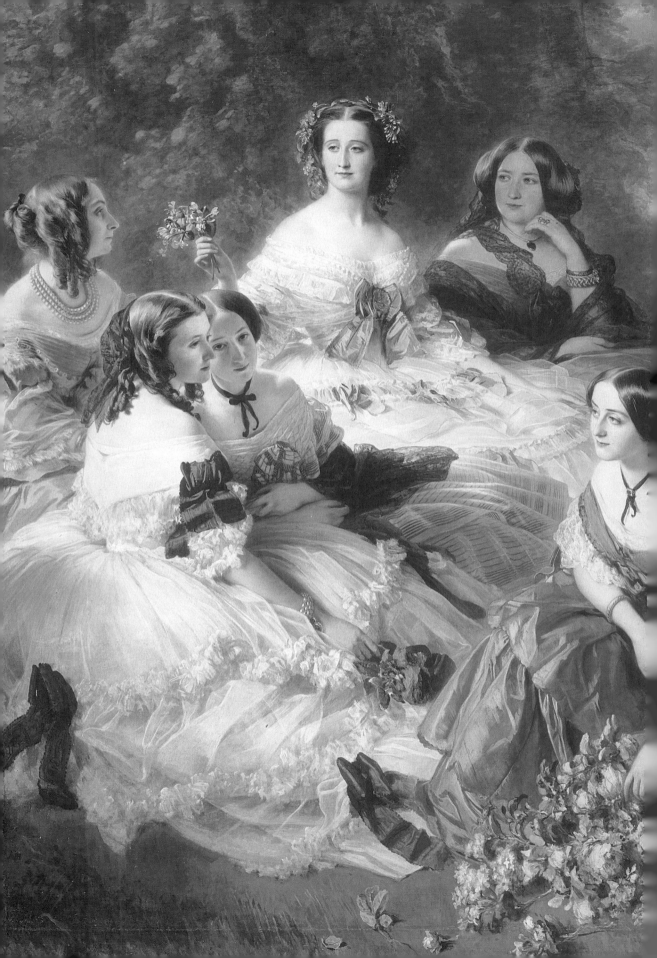

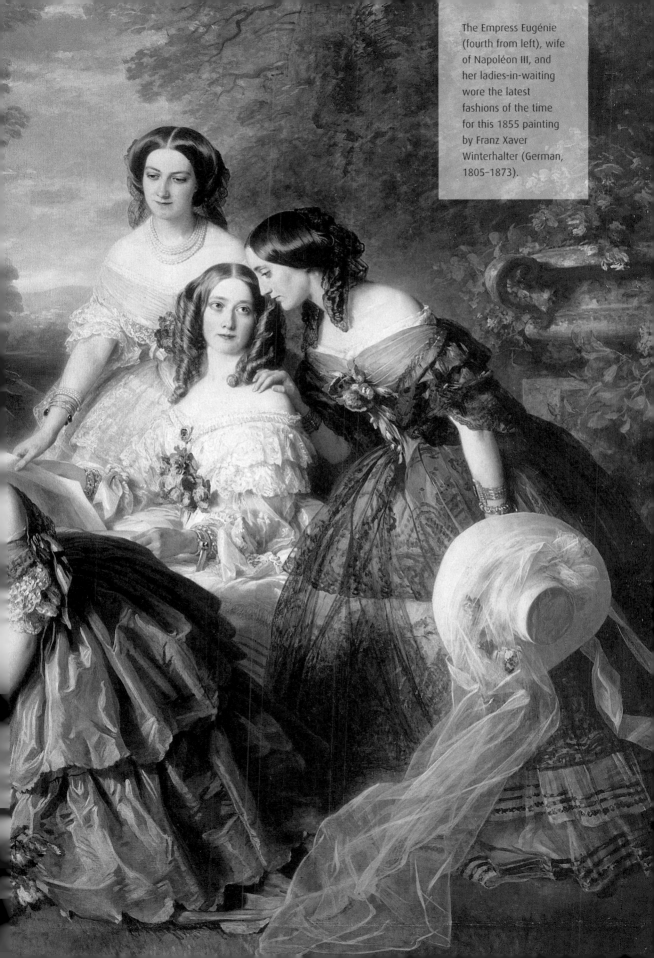

The Empress Eugénie (fourth from left), wife of Napoléon III, and her ladies-in-waiting wore the latest fashions of the time for this 1855 painting by Franz Xaver Winterhalter (German, 1805–1873).

Ball Gown
1861–62

American

A gown for a grand ball is meant to capture all the magic of the occasion: the fantasy of romance, the essence of fashionable femininity, and the rush of expectation. This ball gown has a youthful delicacy in its design, with alternating bands of blue moiré taffeta and plain taffeta brocaded with flowers. The wide skirt would sway gracefully during the dance, although its circumference would necessitate a certain distance between partners despite the flexible hoop worn underneath. The richness of the fabric and the ornamental fringed bowknots add to the gown's festive appearance.

Bows of ribbons woven in matching colors decorate the costume, along with the multicolored silk fringe typical of the period.

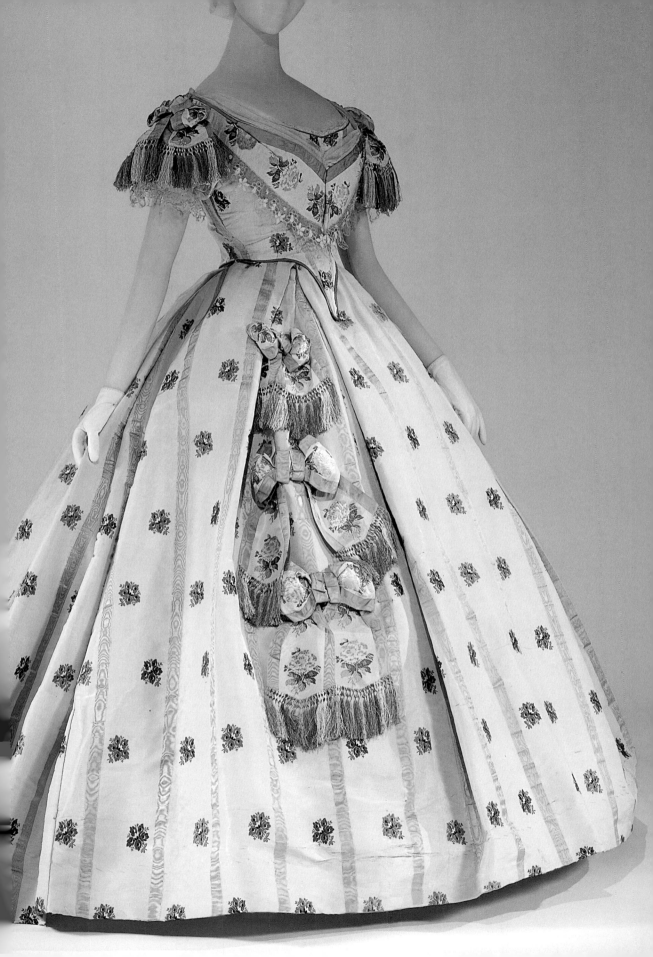

Promenade Dress
1862–64

American

Costumes for leisurewear in the nineteenth century differed little in silhouette from those for any other purpose. For example, even though mountain climbing might demand a shorter skirt and sturdy shoes, it would still be undertaken with a crinoline, albeit somewhat reduced in scale. Summer visits to the seaside did require costumes of more practical fabrics that were washable and durable, or at least not easily ruined by sun and seawater.

This costume is made of white cotton piqué, a fabric with natural body owing to its weave structure that was very popular for summer dresses. The sewing machine, invented in 1846 and in wide use by the 1860s, was used for all the straight interior seams, but the trimmings, like the black wool braid, or soutache, on this costume, were applied by hand.

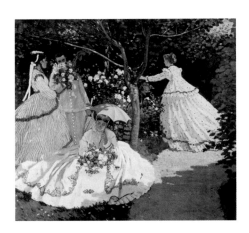

A woman wears a similar white dress trimmed in black in the 1866 painting *Women in the Garden* by Claude Monet (French, 1840–1926).

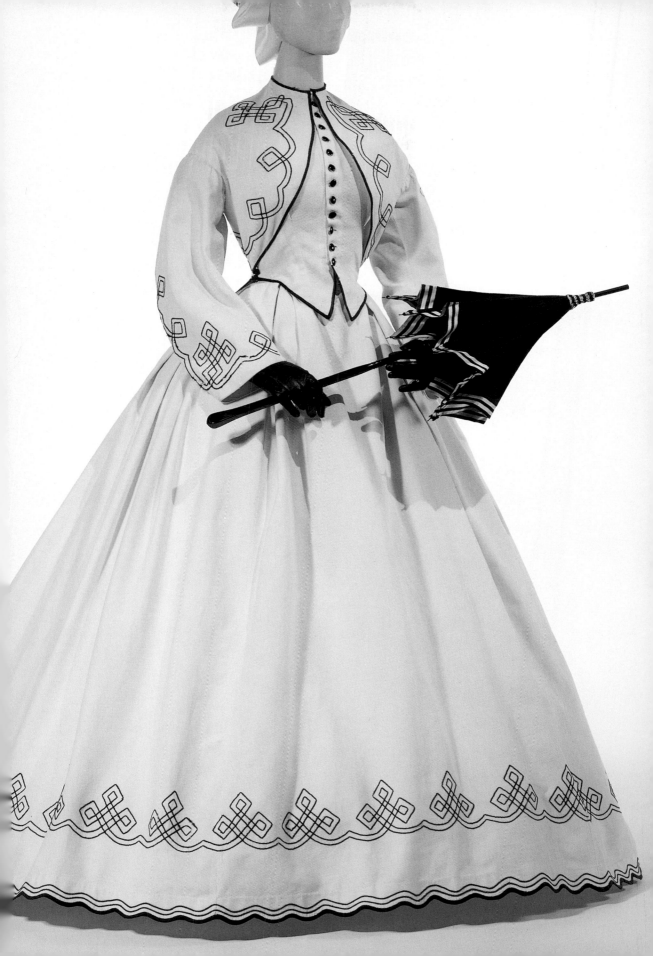

At-Home Gown
1876–78
American

In the back, the floor-length skirt of this one-piece princess-style wool serge dress is draped and gathered into a self-bustle set below the waist. In the front, an opening runs from the neckline to the knife-pleated silk taffeta ruffle just above the hem. The long rows of embroidery bordering the opening and wrapping around the hem of the skirt are an eighteenth-century appropriation. The floral decoration and its placement on the garment arise not from copying women's fashion of the period but from an allusion to eighteenth-century menswear. It is as if an ancien régime waistcoat's ebullient decorative impulse has been transferred to the brown wool of this almost dour nineteenth-century dress.

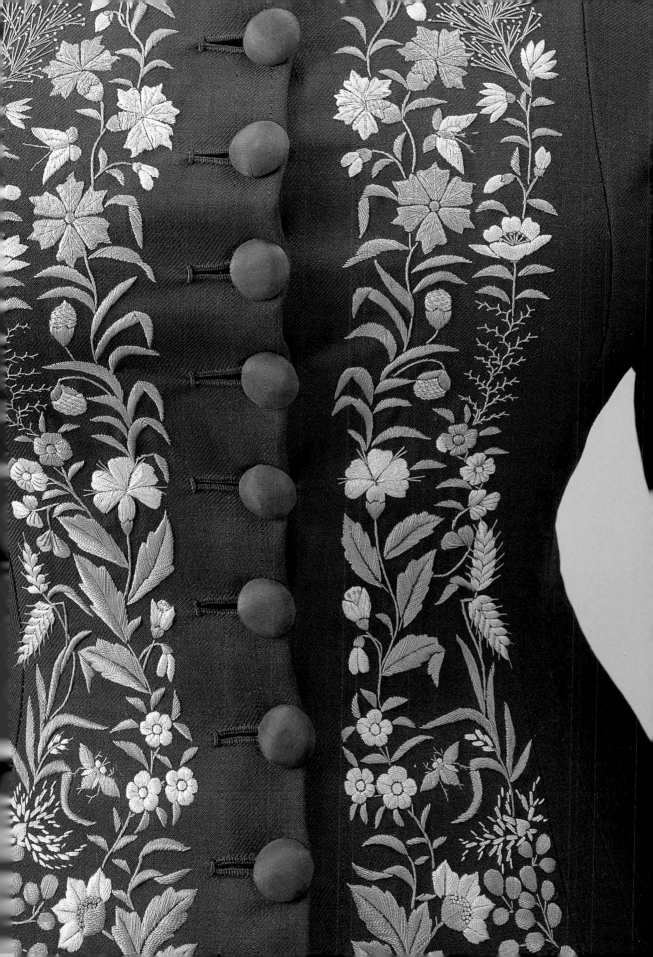

Wedding Ensemble
1880

American

In past centuries, bridal dresses were not always white because many women used the wedding dress as their best dress for as long as possible. This lovely dress, however, epitomizes the fashionable silhouette of the time as well as the type of wedding dress we now think of as traditional.

Wedding dresses are often of special interest to costume historians since the wearer and date are usually known—two critical items of documentation that are lacking for the vast majority of extant costumes. The dress shown here was worn by Clara Popham Redner upon her marriage to C. Fred Richards in Philadelphia on December 1, 1880.

The elaborate pearl trim on this dress is an example of the fanciful details that may be seen on a traditional wedding dress.

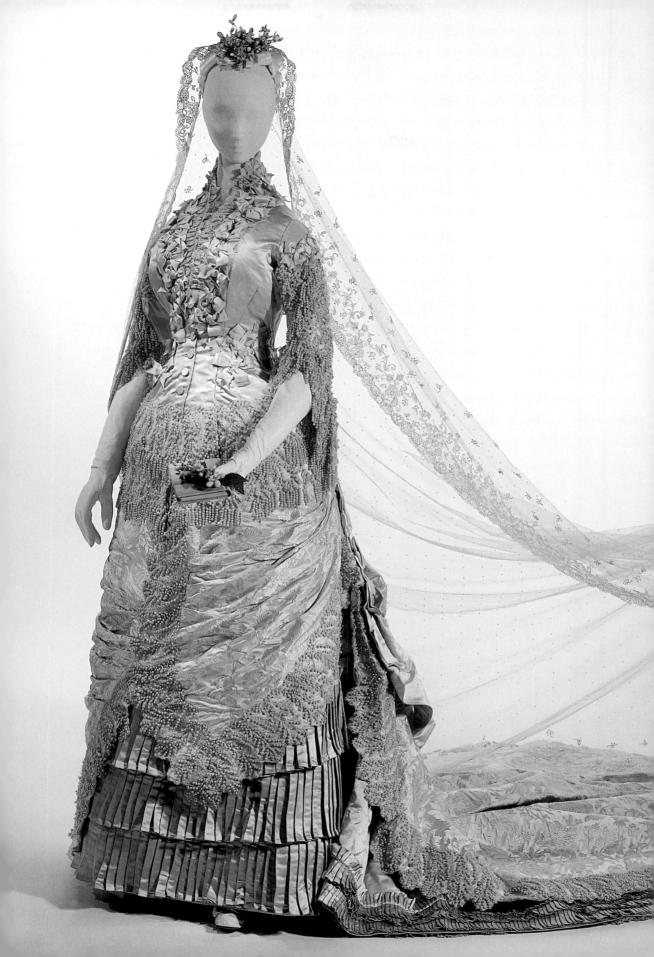

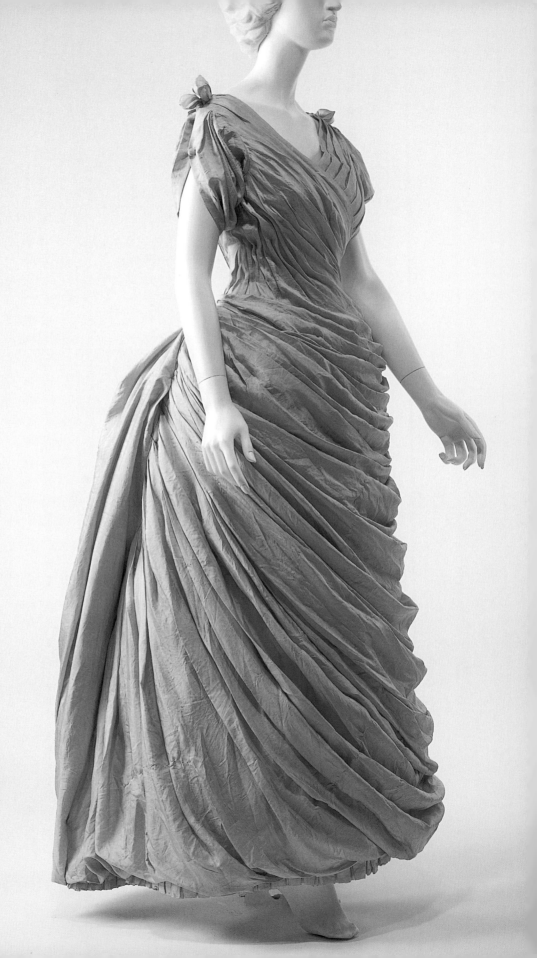

Evening Gown
early 1880s

Attributed to Liberty of London, British, founded 1875

L iberty of London was known for its "artistic" dresses. This evening gown incorporates what were viewed as classical elements of the period. The asymmetrical bodice with the sleeves of a chiton alludes to the wearing of a himation anchored at one shoulder. Likewise, the two bowknots replace the clasps that would have held together an ancient peplos.

But the strongest classicizing detail of the gown is in its densely gathered silk. While the gown's internal structure, with a wasp-waisted corset and bell-shaped underskirt, conforms to the fashionable hourglass silhouette of the period, its surface conjures the wet-drapery of classical statuary.

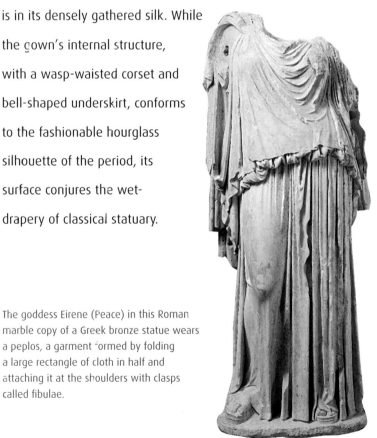

The goddess Eirene (Peace) in this Roman marble copy of a Greek bronze statue wears a peplos, a garment formed by folding a large rectangle of cloth in half and attaching it at the shoulders with clasps called fibulae.

Evening Dress
ca. 1884–86

American or European

As exemplified in this dress, the bustle was at its greatest extension by 1885. It was almost perpendicular to the back and as padded and heavily embellished as a drawing-room hassock of the same period. It was a popular conceit that these bustles could support a tea tray. To sustain the greater weight of the 1880s gowns, light and flexible infrastructures were created with wire, cane, or whalebone and held together by canvas tapes or inserted into quilted channels. The torso above the projection of the bustle was further articulated into an hourglass shape, so much so that it appeared to be as rigid as a piece of armor.

In the 1940s, Bernard Rudofsky (American, b. Austria, 1905–1988) designed a series of satirical interpretations of fashion "deformations," here imagining a double set of legs to rationalize the bustle's expanse.

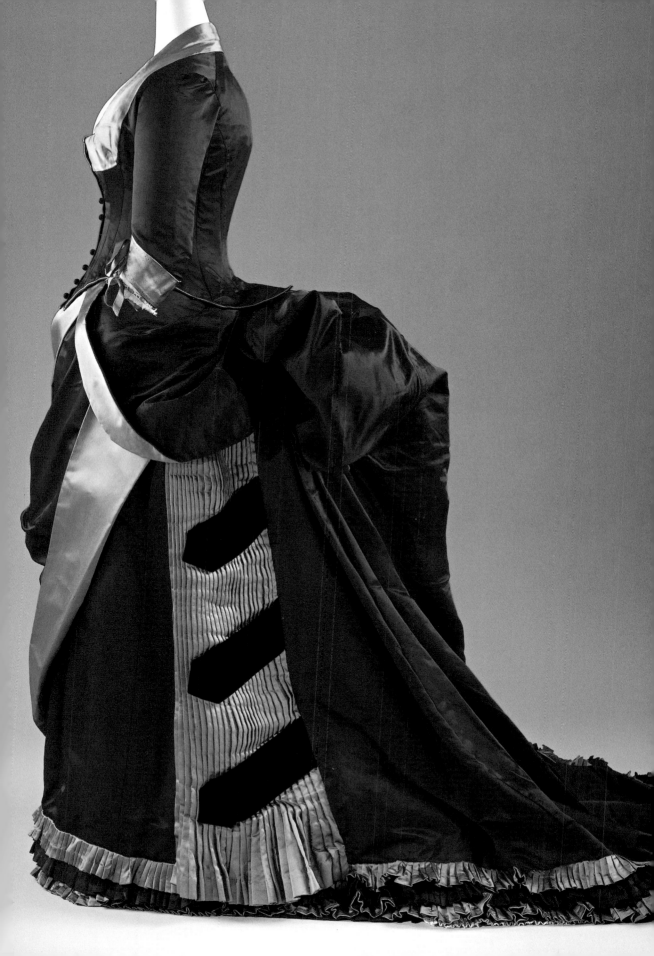

Wedding Ensemble
1887

Herman Rossberg, American, active 1880s

Mr. and Mrs. Andrew Carnegie were among the passengers on the steamship *Fulda* on the night of April 22, 1887, as they departed for their honeymoon in England and Scotland. For her quiet wedding, held little more than an hour before sailing, Louise Whitfield chose to wear the practical gray wool traveling suit pictured at right. The ensemble consists of a skirt and two bodices for day wear, as well as an extra set of cuffs, collar, and front insert, or plastron, of gold embroidery on a red ground to transform one bodice for a more formal occasion.

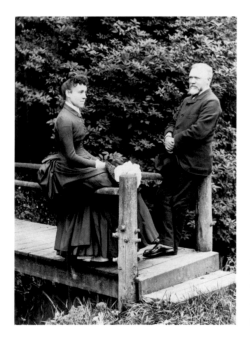

Andrew and Louise Carnegie in 1887. Their marriage was the culmination of a seven-year courtship.

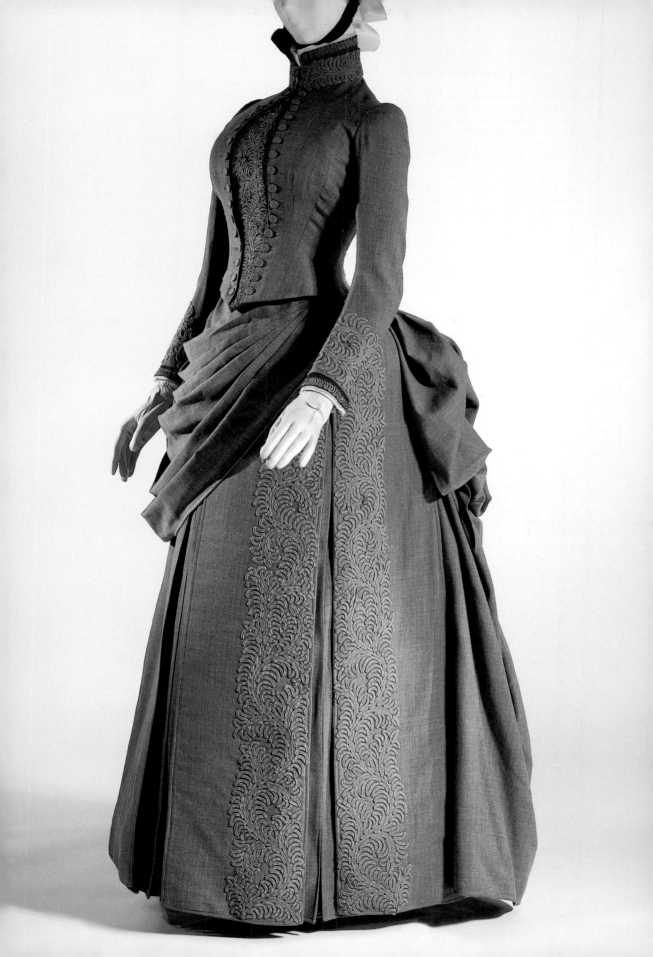

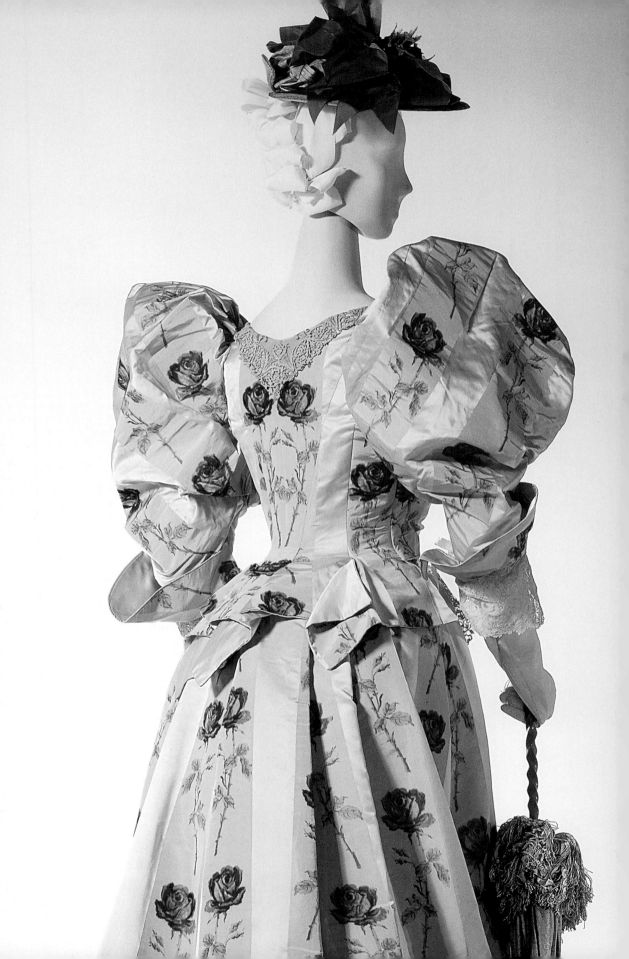

Visiting Dress
ca. 1895
American

After reaching its most exaggerated shape in the late 1880s, the bustle suddenly deflated at the end of the decade to become little more than a small pad at the center back of the waist. Abruptly, the silhouette changed into the hourglass figure that we associate with the Gay Nineties. By 1895, wide shoulders, narrow waists, and wide hemlines were once again in vogue. The aesthetic of both the textile design and dress silhouette of the period is to some extent an exaggeration of earlier ideas. For example, the large scale of the floral pattern in the dress pictured is characteristic of many silk designs of the era, but both the warp print and the floral motif recall eighteenth-century ideas, which have been readapted here to the taste and technology of the late nineteenth century.

In January 1896, the fashion magazine *Nouveautés Parisiennes* published this fashion plate showing the hourglass figure and leg-of-mutton sleeves so popular in the mid-1890s.

Evening Dress
1898–1900

House of Worth, French, 1858–1956

C harles Frederick Worth (French, b. England, 1825–1895) established the first couture house in Paris in 1858. By creating models to show clients in advance of each season, the House of Worth revolutionized the business of fashion. Worth gained immediate popularity when he provided dresses for Empress Eugénie, and his house continued to be a favorite of fashionable Americans into the twentieth century.

The superb example of dressmaking shown here reflects the aesthetic of the late nineteenth century, not only in its striking Art Nouveau pattern of black velvet scrolls on an ivory satin ground, but also in the fashionable S-curve of its silhouette. The textile was woven *à la disposition*, with each section of the costume patterned to its shape, making the fabric's design intrinsic to the composition of the dress.

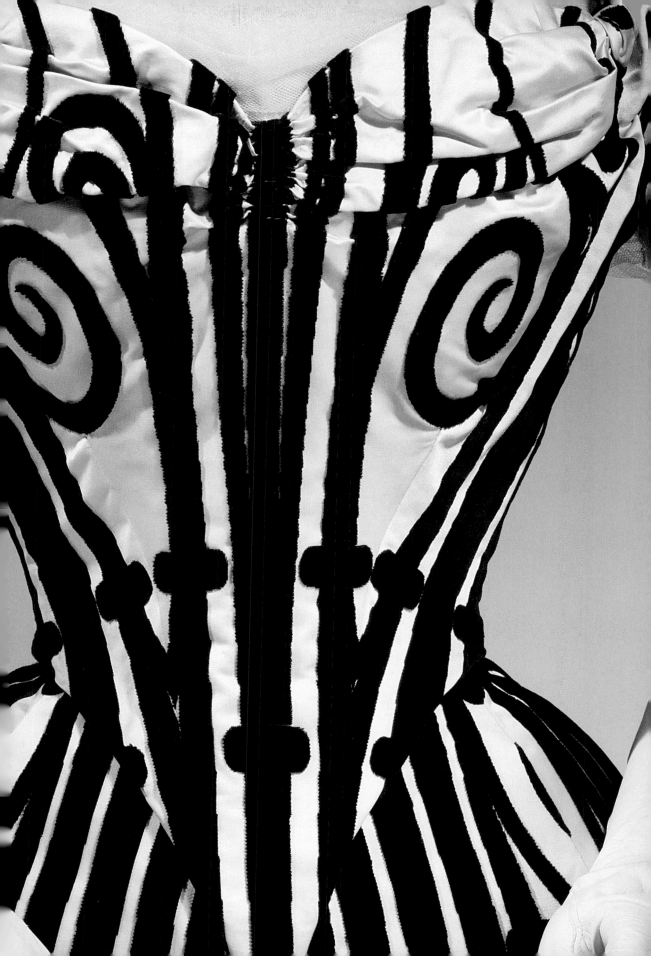

Afternoon Dress
1901

American

This white lace afternoon dress evokes a way of life dramatically different from today's, yet it represents a combination of modern mechanization and the meticulous handwork of previous eras. A narrow machine-made tape, woven loosely, was arranged in various floral and medallion shapes that were then held in place by hand-worked lace stitches.

Even rarer than knowing for whom a costume was made is the existence of a photograph of the costume worn by its original owner. When Winifred Walker Lovejoy donated the dress in 1980, she also presented The Costume Institute with such a photograph of her mother, Winifred Sprague Walker Prosser.

The original owner, Winifred Sprague Walker Prosser, wore the dress when she posed for this elegant portrait.

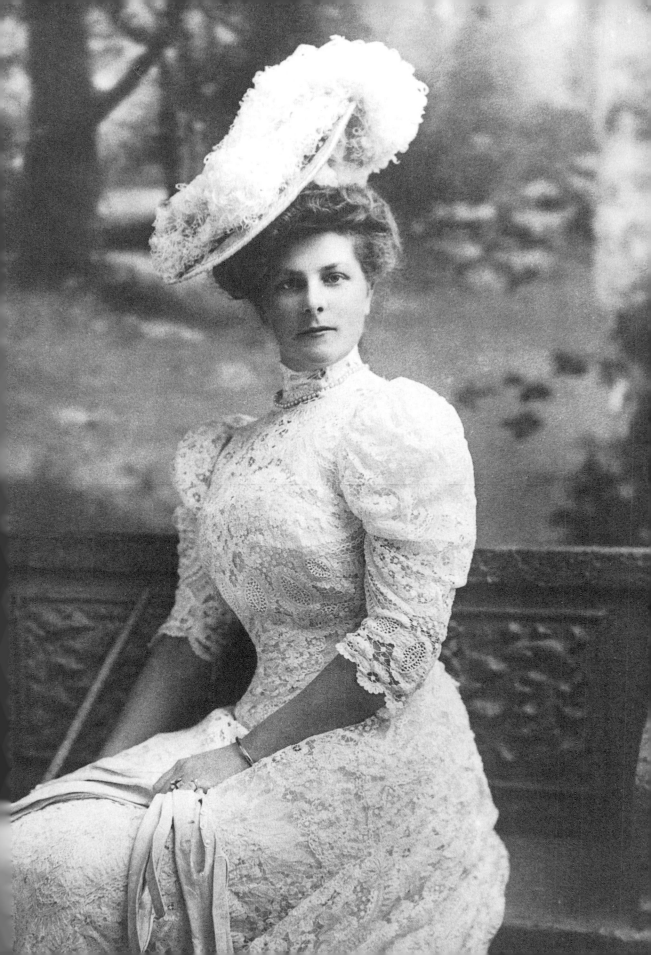

Dress
1902–04

American

The apogee of the white cotton summer dress is evident in this ethereal confection of tucked and gathered mull with lace trim and drawnwork. For a few brief years at the beginning of the twentieth century, the pigeon-breasted S-curve silhouette apparent in this dress was the preferred ideal. The massive pouchlike shape of the monobosom was a consequence of the lowered topline of the corset and an inventive array of prostheses and shape makers intended to conceal the natural form of the breasts.

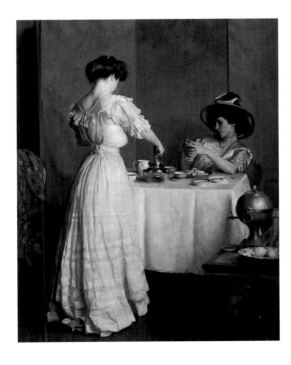

Another example of the white summer dress can be seen in *Tea Leaves*, a 1909 painting by William McGregor Paxton (American, 1869–1941).

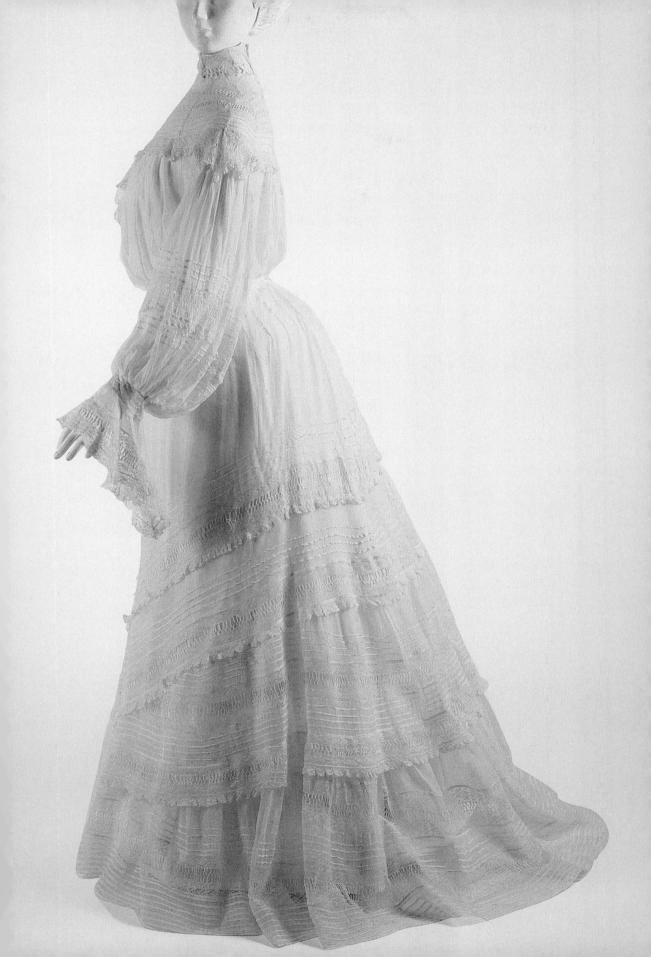

Evening Gown
1910–14

Callot Soeurs, French, 1895–1937

I n this evening gown, the Belle Époque silhouette has collapsed into a cylindrical wrap of lingerie-weight cotton net. The boldness of innovation and the technical skills of Callot Soeurs are especially evident in the applied ornament, added for the magical effect it produces when worn in a candlelit room. The sequins are of various types and were applied by hand in abutting and fish-scale patterns. Heavy bead tassels anchor the light net overdress so it cleaves more closely to the silk and lace underdress.

Some of the sequins on Callot Soeurs' gown are punched into filigree pinwheels, while others are hammered flat. In some instances, metal is overlaid on faceted crystal.

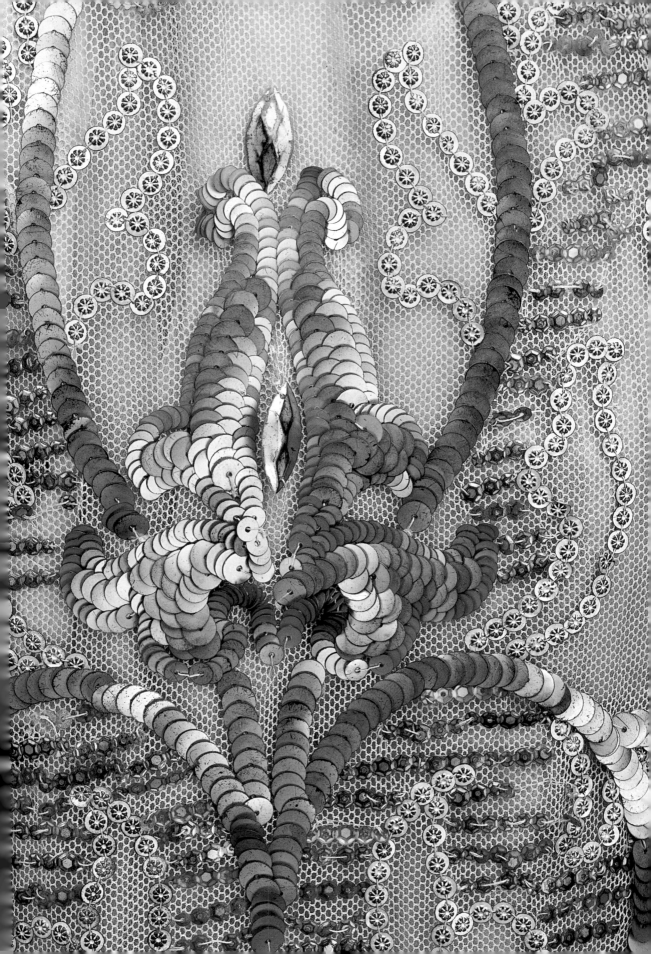

"Théâtre des Champs-Élysées" Gown
1913

Paul Poiret, French, 1879–1944

T heater played an important role in Paul Poiret's creativity. It not only inspired many of his most imaginative flights of fancy but also provided an opportunity for Poiret to introduce his more avant-garde styles into society through his designs for the great actresses of the day. Opening night at the theater, with its formal dress codes, provided a venue where extravagant display was not only appropriate but expected.

Poiret's "Théâtre des Champs-Élysées" evening gown was worn by his wife, Denise, to the premiere of Igor Stravinsky's *Sacre du Printemps*, marking its opening at the Théâtre des Champs-Élysées in 1913. With its ivory tonalities, the gown is an exquisite allusion to neoclassical dress. However, Poiret reinterpreted the simple white mull gown of the late eighteenth century, using richly patterned silk damask overlaid with fragile silk tulle. Double bands of lead-crystal rhinestones articulate the high waist and give the hem of the tulle overskirt a subtle hooplike support.

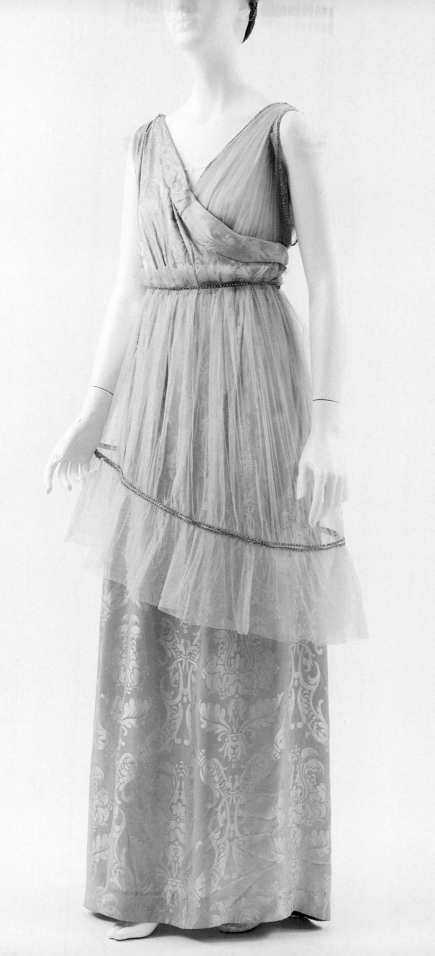

Ensemble
1920s

Raymond Duncan, American, 1874–1966

Raymond Duncan, brother of the dancer Isadora Duncan, was a fervent advocate of classical dress. In fact, Duncan once let his son walk through New York's Central Park in midwinter clad only in a short chiton, chlamys, and sandals—which resulted in his being charged with endangerment of a child.

For this ensemble, designed for his wife, Duncan substituted a similarly constructed but wider chiffon underdress for the chiton. The pairing of sheer chiffon with the opaque tussah silk tunic, however, is more evocative of nineteenth-century artistic conceits, and the apples, grapes, and leaves Duncan hand-painted on the tunic are rendered in the Arts and Crafts style.

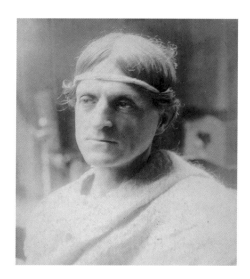

Raymond Duncan, shown here in 1915, and his family not only dressed in classical Greek clothing themselves but also refused to admit guests wearing modern dress into their home.

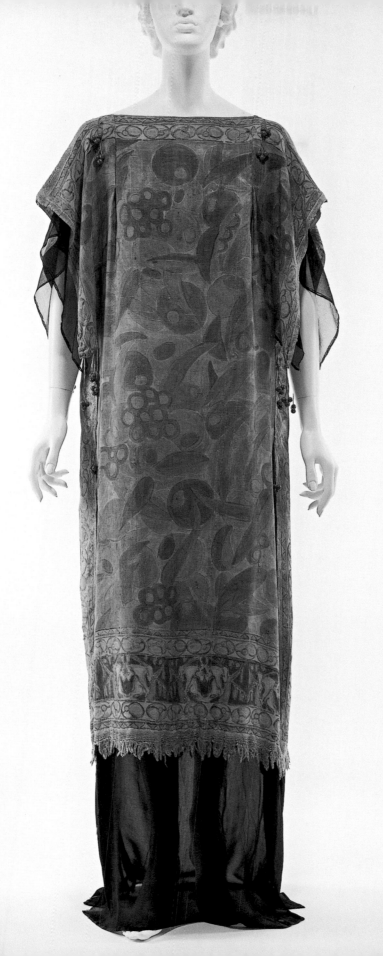

Evening Gown
1920s

Mariano Fortuny, Italian, b. Spain, 1871–1949

Mariano Fortuny created pleated dresses that were originally designed to be worn as tea gowns for informal entertaining at home. By the 1920s, as styles and mores evolved, their body-conforming sensuality made them seductive evening attire for the fashionably adventurous, such as actresses Lillian and Dorothy Gish.

Though Fortuny was secretive about the processes employed in his designs, it is likely that the panels of silk were stitched loosely by hand across the width of the fabric with a thick basting thread. When the edge was reached, the needle was reversed and a new row was made. This process then continued, with the thread zigzagging back and forth through the length of fabric. At the end of the panel, the thread was pulled in tightly, creating a narrow hank of cloth that was passed through heated ceramic rollers. The process did not set the pleats permanently. Clients had to return their dresses to Fortuny to have the pleats reset if they were flattened at the seat or inadvertently dampened.

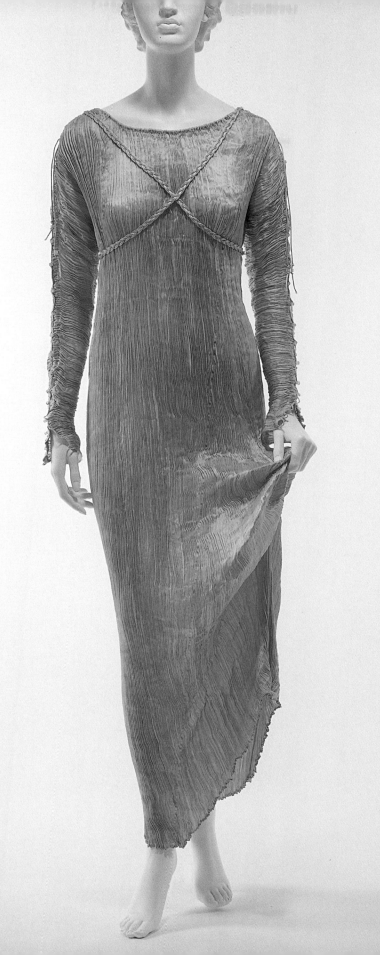

Afternoon Dress
ca. 1923

Paul Poiret, French, 1879–1944

Among the great conceptual masterworks of Paul Poiret's oeuvre, this dress stands as an example of his most reductive approach to dressmaking. Two pieces of silk faille have been identically printed in meter-and-a-half squares, with a border of navy blue surrounding a wine red square. One square is the top, with an opening for a bateau neckline. An underdress consists of a chemise-style bodice, completely obscured when the top is worn, with gilt-braid buttonlike elements at either shoulder that anchor the neckline of the top in place. The second square is the skirt, attached along the top edge to the waist of the bodice and wrapped around until both sides meet to form a center back seam.

Poiret's conceit, to create a dress out of two uncompromised squares of fabric, anticipates the work of designers like Halston and Issey Miyake fifty years later, when a similar geometry emerged in the pattern pieces of their designs.

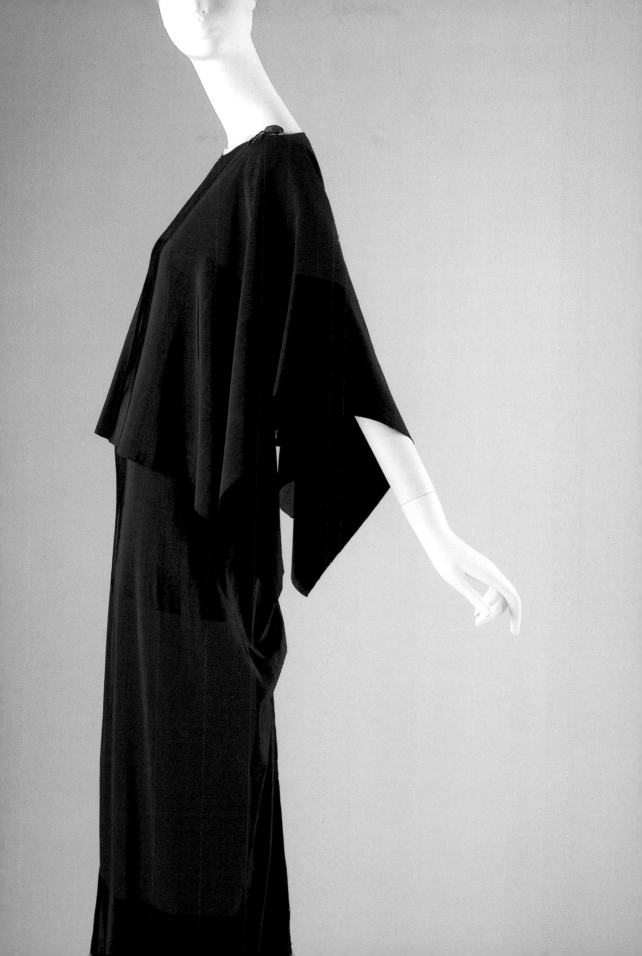

"Irudrée" Evening Gown
ca. 1923

Paul Poiret, French, 1879–1944

Paul Poiret's technical and commercial innovations were fundamental to the emergence and development of modernism, yet his vision of beauty was at odds with *la garçonne*, the movement's feminine archetype. Though his wife's slender figure was the prototype for that boyish silhouette, Poiret dismissed its emphasis on androgyny, describing its followers as "Cardboard women, with hollow silhouettes, angular shoulders, and flat breasts." Nevertheless, Poiret created designs of remarkable structural modernity.

Despite its low-slung tubular rouleau, which is a nod to the hip roll, or farthingale, of the Renaissance, Poiret's "Irudrée" gown stands as an icon of modernist design in its structural simplicity. The skirt is made from two pieces of fabric sewn selvedge to selvedge to form side seams gathered at the dropped waist of the bodice. At the hem, it is finished with a fine picot edging usually reserved for lingerie. The bodice is made from one length of material shirred at the right-hand side seam for fit.

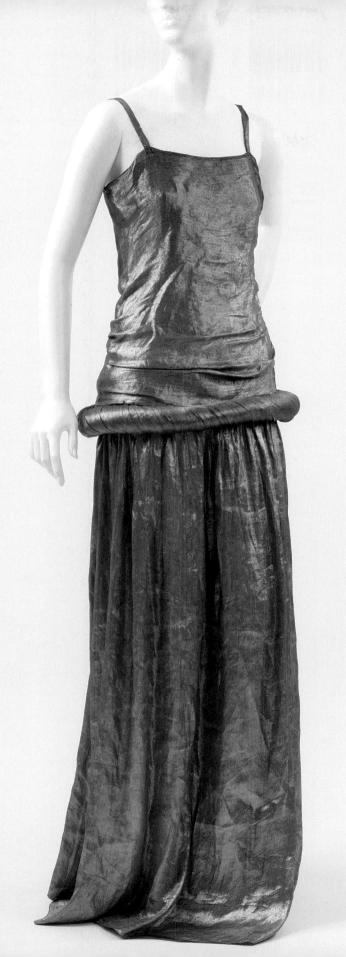

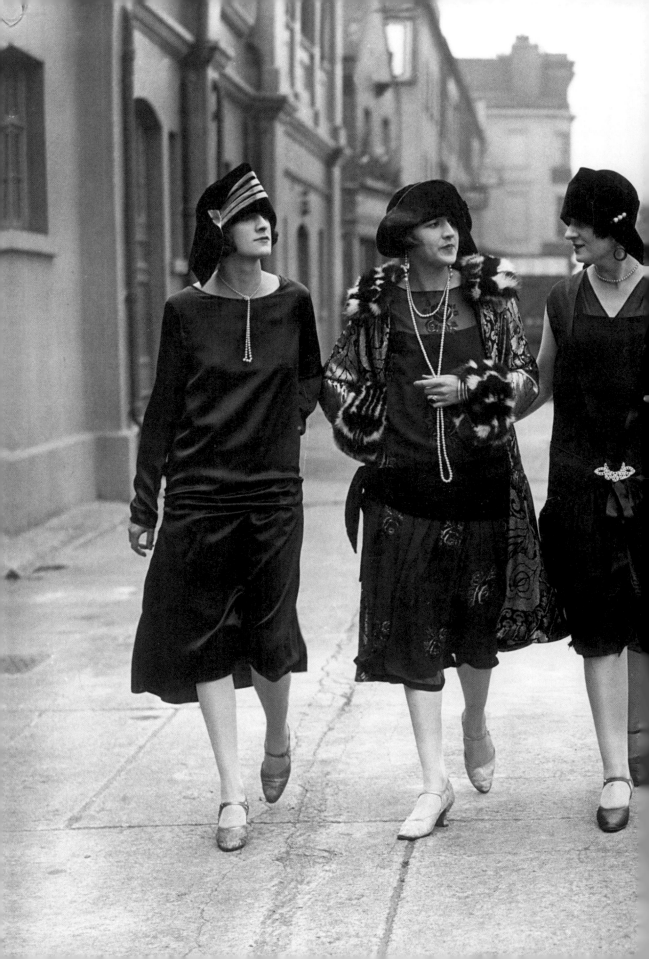

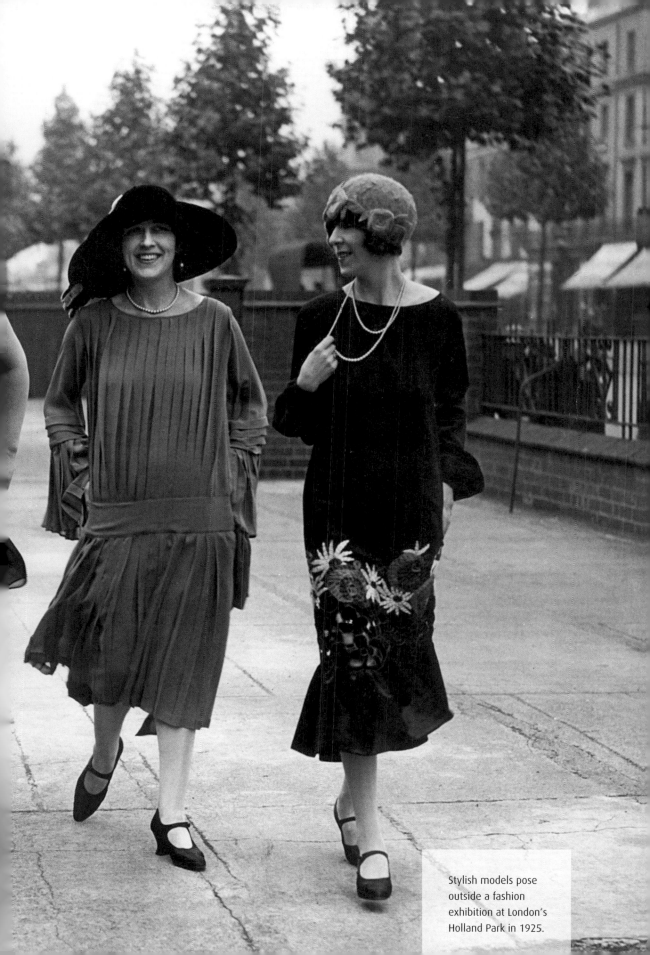

Stylish models pose
outside a fashion
exhibition at London's
Holland Park in 1925.

Robe de style
Spring/Summer 1924

Jeanne Lanvin, French, 1867–1946

Jeanne Lanvin possessed one of the most cultured imaginations in early twentieth-century design. She studied Far Eastern and Middle Eastern dress and textiles; she understood and led the exploration for avant-garde cylindrical design; and she revived the panniered silhouette of the eighteenth century with the *robe de style,* her planar but broad-skirted signature effect.

Chinoiserie roundels that intimate the elaborate past of the Chinese court animate the *robe de style* shown here. Dabbling with a conflation of historicisms and techniques, Lanvin mingled symbols of the Far East with the decorative techniques of the West, paillettes and beads, and a weightless ivory silk tulle corded with silver metallic thread.

Lanvin's *robe de style* appeared in this fashion plate by Eduardo García Benito (Spanish, 1891–1962) published in *Vogue* on June 15, 1924.

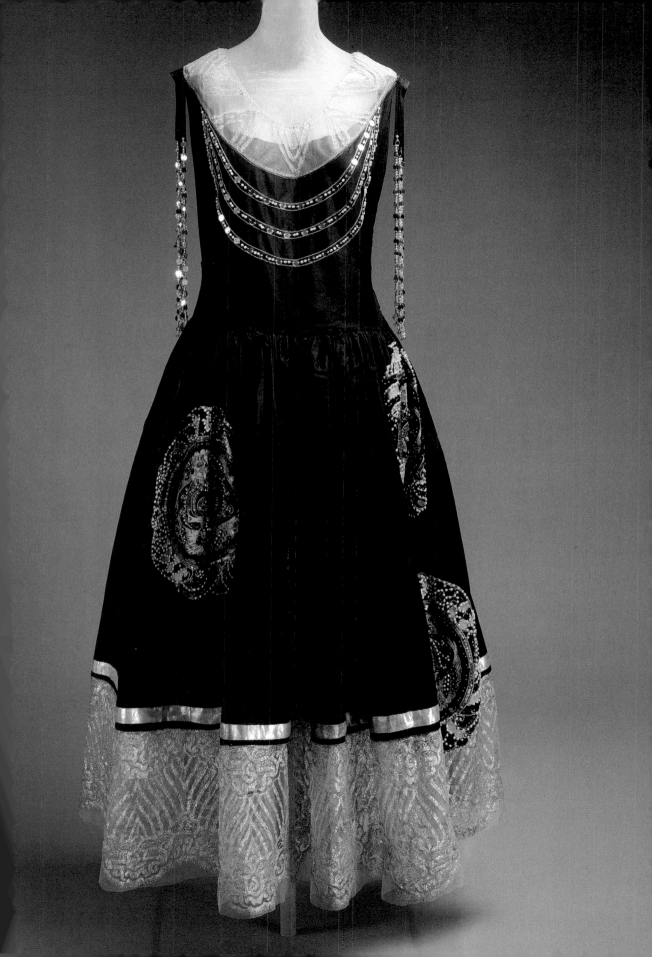

Evening Dress
ca. 1926–27

Attributed to Gabrielle "Coco" Chanel, French, 1883–1971

I n addition to her revolutionary knit sportswear,
Chanel created innovative evening wear in the 1920s.
Her use of metallic lace, lavish embroidery, and beading
gave the illusion of metal metamorphosed into supple
liquidity. The exquisite workmanship was executed by
Chanel's own embroidery workshop. The ornament of the
dress, in both pattern and color palette, resembles the Asian
lacquered screens that the designer loved and collected.

The metallic lace and
sequins on this Chanel
evening dress were
applied in tightly
overlapping rows.

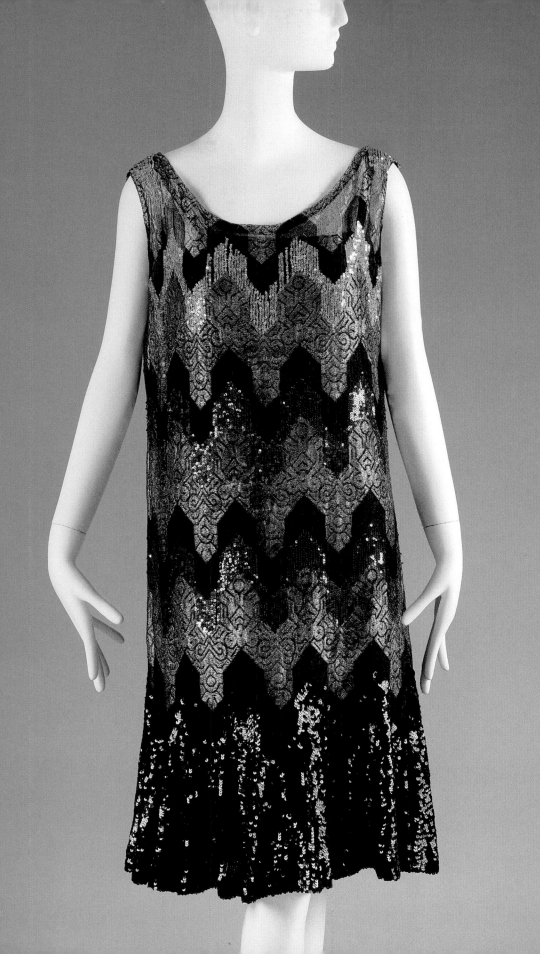

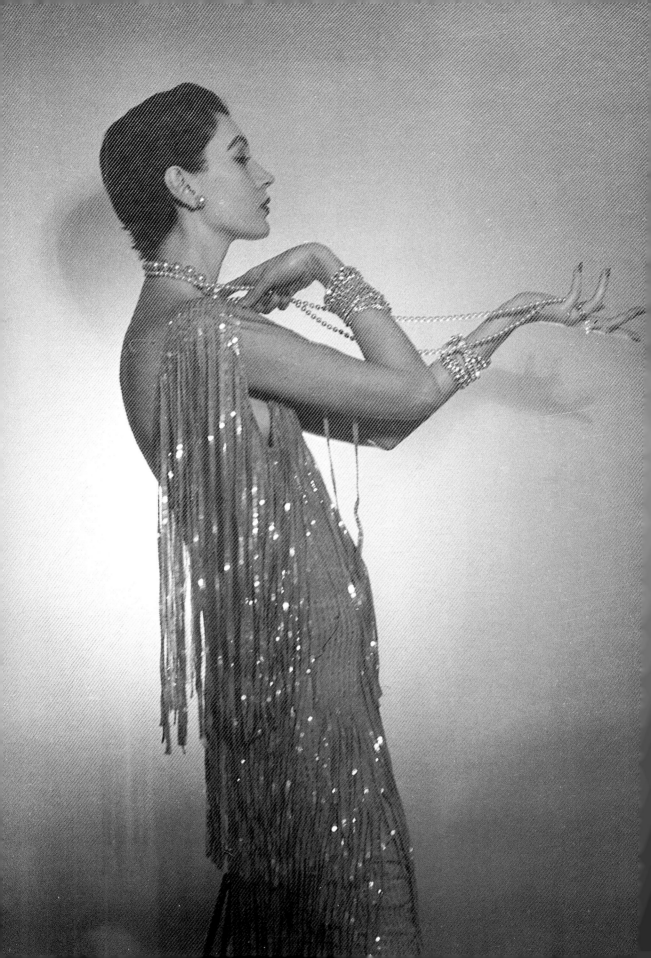

Evening Dress
1926–27

Edward Molyneux, French, b. Britain, 1891–1974

T he flapper dresses of the 1920s coexisted in couture and ready-to-wear, the latter often gaudy with exuberant beaded embroideries, the former with the finer, more detailed effects of the made-to-order atelier. With its delicate allover shimmer and purity of line, Edward Molyneux's contribution can be placed firmly in couture. The dress is covered with narrow pieces of silk georgette, each sewn with a line of sequins and attached at one end to the dress to create a fringe to enhance the effect of movement.

The Costume Institute's Edward Molyneux flapper dress was worn by the model Dovima in a 1953 photograph by Cecil Beaton (British, 1904–1980). As he did with other photographs in this series, Beaton used a mesh overlay to create a subtle textured effect.

Day Ensemble
ca. 1927

Gabrielle "Coco" Chanel, French, 1883–1971

The spirit and style of Coco Chanel immeasurably influenced the development of twentieth-century women's fashion. It was Chanel who ultimately understood what the century's far-reaching changes in lifestyle would mean for women and how clothing could accommodate them. Long envious of the practicality, ease, and good design of tailored men's apparel and also realizing the need for even greater freedom of movement in women's clothes, Chanel often used less-structured tailoring in her innovative early designs. At the same time, she invariably mediated pragmatism with touches of refinement and femininity.

The dress neckline and hem as well as the appliqués of chiffon on the coat were carefully cut to follow the floral pattern of the textile. The coat's lining was hand sewn so that the stitches are not visible on the exterior.

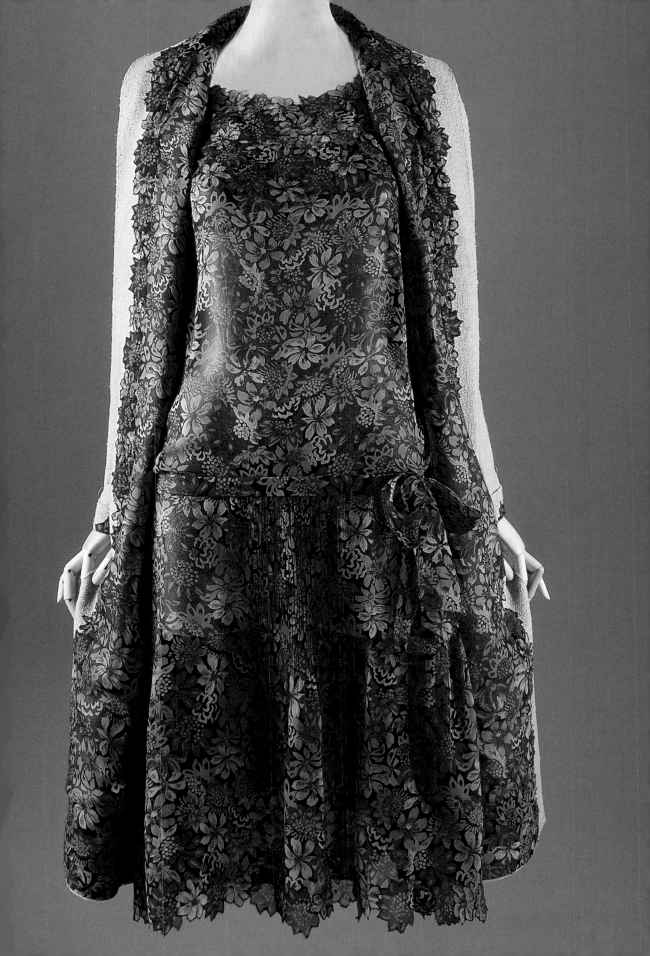

Evening Dress
1928

Louiseboulanger, French, 1878–1950

T his dance dress by Louiseboulanger falls straight from the shoulders, with acknowledgment of the bust rendered only in the deep V-neckline and even then partially obscured by a matching scarf. The hips have also been swallowed into the straight line of the dress, while the dropped "waist" demarcated by the feather skirt is practically no waist at all. Dancing, especially frenetic dancing like the Charleston, was popular in the 1920s, and the applied featherwork on this dress would have lent the movement particular drama.

The dress's trim is made of individual filaments of ostrich plume knotted together to form longer strands, with each feather dyed a different tone for the effect of an ombré cascade.

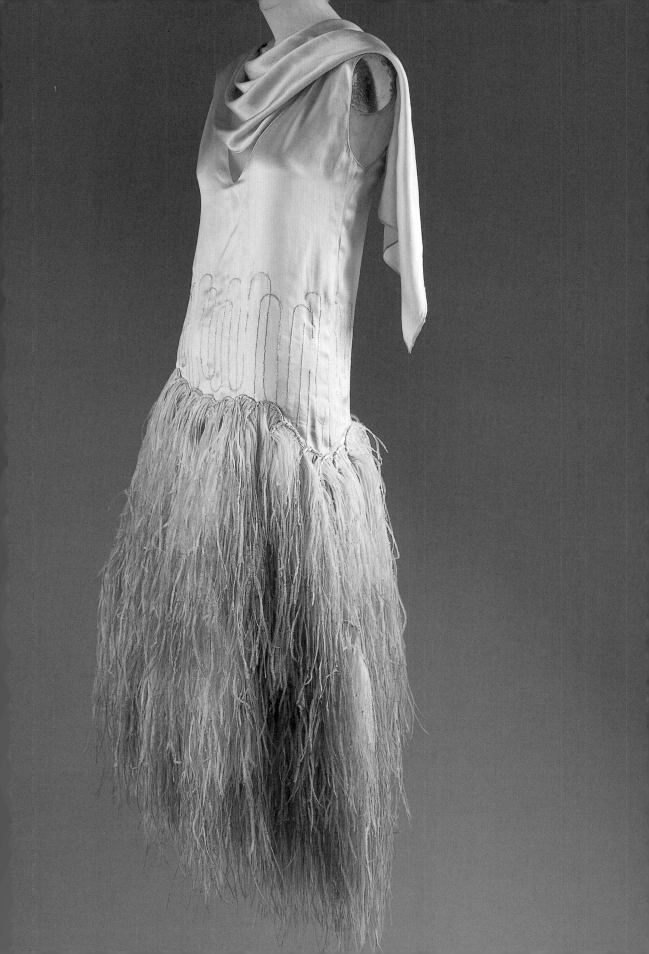

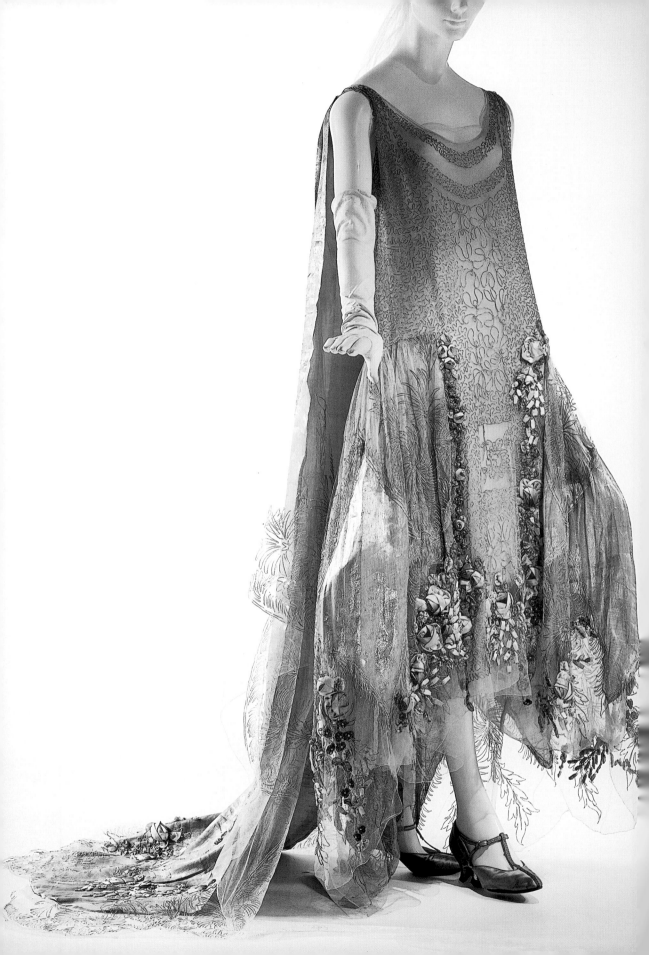

Court Presentation Ensemble
1928

Boué Soeurs, French, 1899–1933

Presentation at the Court of Saint James's was a momentous social accomplishment for many women. This Boué Soeurs costume, which was worn by Mrs. George Henry O'Neil, the former Bertha Fadelhan Drake, for presentation before George V in June 1928, has a train, headdress, and fan, all made to conform to the dress rules that governed the occasion at the time. The train is detachable so that the dress could quite easily be worn for dancing after the court ceremonies had concluded. Though the *robe de style* silhouette, with its structural panniers, is reminiscent of the eighteenth century, the dress's body-obliterating shape and light, translucent layers reveal its twentieth-century origins.

Decorative ribbon flowers, a signature of the Boué Soeurs design house, evoke the ribbon ornaments of the eighteenth century.

Cape and Dress
ca. 1931

Jean Patou, French, 1887–1936

In the mid-1920s, Jean Patou was in constant demand by Parisian couture clients and the American leisure class. Celebrated alongside Chanel for innovations in sportswear fabrics and separates styling, Patou was also credited with pioneering the shortened skirt for both daytime and early evening wear.

By the latter part of the decade, however, he was pushed to adapt a new silhouette. The risqué skirts championed by the New York flapper fell out of fashion with international café society, who now preferred more romantic full-length sheaths. The ensemble shown here is emblematic of the simple, refined Parisian evening silhouette that dominated the 1930s. The delicate drape of the dress, executed in lavish hand-painted silk satin, was intended for more formal occasions, but the small removable cape allowed for wear at cocktail hour.

Among the elite, cocktail gatherings became de rigeur with the end of Prohibition and during the Depression. In the 1930s, the designer became so enamored of private cocktail affairs that he created custom-made "Cocktail" perfumes that were sold in a "Bar" scent box to his couture clientele.

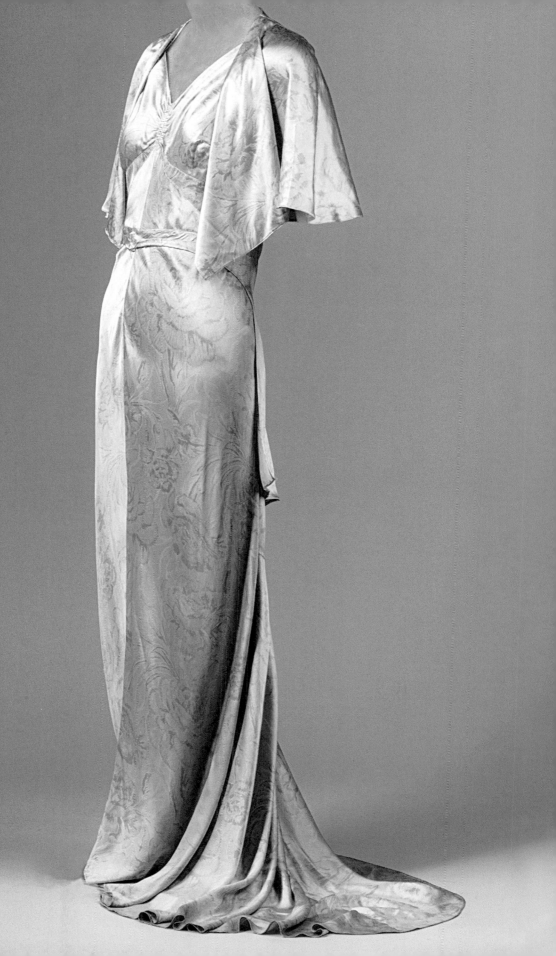

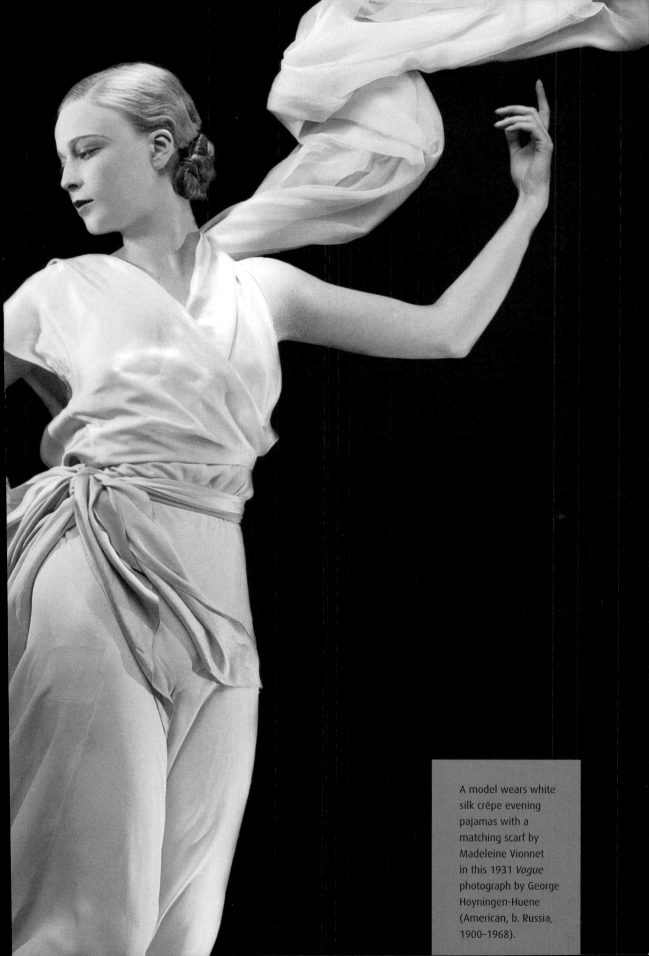

A model wears white
silk crêpe evening
pajamas with a
matching scarf by
Madeleine Vionnet
in this 1931 *Vogue*
photograph by George
Hoyningen-Huene
(American, b. Russia,
1900–1968).

Evening Ensemble
1933–35

Gabrielle "Coco" Chanel, French, 1883–1971

After surviving an impoverished childhood and strict convent education, Coco Chanel pursued a radically different lifestyle, first on the stage, where she acquired her nickname, then as a milliner, and finally, as an haute couturiere. In 1921, she launched her signature perfume, Chanel No. 5, and in the 1920s, introduced her "little black dress," which *Vogue* likened to the Ford, alluding to its almost universal popularity as a fashion basic. Chanel's evening ensembles followed the long, slim line for which she was known, but were softened and romanticized with decorative elements, such as tulle, lace, and the ostrich feathers seen here.

Known for a relentless drive for perfection, whether in design or fit, and strong opinions in all matters of taste, Chanel backed her clothing with the authority of her personal conviction. She is seen here in a 1930s photograph by Adolph de Meyer (American, b. France, 1868–1949).

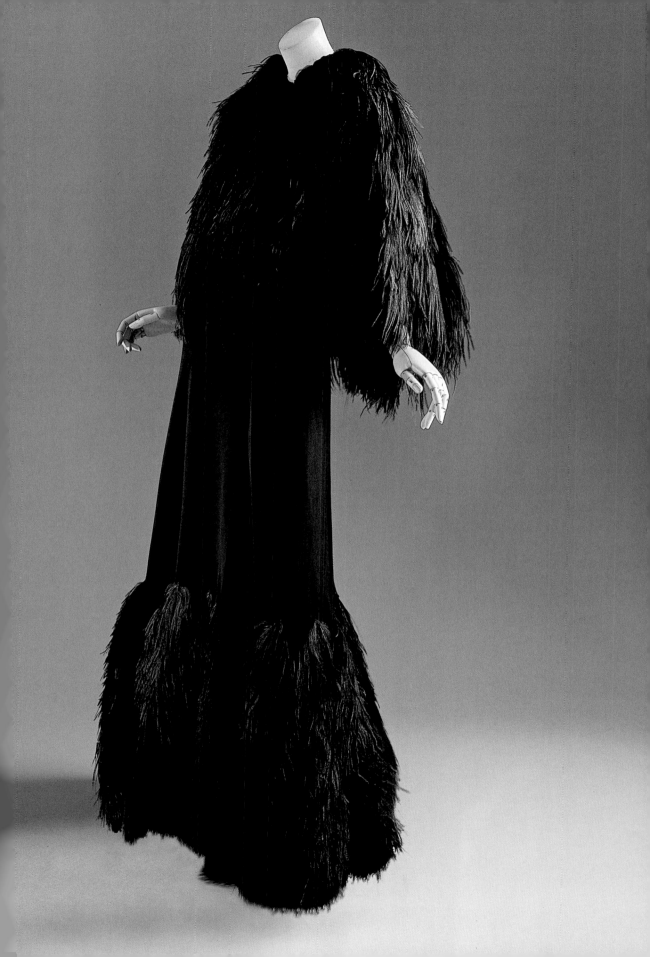

Evening Ensemble
ca. 1936

Maisons Agnès-Drecoll, French, 1931–1963

Displaying a chinoiserie delicately appropriated from the decorative arts, the Maisons Agnès-Drecoll's coral-orange bolero is worn atop this Western-style column dress. The result is a Shanghai-like synthesis of East and West. By the 1930s, frequent trade expositions in Paris had encouraged a keen awareness of Chinese costume and arts among French fashion designers, including Madame Grès, Jeanne Lanvin, and Agnès-Drecoll. Here, Agnès-Drecoll clearly cites courtly Manchu dress and the iconography and signification of rank badges on the gown's bodice and coordinated bolero.

The Chinese motifs on the orange silk bolero are embroidered in blue, ecru, and metal-wrapped thread.

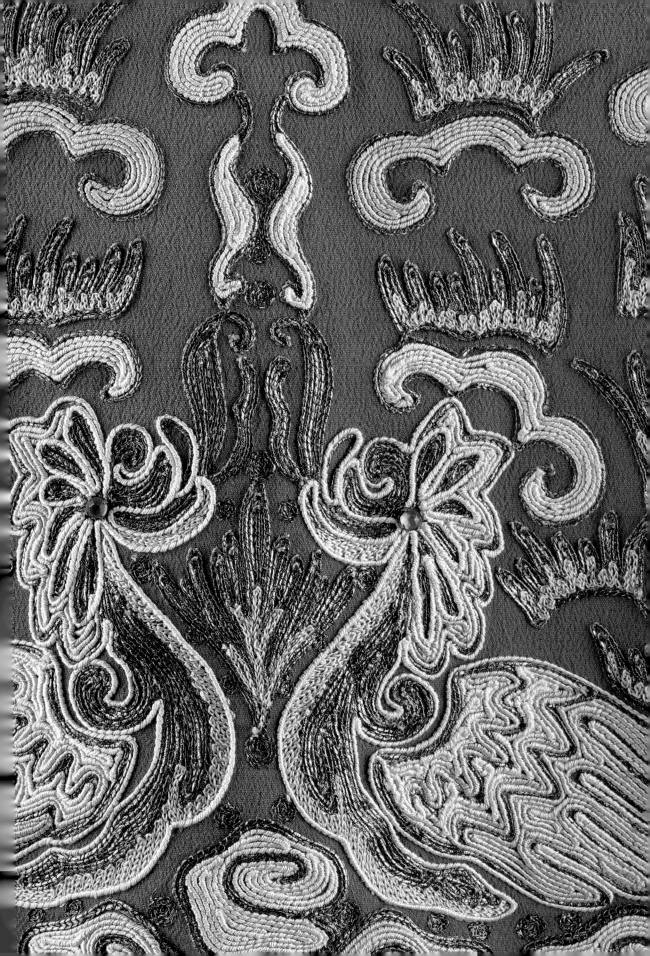

Wedding Ensemble
1937

Mainbocher, American, 1890–1976

In December 1936, King Edward VIII of England abdicated the throne in order to marry "the woman I love." For her wedding, Wallis Warfield Simpson, an American divorcée and future Duchess of Windsor, wore an ensemble by Mainbocher. Known for his sense of decorum, Mainbocher created a simple, floor-length dress with a matching long-sleeved jacket that was perfectly appropriate for the occasion. Even the gloves were specifically designed to accommodate the wedding ring. Though the dress was originally "Windsor blue," a color developed by Mainbocher to match the Duke's eyes, a defect in the stability of the dye caused the material to lose all its color.

The Duke and Duchess of Windsor on their wedding day, June 3, 1937.

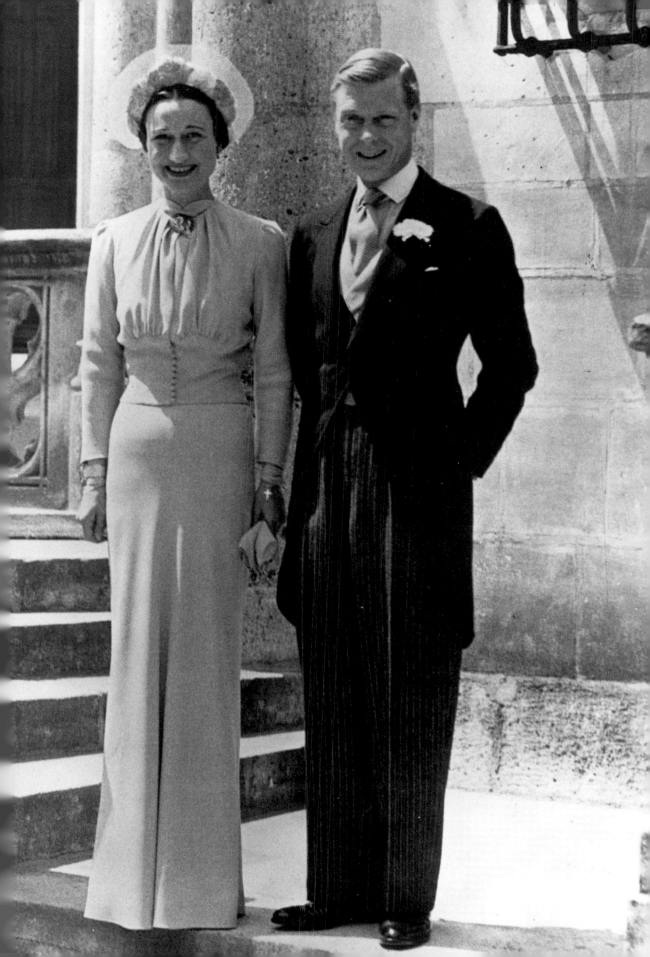

Evening Dress
Fall/Winter 1938–39

Gabrielle "Coco" Chanel, French, 1883–1971

T he decoration of sequined fireworks on this evening dress, which was worn by Countess Madeleine "Minou" de Montgomery to the seventy-fifth birthday party of Lady Mendl (née Elsie de Wolfe, a pioneering American interior decorator and famous party-giver) in 1939, was a fitting symbol of the evanescent world on the brink of war. For, as American journalist Janet Flanner (1892–1978) wrote in her book *Paris Was Yesterday*, "In the summer of 1939, fêtes were held and fireworks were fired, for the *beau monde's* . . . pleasure. The Grand Prix race at Longchamps was held at night under floodlights: a splendid affair attended by the most elegant figures of Paris society. . . . But by then, the Thirties were at the point of death. Their executioner was Adolf Hitler. On September 1, 1939, those of us in Paris who were listening to the early-morning news broadcast heard Herr Hitler announce in German, at once translated into French, that 'as of this morning, we are at war with Poland.'" The thirties were over. World War II had begun.

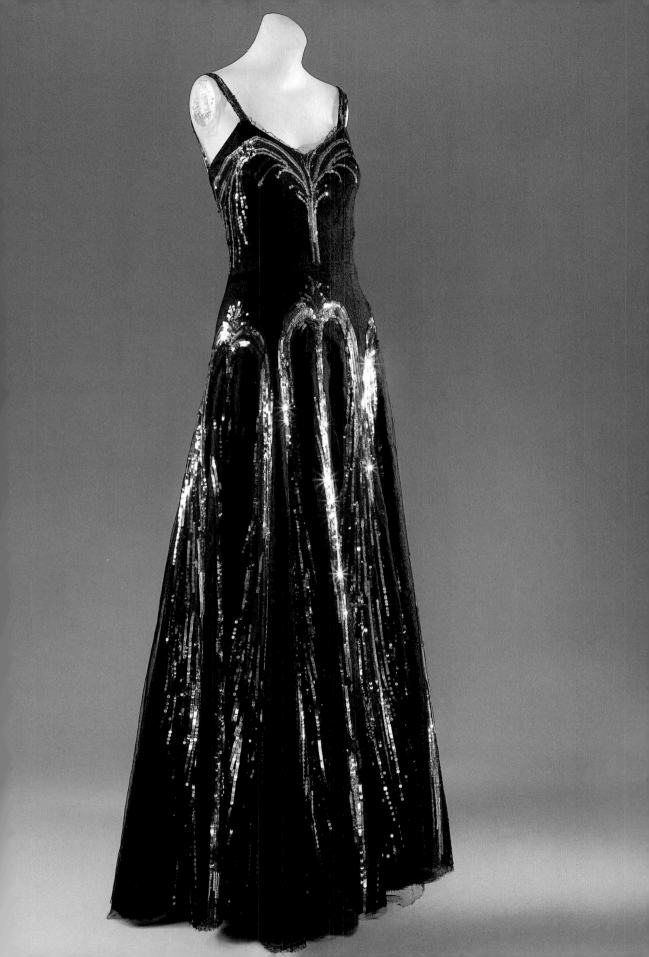

Evening Dress
Spring/Summer 1938

Madeleine Vionnet, French, 1876–1975

In the 1930s, evening dresses were made of clinging bias-cut fabrics that were flattering to a supple figure and expressed the body underneath with every motion. A dress like the one shown here would not have allowed for much excess flesh. In addition to diet and exercise, the ideal silhouette sometimes required a return of corsets to give more form and control to the figure. As a 1933 *Harper's Bazaar* article cautioned, "You cannot have a roll of flesh about the midriff. An uncontrolled derrière is vulgar in a slinky dress."

Individual graduated lengths of thread were passed and looped through the fabric of this Vionnet dress, with each thread forming two drops of the fringe.

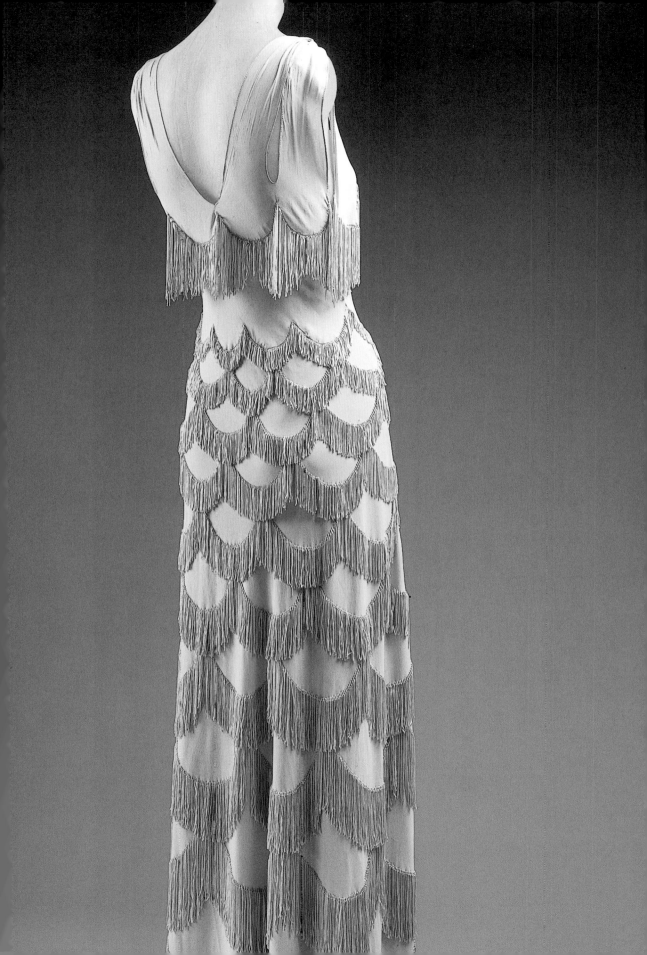

Evening Ensemble
1939

Elsa Schiaparelli, French, b. Italy, 1890–1973

Fashion in the mid-1930s glorified styles of other cultures. Indian and Southeast Asian styles were particularly evident in the work of Elsa Schiaparelli. *Vogue* remarked that her "sari dresses" made women look like "Hindu princesses." This orange sari dress was worn by Patricia Lopez-Wilshaw, great-niece of the elegant Chilean heiress Eugenia Errázuriz.

Like her great-aunt, Lopez-Wilshaw was a considerable force in the fashion world. During the Phony War (the early months of World War II), Lopez-Wilshaw's Wednesday suppers became a well-known site of fashionability in Paris. As noted in *Vogue*, "At the first parties, Patricia Lopez wore a short afternoon dress, but little by little, women arrived in long black sheaths, and now you definitely have to dress for dinner. This is part of the general discipline. Women must be attractive and the signal of emulation is given. Nothing eccentric or fussy, but sound, refined taste."

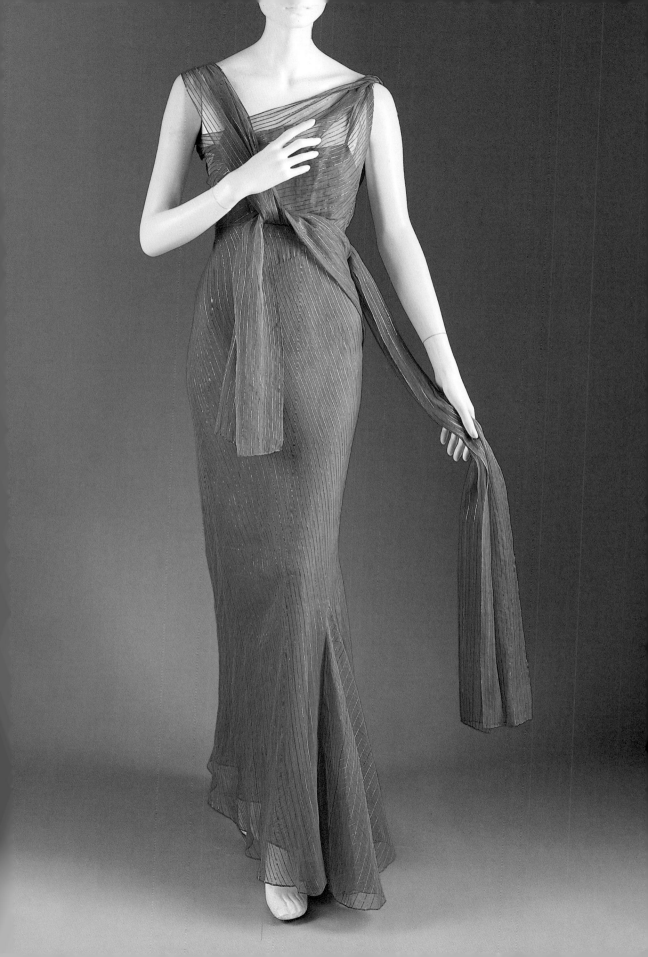

"Cyclone" Evening Dress
1939

Jeanne Lanvin, French, 1867–1946

In 1889, Jeanne Lanvin began her business as a milliner at 22, rue du Faubourg Saint-Honoré in Paris, where the company still has offices today. She opened a women's and young women's department in 1909 and gained couture house status that same year. The source of Lanvin's inspiration was her daughter, Marguerite, later the Comtesse Marie-Blanche de Polignac, who invariably wore her mother's clothes. Among them was this "Cyclone" evening dress of two-tiered gray silk taffeta embroidered with metallic sequins and pink beads at the bust and on a decorative pocket attached at the waist by a self-belt.

In 1933, Édouard Vuillard (French, 1868–1940) painted Jeanne Lanvin sitting at her desk, the shelves behind her lined with pattern books and fabric swatches.

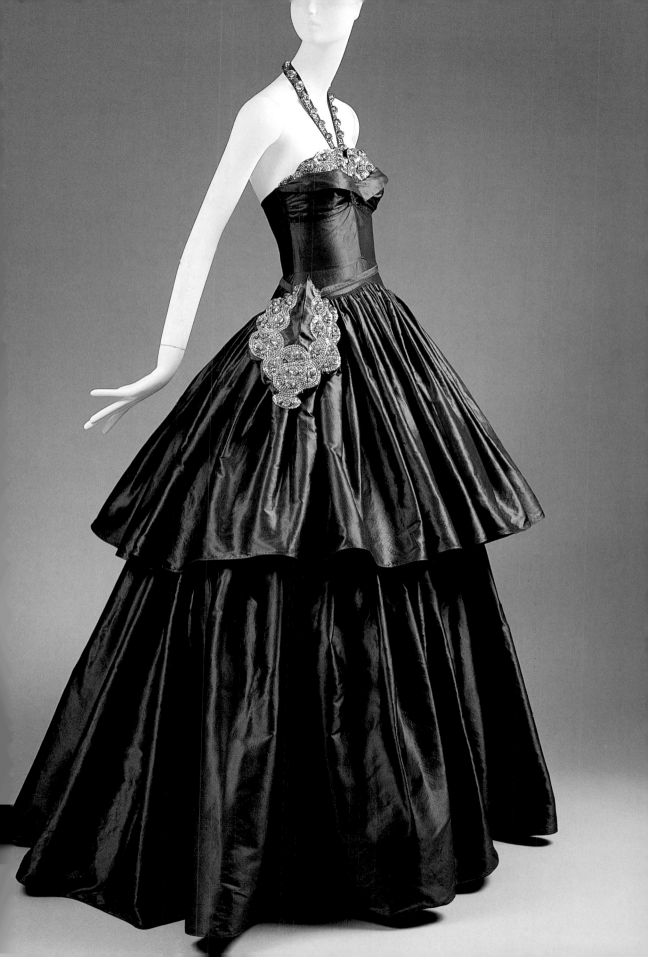

"Velázquez" Evening Dress
1939

Cristóbal Balenciaga, French, b. Spain, 1895–1972

F ew twentieth-century costumes, when viewed as three-dimensional works of art, have the strength of line or sculptural qualities of those designed by Balenciaga.

The Museum's "Velázquez" dress is one of several similar Balenciaga designs that were inspired by the paintings of Diego Rodríguez de Silva y Velázquez (Spanish, 1599–1660), the official court painter of King Philip IV of Spain. In paintings by Velázquez, the Infanta Marie-Marguerite, the king's eldest daughter, is depicted wearing a dress with a tight-fitting bodice and a wide skirt. As well as referencing this silhouette, Balenciaga's "Velázquez" dresses anticipated Christian Dior's celebrated postwar "New Look."

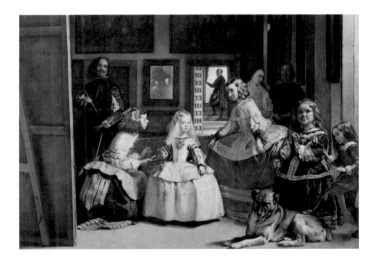

The Infanta Marie-Marguerite is third from the left in *Las Meninas* (detail), painted in 1656 by Velázquez, who included a self-portrait as well as portraits of the king and queen, seen reflected in the mirror above the Infanta.

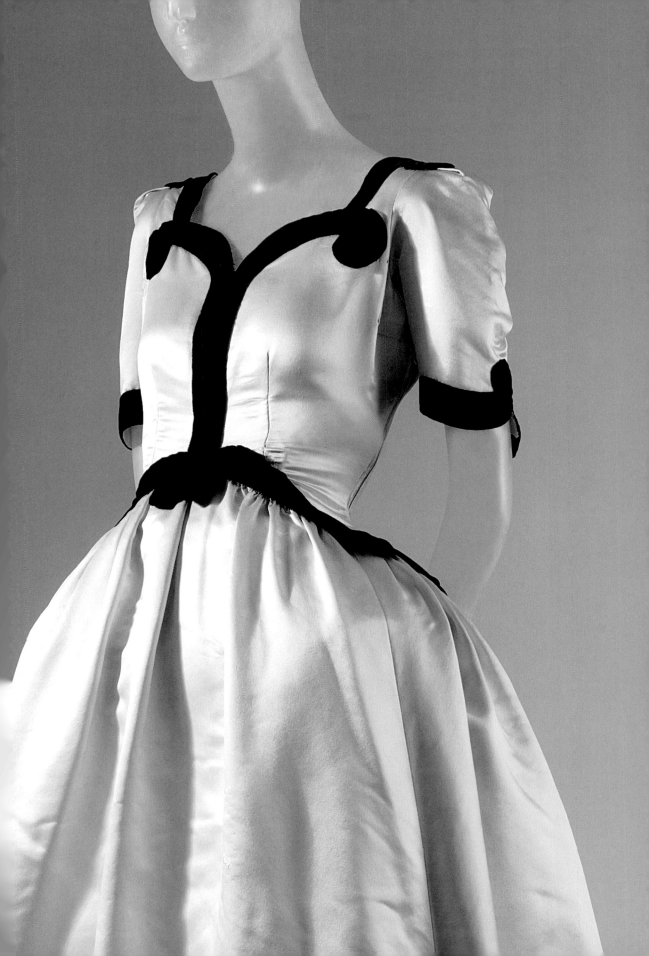

Dress
ca. 1940

Valentina, American, b. Russia, 1899–1989

Born in Russia, Valentina fled the country at the outbreak of the Revolution. She moved to New York in 1923 and, with the help of her husband, opened a dress shop in 1928. In addition to designing for socialites, Valentina created costumes for the stage and film, and counted stars such as Greta Garbo, Katharine Hepburn, and Gloria Swanson among her clients. Valentina's chic dresses were always elegant and never overwhelming. For example, her discreet black dresses were always perfect for pictures in the days of black-and-white photography, with necklines offering dramatic and graceful frames to the face.

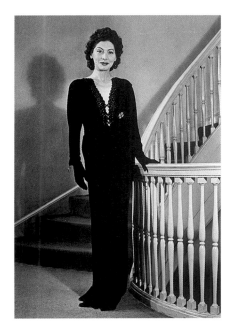

Known for her minimalist designs, Valentina once said, "Simplicity survives the changes of fashion. . . . Fit the century, forget the year."

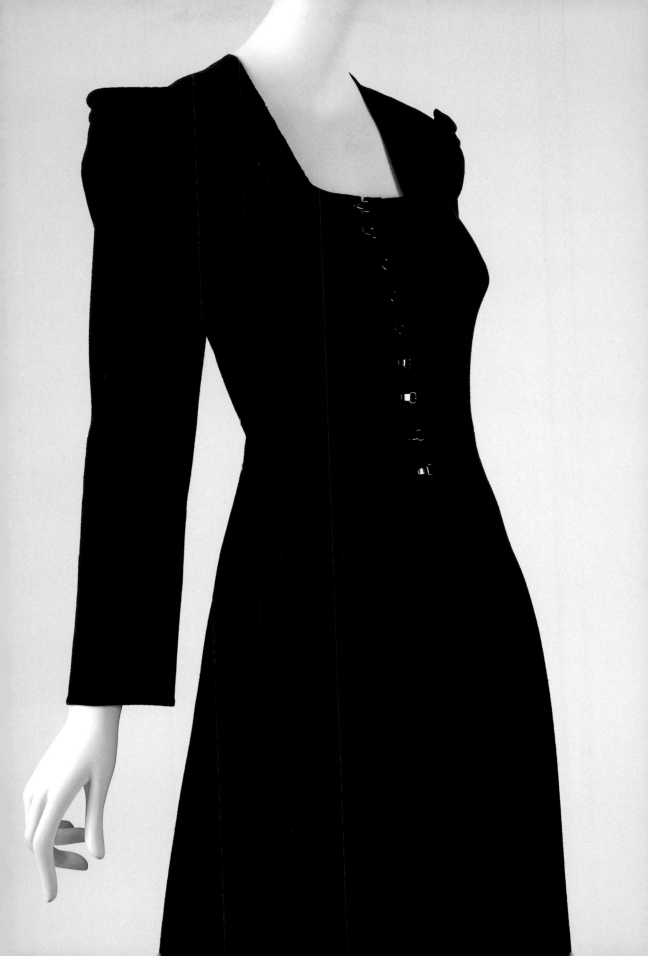

"Popover" Dress
1942

Claire McCardell, American, 1905–1958

Claire McCardell was a driving force behind the "American look" and ready-to-wear fashion. Instead of continuing the tradition of authoritarian Paris–based fashion and imposing her designs on women, McCardell created clothing for the women who wore it. Her clothes were comfortable and easy to care for yet elegant. Among her innovations were the bias-cut "tent" dress, the "diaper" bathing suit, ballet slippers for everyday wear, interchangeable separates, and the wraparound "Popover" dress.

Fashion editor Sally Kirkland, in *All American: A Sportswear Tradition*, reported that McCardell's $6.95 cotton "Popover" dress "sold in the thousands (its low price was because it was classified as a 'utility garment' and Claire's manufacturer . . . was able to make a special deal with labor). But some form of a wraparound dress around $25 or $30 was always in Claire's collection thereafter."

McCardell showed that the modern woman could both do the cooking and be chic. In a photograph by Louise Dahl-Wolfe (American, 1895–1989), the model wearing the "Popover" has one hand in an oven mitt and the other in her capacious pocket.

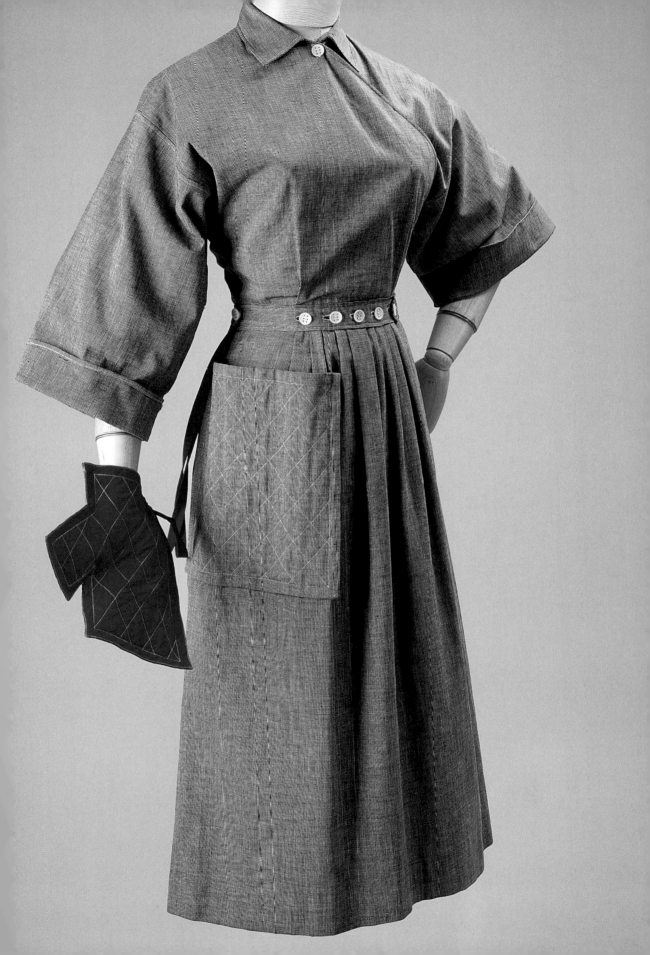

Evening Ensemble
1945

Gilbert Adrian, American, 1903–1959

During the 1920s and '30s, Gilbert Adrian was a costume designer, first in New York and then at Metro-Goldwyn-Mayer in Hollywood. His clothing for stars such as Joan Crawford, for whom he created the broad-shouldered silhouette, and Jean Harlow, whose slinky Adrian dresses became her trademark, was often copied for the ready-to-wear market. In 1942, he started his own business in Beverly Hills, designing both custom and ready-to-wear clothing. In the dramatic ensemble shown here, he created an overall abstract design, combining colors in the manner of a painting by Georges Braque (French, 1882–1963).

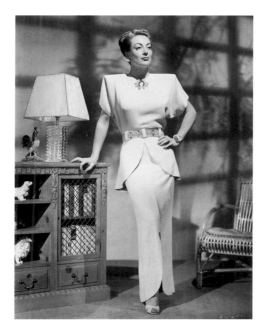

Award-winning actress Joan Crawford posed in a dinner dress by Gilbert Adrian in the mid-1940s.

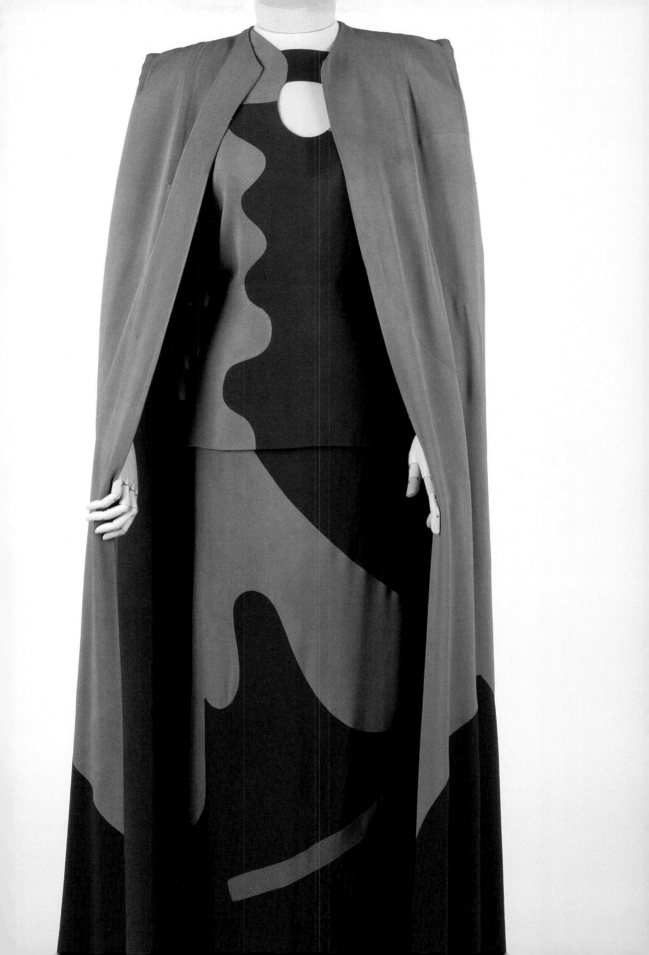

"Roan Stallion" Dress
1945

Gilbert Adrian, American, 1903–1959

Gilbert Adrian's designs combined a sense of comfort, casualness, and ease with dramatic colors and interesting textures to create a very sophisticated, cinematic glamour. The same great imaginative flair that characterized the costumes the designer created for Hollywood films also set street fashion and made his couture creations memorable. He won an American Fashion Critics Award in 1945 for his striking "Roan Stallion" dress.

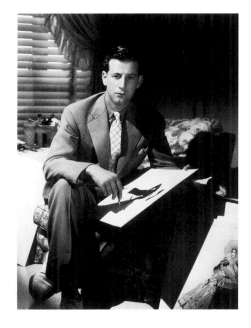

Gilbert Adrian's flair as a costume designer in Hollywood carried over into his couture business.

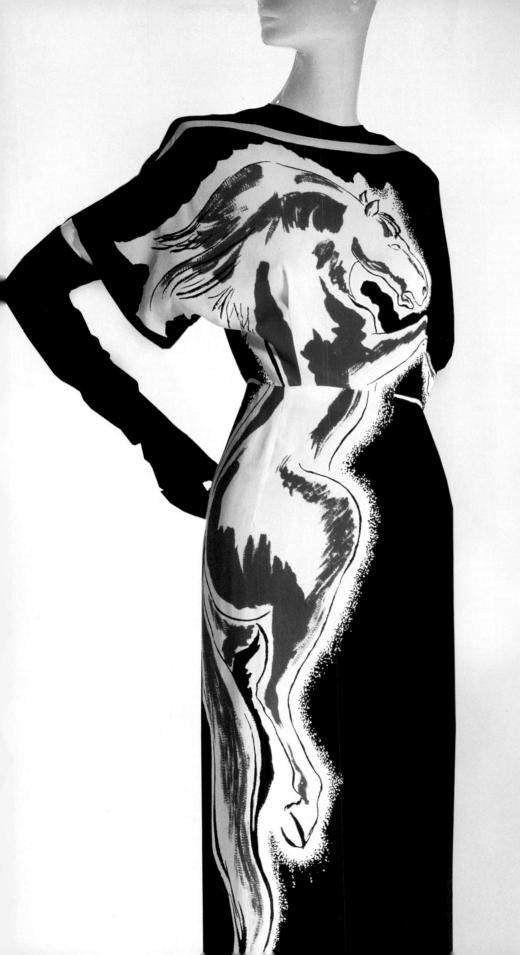

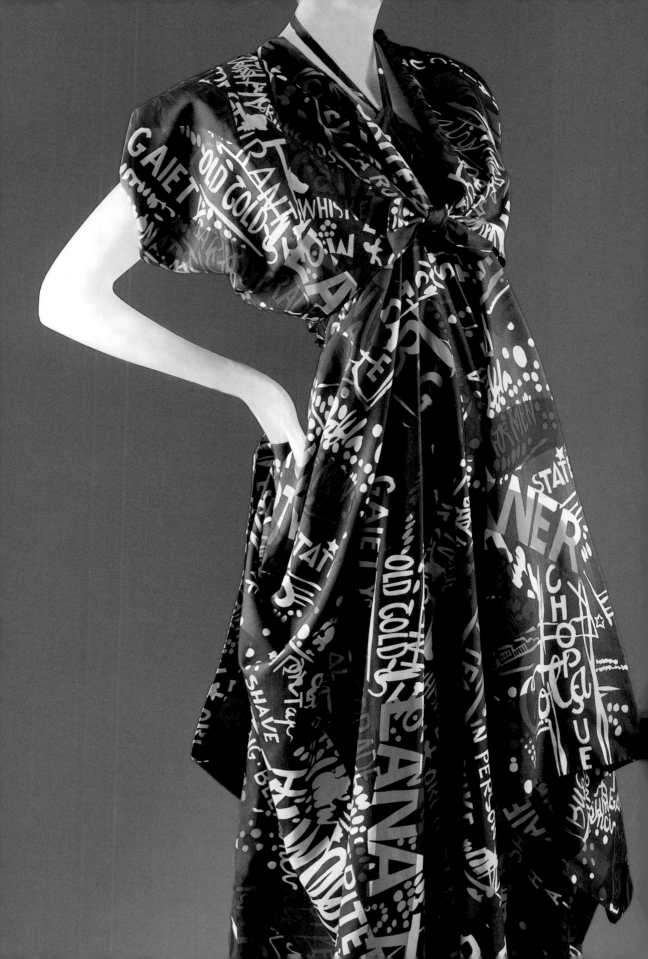

Evening Dress
Spring/Summer 1947

Jacques Fath, French, 1912–1954

In Jacques Fath's elegant evening gown, the piecing and boning of the corset-bodice appear like pentimenti on its surface. Known for glamorous dresses that set off the head and shoulders, the designer exploited shell-pink satin and its association with the boudoir by merging the construction of a nineteenth-century corset and its back lacing with the liquid drape of pre–World War II fashions. The color of the satin and the faint archaism of its lacing imbue the design with recherché audacity.

The lacing on the back of Jacques Fath's dress is reminiscent of that on nineteenth-century corsets, such as the one shown in this 1893 illustration.

"Palm Beach" Evening Ensemble
1945

Nettie Rosenstein, American, 1890–1980

A kin to Stuart Davis's urban and signage-based graphic acumen is Nettie Rosenstein's enthusiasm for the electricity of advertising design, which she translated into an evening dress with a nonchalant 1940s drape inspired by Moroccan men's garb. Reminiscent of a nighttime city aglow with neon lights, Rosenstein's theater marquees, signs for chop suey establishments, and electric cigarette and beverage signs rendered in brilliant color against a black background foreshadow the art of popular visual culture so often captured through typography.

Taking his cue from advertising, Stuart Davis (American, 1892–1964) combined visual elements of urban life with words and letters in *Report from Rockport* (1940) to convey the speed and vitality of American life in the mid-twentieth century.

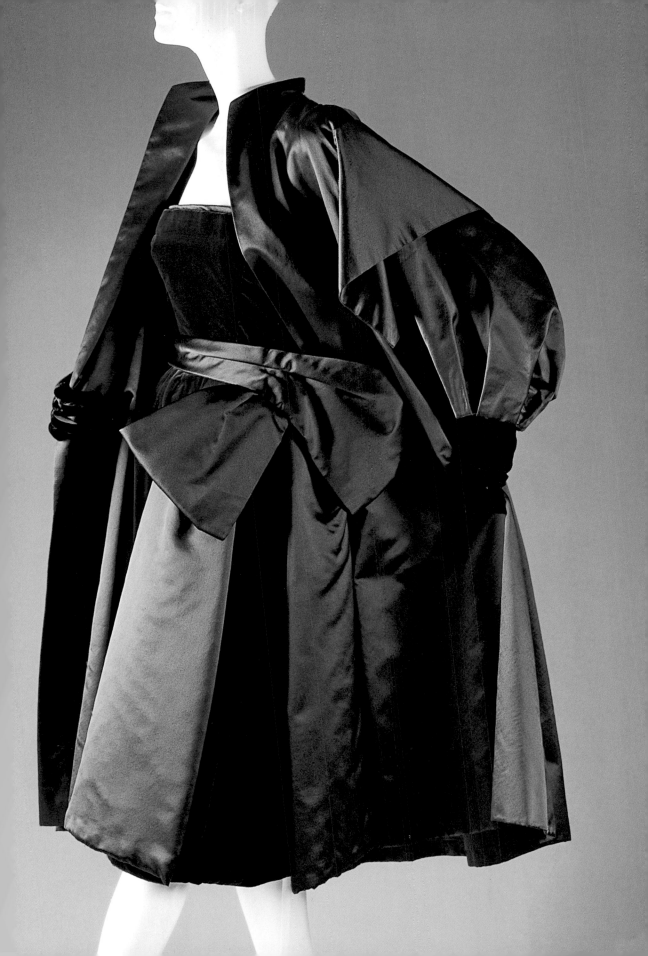

Dinner Dress
Fall/Winter 1949–50

Christian Dior, French, 1905–1957

T hough known for his ultrafeminine silhouettes, Christian Dior appropriated many elements of menswear for his designs, including gray-flannel tailoring, houndstooth patterns, white cotton piqué, and tuxedos. Here, a black wool column is accented with the black silk faille that would normally be found in the lapel and cummerbund of a man's tuxedo. Visible in the asymmetrical wrapping of the pattern pieces is Dior's interest in the drape of fabric.

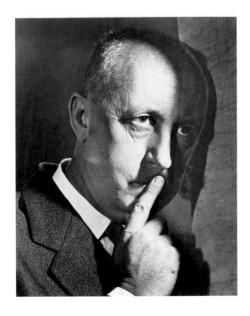

Christian Dior pioneered license agreements in the fashion business. By 1948, he had arranged licensing deals for fur, stockings, and perfumes that not only were lucrative, but also made him a household name. Dior is seen here in a 1954 photograph by Yousuf Karsh (Canadian, b. Armenia, 1908–2002).

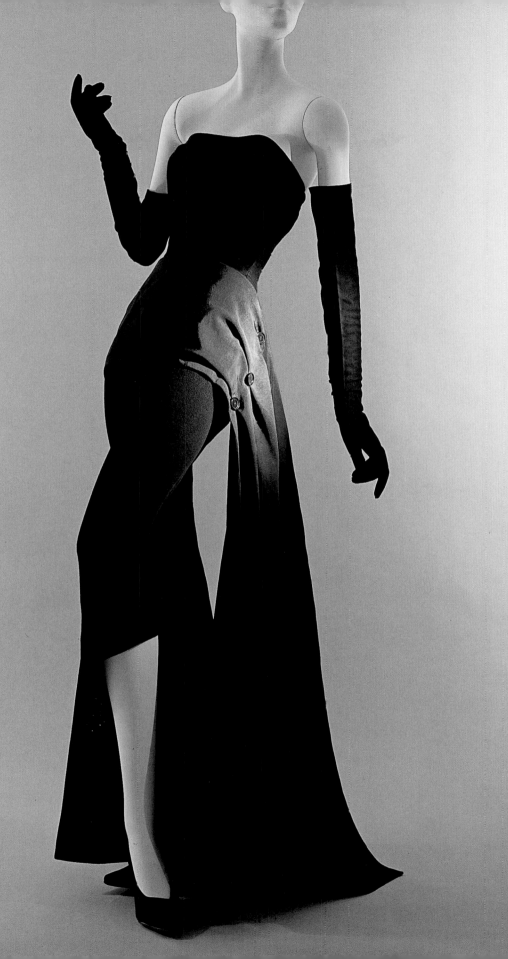

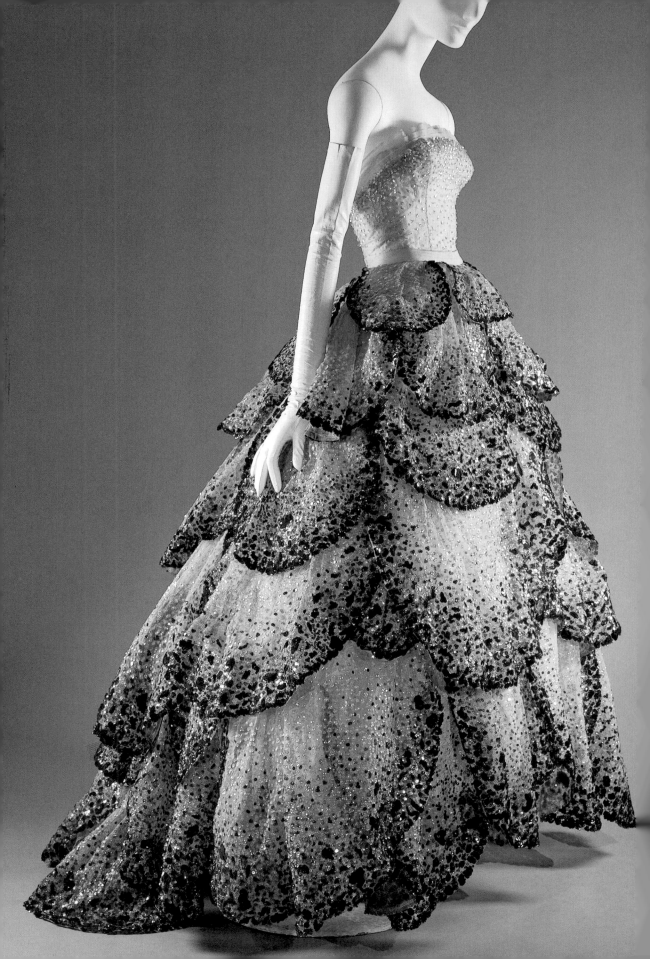

"Junon" Dress
Fall/Winter 1949–50

Christian Dior, French, 1905–1957

In 1949, dresses called "Venus" and "Junon" were among Christian Dior's most coveted designs. "Venus" was realized in his signature eighteenth-century gray, frosted with iridescent beading and embroidery. But "Junon," or Juno to the Romans, was more vividly conceived. The magnificent skirt of forty-five petals, like abstractions of peacock feathers without their "eyes," obliquely references the bird associated with the queen of the gods.

Each petal on the "Junon" dress sparkles with iridescent sequins in varying shades of pale greens and blues to emerald green and navy blue, with sprinklings of rust.

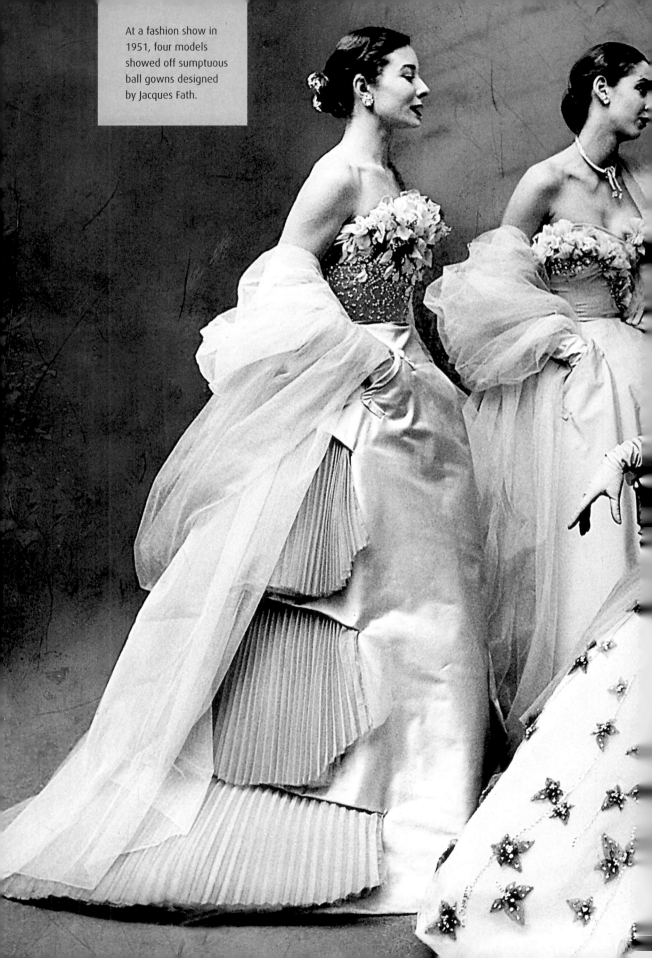

At a fashion show in 1951, four models showed off sumptuous ball gowns designed by Jacques Fath.

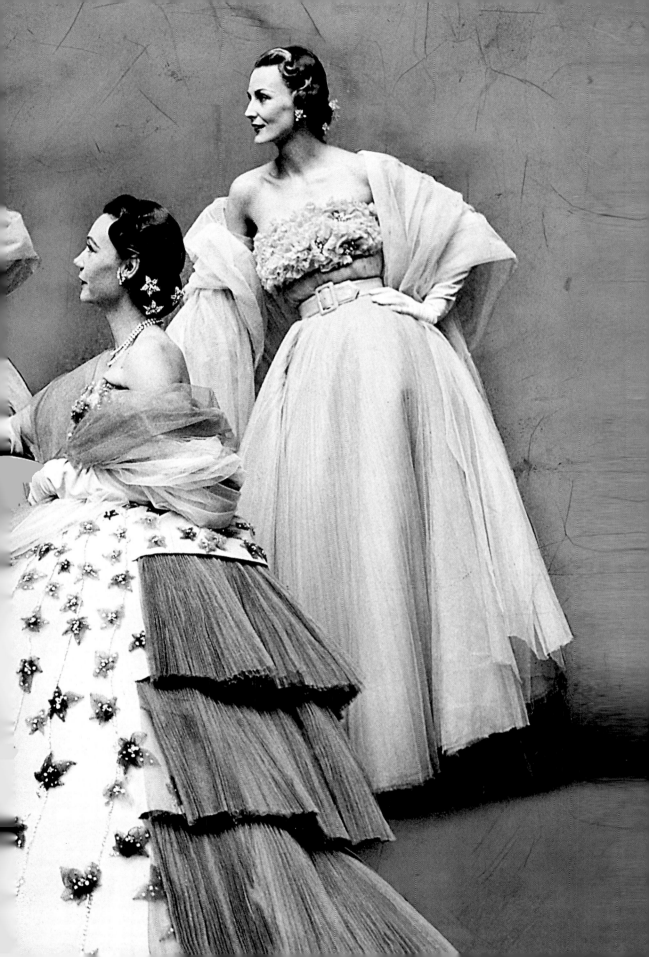

"La Cigale" Dress
Fall/Winter 1952–53

Christian Dior, French, 1905–1957

*H*arper's Bazaar (September 1952) described "La Cigale" as built in "gray moiré, so heavy it looks like a pliant metal." In 1952, what has been called the Dior slouch—hips forward, stomach in, shoulders down, back curved—was placed inside a severe International Style edifice. The devices customarily used to soften surface and silhouette in Dior were eschewed, and the dress was enhanced by the fashionable C-curve posture.

American periodicals continued to promote French couture lines after World War II, but they also included American design images and Parisian ready-to-wear lines in order to appeal to a wide economic range. "La Cigale" has the underpinnings of couture, but with its long fitted sleeve, smooth bodice, and ingeniously simple skirt cut, the dress could easily be adapted for the department store. Dior quickly saw the advantages of promoting cocktail clothing in the American ready-to-wear market, designing specifically for their more inexpensive lines.

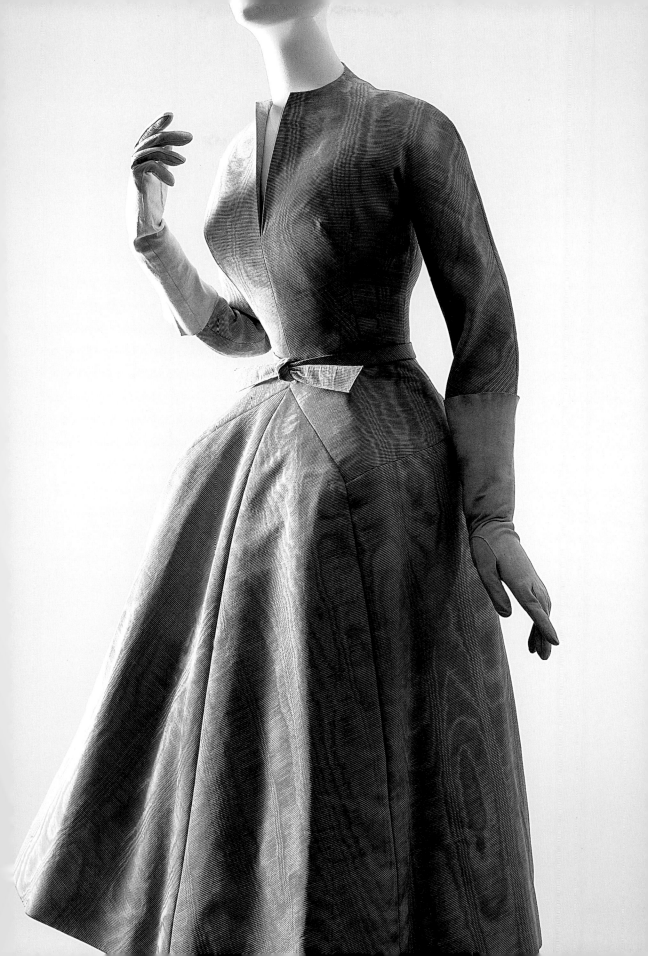

"May" Ball Gown
Spring/Summer 1953

Christian Dior, French, 1905–1957

Christian Dior called his 1953 spring/summer collection—which featured an abundance of floaty, flowery prints—"Tulip." For the "May" ball gown, the designer set exacting tasks for his embroiderer, Rene Bégué, known as Rebé. The embroidery is set in a nuanced spacing of elements with the densest application at the waist, thinning as it falls away to the hem. This seemingly organic application, simulating a diminishment in nature, is further enhanced by Rebé's repertoire of embroidery stitches to create dimensionality on the surface.

Christian Dior's embroiderer Rebé used different embroidery stitches to create the optical effect of variations in a meadow.

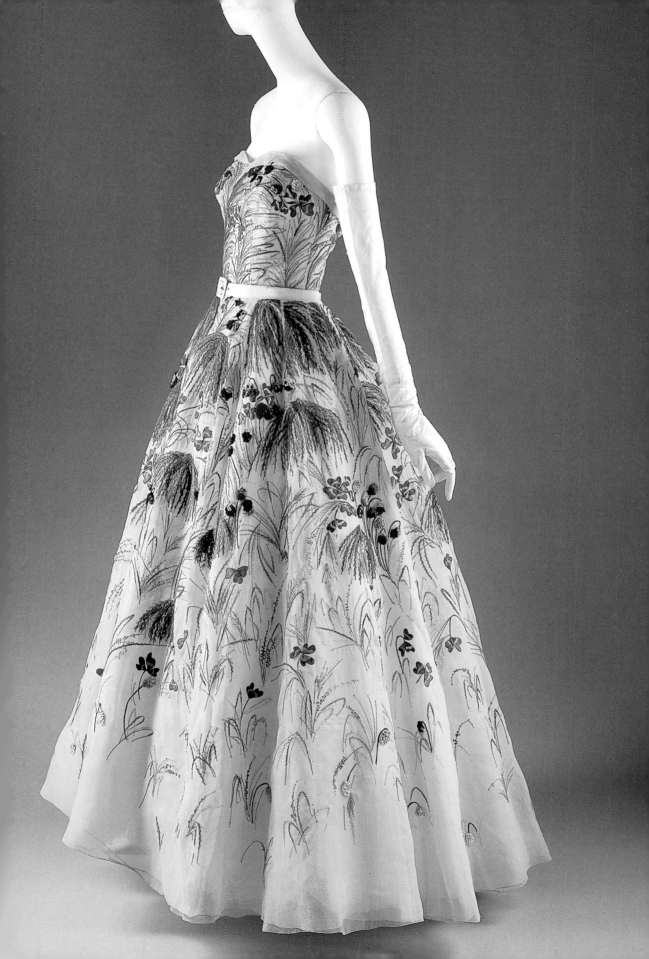

Evening Gown
Fall/Winter 1954–55

Madame Grès (Alix Barton), French, 1903–1993

In the 1930s, Madame Grès gowns were often characterized by innovative seaming that resulted in bias, body-conscious drapes. Though her approach to fashion could not have been more different from Christian Dior's wasp-waisted "New Look," she introduced a technique that married her interests in fluid classical forms to the vogue for a structured body. Her pleated jersey gowns from this period all utilized a masterful anchoring of the carefully manipulated jersey to a light but boned corselette.

The gold lamé ribbons in this gown express the structural "joins" of the vertically running panels of cloth, which start at the neckline and continue unbroken to the hem. To give the appearance of a waist seam, the pleats were individually tacked to the gown's understructure.

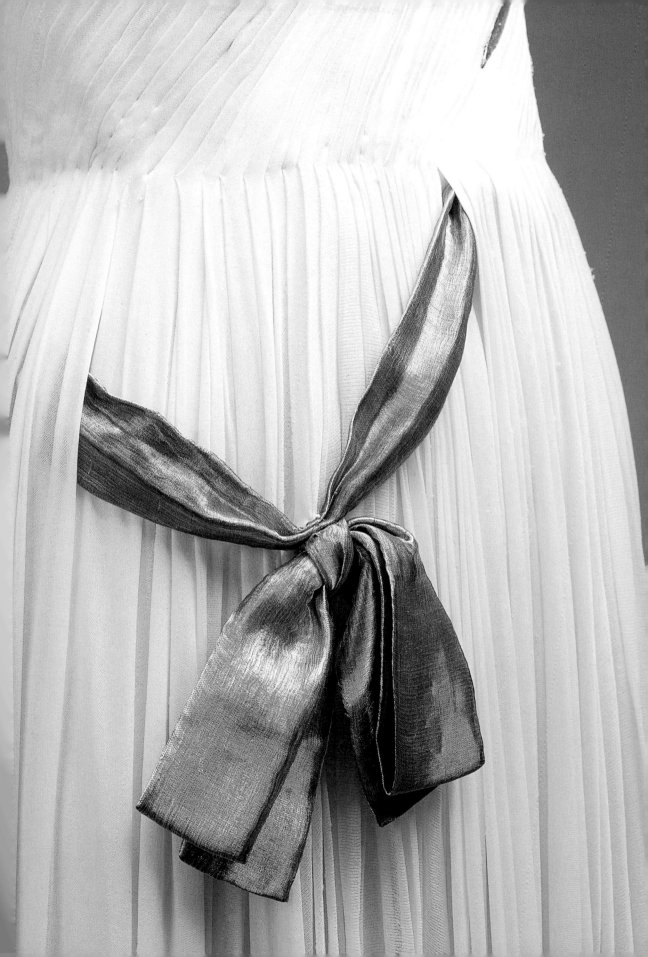

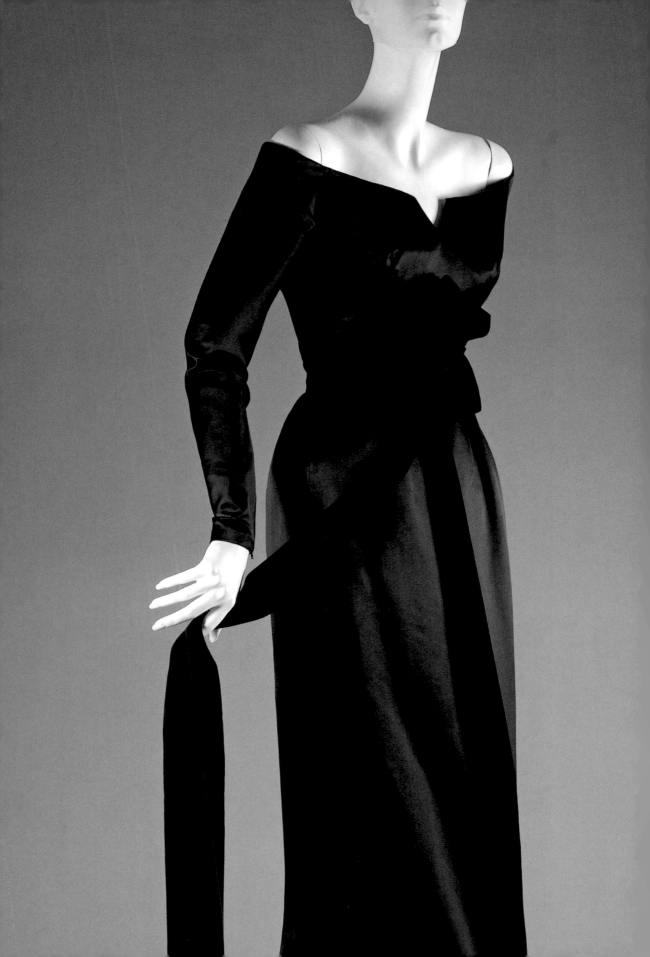

"Y" Evening Dress
Fall/Winter 1955–56

Christian Dior, French, 1905–1957
with assistant Yves Saint Laurent,
French, b. Algeria, 1936–2008

Only months after completing his formal studies
and moving to Paris, Yves Saint Laurent was hired
by Christian Dior. Exemplifying Dior's faultless minimalism
of 1955, the young Saint Laurent's first dress design as
one of Dior's assistants was a simple column contrasting
matte velvet with satin. The stability of the off-the-shoulder
neckline was accomplished by the hand shaping of the
fabric rather than by any rigid understructure.

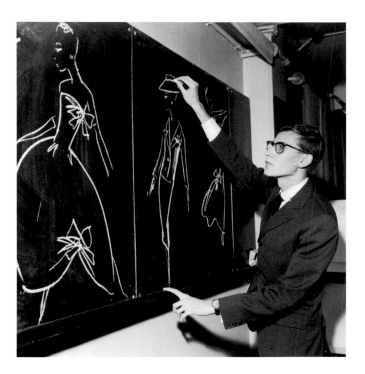

Twenty-one-year-old Yves Saint Laurent sketching fashion designs on a
chalkboard in November 1957, the month he was named successor to
Christian Dior.

"Eventail" Cocktail Dress
Fall/Winter 1956–57

Christian Dior, French, 1905–1957

In his romantic "Aimant" collection, Christian Dior emphatically reiterated his commitment to the eighteenth century made modern. Here, referring to the ubiquitous fan women used to "communicate" at court, Dior raised the waist but delighted in the fullness of the skirt and the pronounced form of the bust. It was, of course, the rigidity of inner structure emanating from the corset that permitted Dior the license of the strapless gown, just as the décolletage of the eighteenth century was made possible by the rigid shaping of the bust and waist.

The instrument of powerful and coquettish women, the fan both conceals and discloses. Dior's comparison of the cocktail-party hostess and the eighteenth-century woman denotes the relevance of clothing and decoration to the social function of women during these eras. While clearly ornamented differently, these personalities depended on a superficial facade through which to communicate their respective social facility.

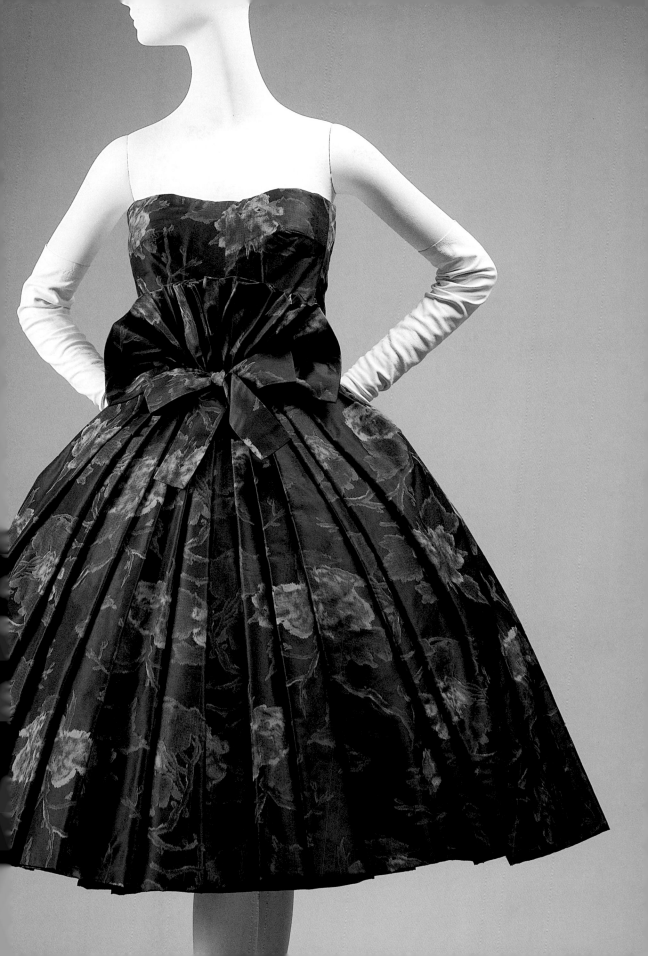

Day Dress and Coat
Fall/Winter 1957–58

Anne Fogarty, American, 1919–1980

Versatility and resonance were built into 1950s clothes, which often repeated the material of a dress in the lining of its complementary coat. Anne Fogarty had military order in mind when she coordinated this tailored coat with a knit dress. While she generally created dresses and ensembles of high style, she nonetheless thought in pragmatic terms, writing in her 1959 book, *Wife Dressing: The Fine Art of Being a Well-Dressed Wife*, "If I had to boil down my thinking about clothes into one word, that word would be—DISCIPLINE—of the mind, the body, and the emotions. DISCIPLINE makes you the woman you are rather than a hodgepodge of everyone else's ideas."

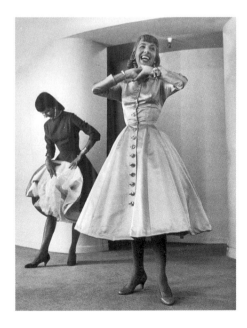

Anne Fogarty models one of her own designs in 1953.

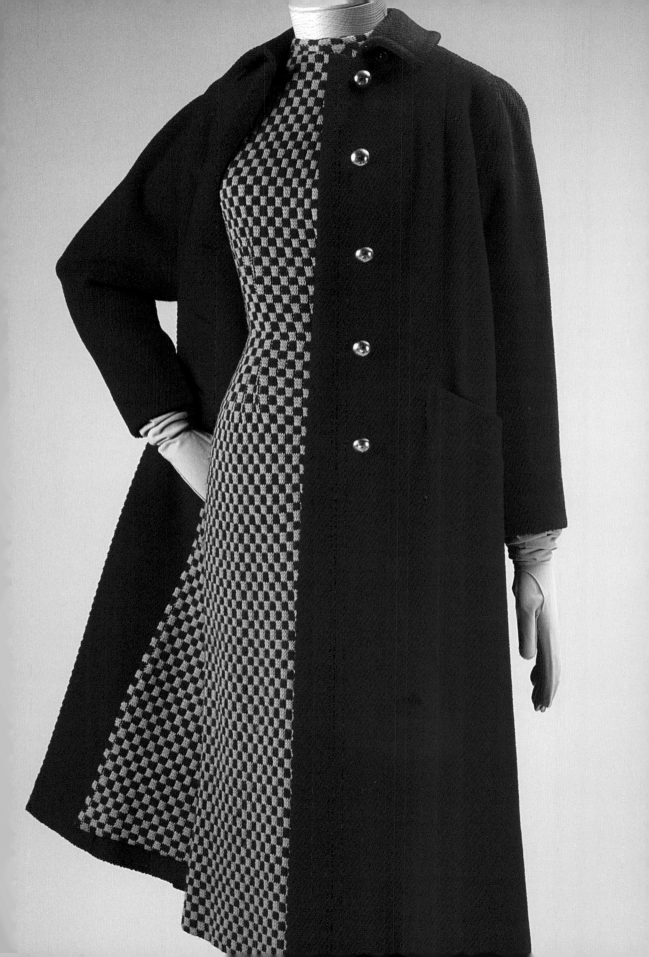

"Lys Noir" Evening Dress
Fall/Winter 1957–58

Christian Dior, French, 1905–1957

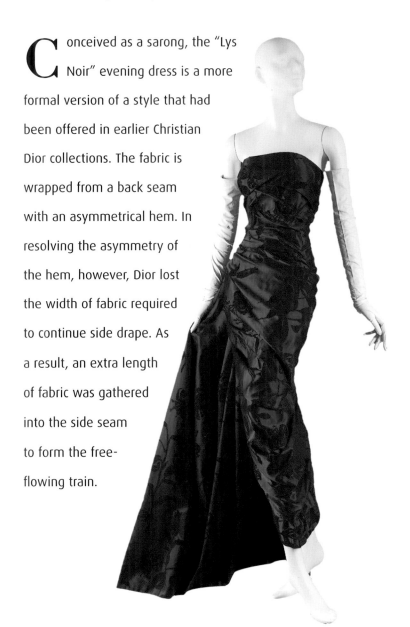

Conceived as a sarong, the "Lys Noir" evening dress is a more formal version of a style that had been offered in earlier Christian Dior collections. The fabric is wrapped from a back seam with an asymmetrical hem. In resolving the asymmetry of the hem, however, Dior lost the width of fabric required to continue side drape. As a result, an extra length of fabric was gathered into the side seam to form the free-flowing train.

Though Dior's dress and train appear to be made of continuous fabric, they are, in fact, two pieces.

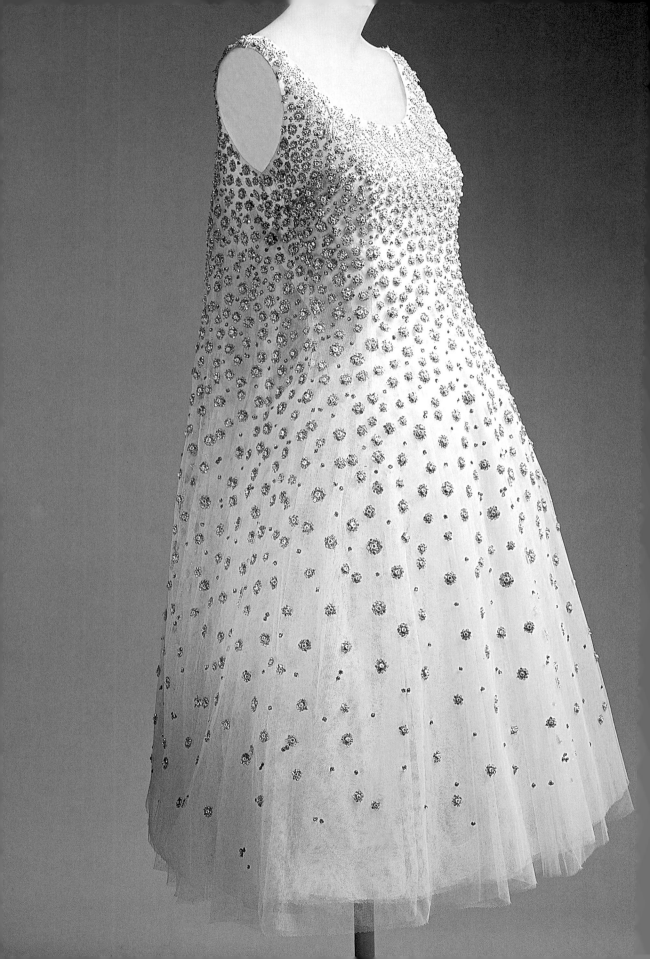

"L'Éléphant blanc" Evening Dress
Spring/Summer 1958

House of Dior, French, founded 1947
Yves Saint Laurent, French, b. Algeria, 1936–2008, designer

Creating the trapeze silhouette for Dior, Yves Saint
Laurent designed a rigid understructure veiled by
a flyaway cage. A boned corset anchors the dress but allows
the illusion of a free-swinging cone. Saint Laurent also
employed shimmering embroidery on net, introducing a
finishing flourish to the veil-like surface. Thus, the designer
gained the effect of ethereal, buoyant freedom while
retaining the structure of the couture.

The dress's layers of white
net are embroidered with
silver thread, sequins,
and rhinestones in a dot
pattern denser at the top
of the bodice, where the
scoop neckline is edged
with a V motif and silver-
bead tassels.

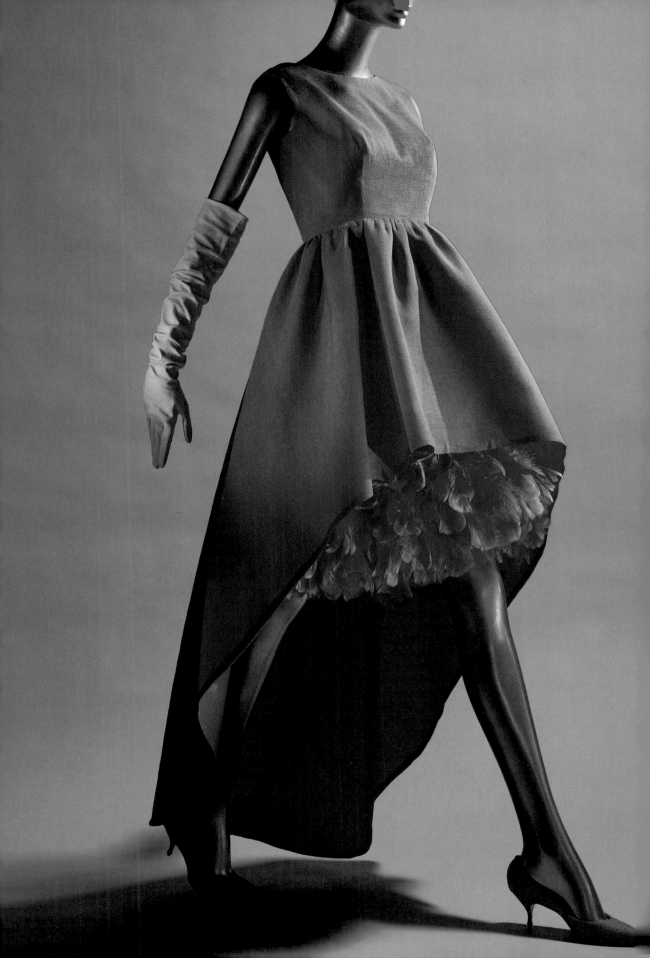

Evening Dress
ca. 1960–65

Cristóbal Balenciaga, French, b. Spain, 1895–1972

In the 1950s and '60s, Cristóbal Balenciaga gained widespread fame among upper-class Americans and Seventh Avenue manufacturers. Hailed for its accommodating fit, his cantilevered cut effected a slimmer silhouette on the curviest forms of his clients and was also prized by ready-to-wear houses that modeled their lines after the master's flattering styles.

Inspired by the flamenco dress, Balenciaga designed gowns that rose at the front, allowing the wearer's motion to fill the long train with air so it would billow out behind her.

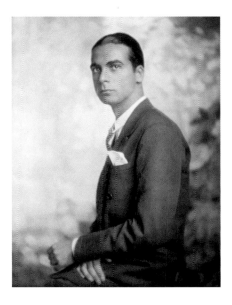

Cristóbal Balenciaga, shown here in about 1927, is regarded as a great artist whose influence is still being felt in the twenty-first century. The modern look that he created has been carried on by André Courrèges, Emanuel Ungaro, Hubert de Givenchy, and Nicolas Ghesquière (French, b. 1971), among others.

Cocktail Dress
ca. 1960

Madame Grès (Alix Barton), French, 1903–1993

Although Madame Grès is best known for her densely pleated silk jersey "goddess" gowns, she also favored evening wear in more varied silhouettes and fabrics. Her reliance on draping a live model instead of sketching her designs may be seen in one element of her work that emerged as a signature: her preference for unbroken lengths of fabric to compose her designs. Always sympathetic to the sari—its function to wrap and its propagation of bias as a consequence of spiraling drapery—Madame Grès was particularly influenced by her research sojourn in India in the 1950s. An avid student of historical and exotic dress, Grès did not mimic but absorbed and translated discrete elements into her own eclectic vernacular.

A traditional Indian design decorates the border of Madame Grès's sari-like cocktail dress.

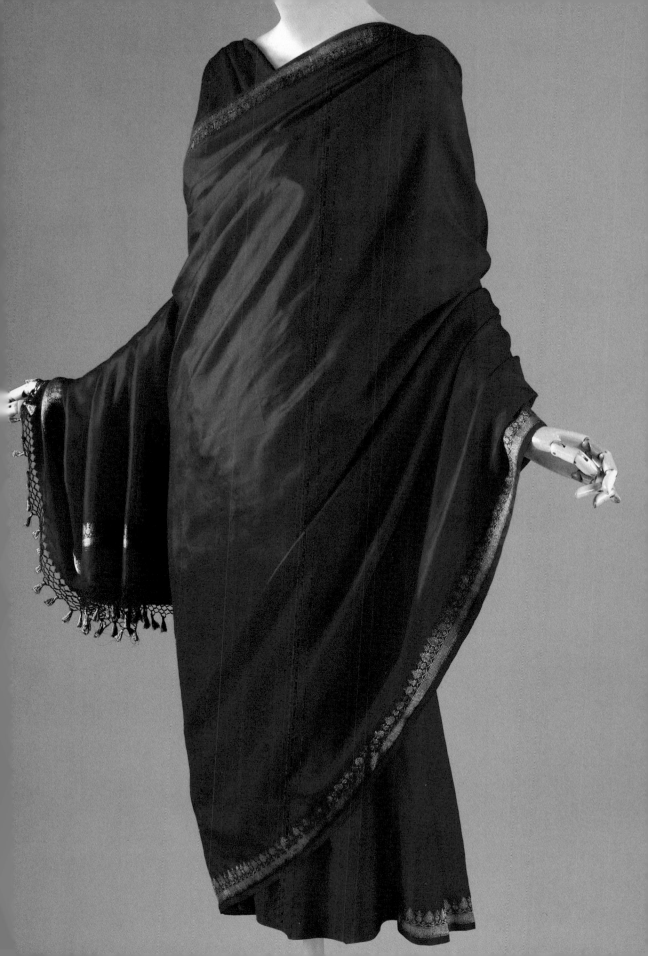

Evening Dress
Early 1960s

Hubert de Givenchy, French, b. 1927

In this evening dress, Hubert de Givenchy created a tiered register of luxurious forms. The pink net overblouse is embroidered with pink crystals and gold and pink metallic thread, and ends in a fringe of ostrich filaments and individually glued feathers. The proximity of these extravagant textures enriches the waist of the gown. The lushness of the overblouse and its pendant feathers allowed the designer to create an uncertain placement of the waist, even while directing attention to this zone.

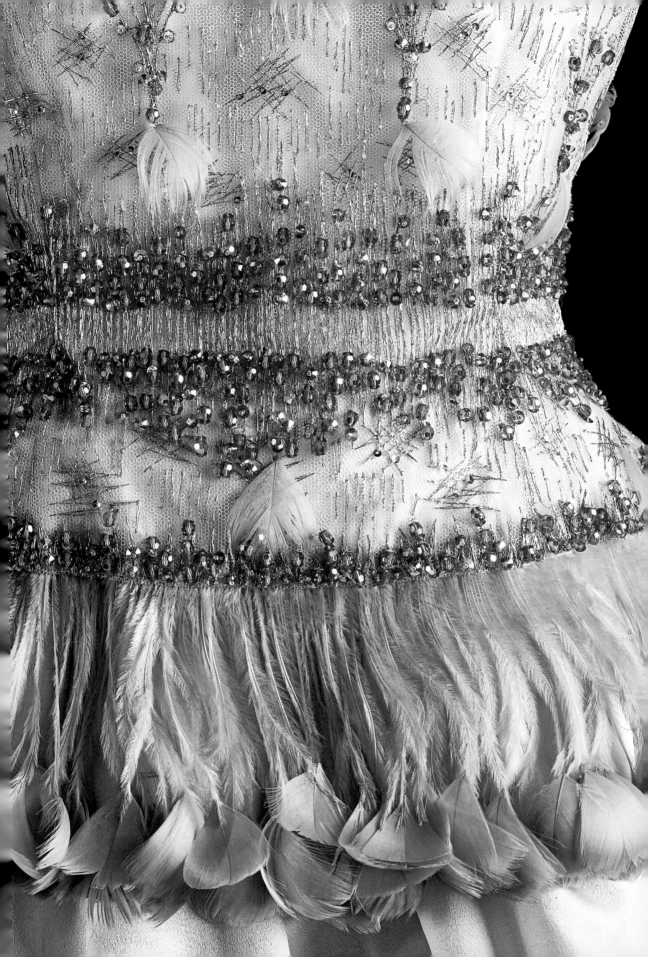

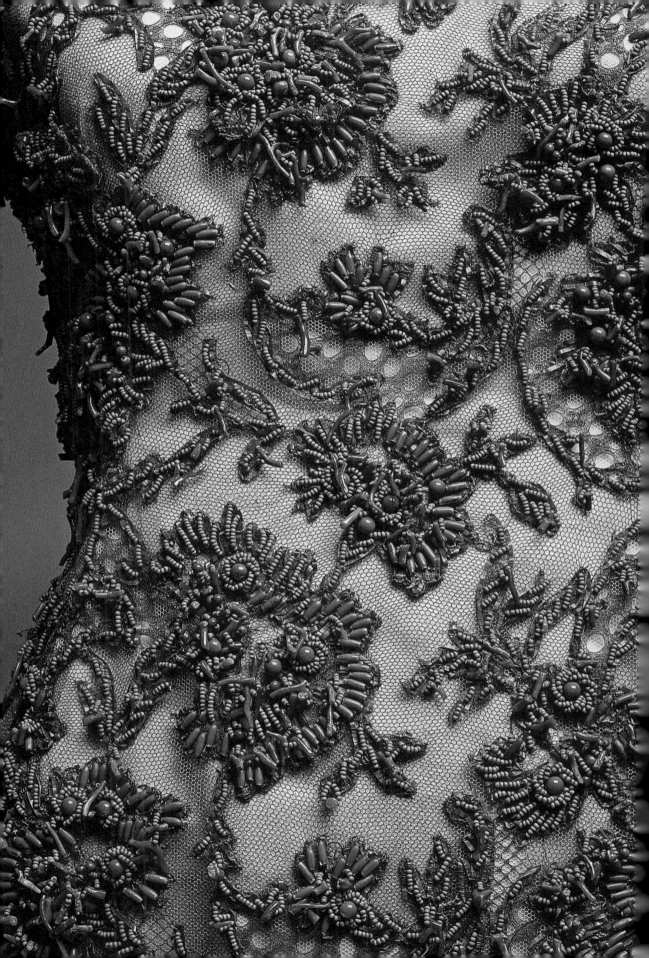

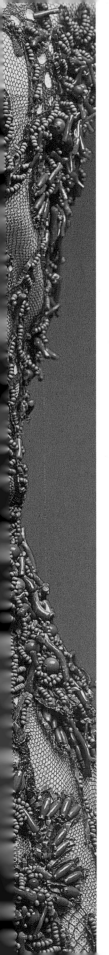

Evening Gown
1963

Hubert de Givenchy, French, b. 1927

Hubert de Givenchy began his fashion career at the age of seventeen, working for Jacques Fath. After working for other design houses, including that of Elsa Schiaparelli, he decided to go out on his own. He showed his first solo collection in the winter of 1952, and his designs had become best sellers by the following summer.

A princess-seam dress skimming the torso but flaring to the hem, this costume is almost severe, but it is rendered rococo by the surface treatment. Givenchy's special trait was to find an equilibrium between excess and simplicity. An austere form supports heavily encrusted embroidery, making a gown that works as a spare yet extravagant design.

Givenchy applied coral with matching glass beads in high relief on the armature of a minimalist silhouette.

Day Ensemble / Coatdress
1965

André Courrèges, French, b. 1923

André Courrèges, who originally wanted to be an architect, has said, "Designing a building and making a dress have much in common. The principal concern of both is to give the impression of grace and harmony while at the same time being practical." Attuned to the fashion of the young, the designer's sensibility evolved from his training with Cristóbal Balenciaga. In the costumes shown here, Courrèges applied a surgical cut and strict tailoring to the geometric symplicity in vogue.

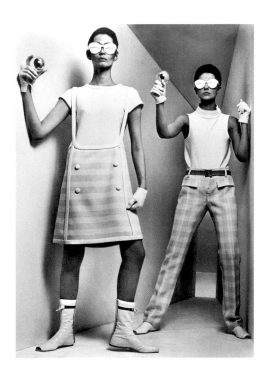

André Courrèges's most memorable collections showed models wearing slit-eyed sunglasses, white gloves, and flat white boots with crisply cut, above-the-knee dresses and narrow slacks, as seen in this 1965 photograph by William Klein (American, b. 1928).

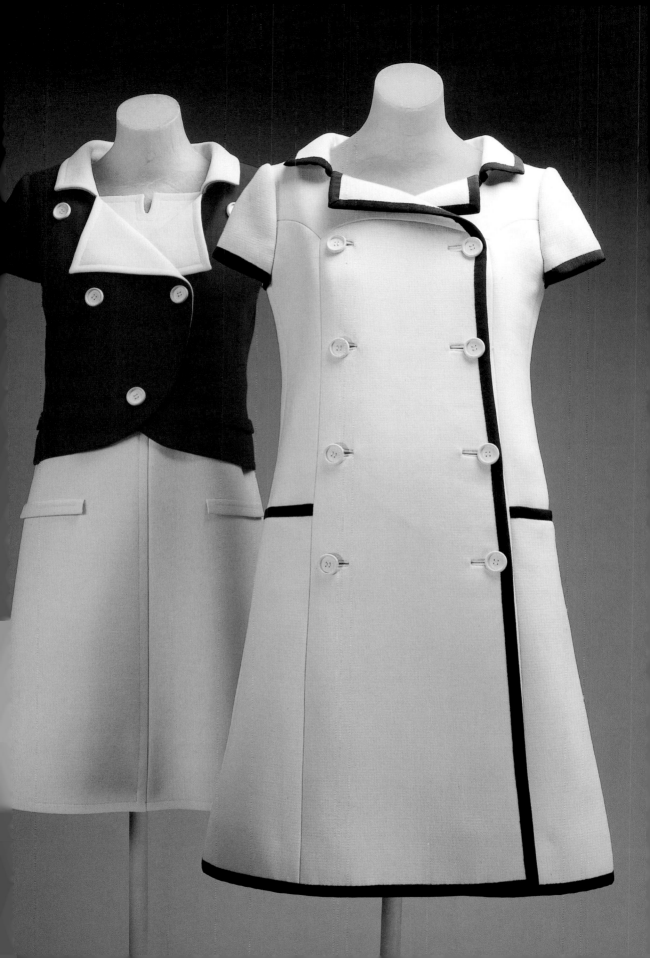

"Mondrian" Day Dress
Fall/Winter 1965–66

Yves Saint Laurent, French, b. Algeria, 1936–2008

As the sack dress evolved into the modified form of the shift, Yves Saint Laurent realized that the planarity of the dress was an ideal field for color blocks. Inspired by a book on the work of Piet Mondrian (Dutch, 1872–1944), Saint Laurent devised a collection explicitly referencing the artist's work. He also demonstrated a feat of dressmaking, piecing together each block of wool jersey in order to create the semblance of a Mondrian geometry while imperceptibly accommodating the body by hiding all the shaping in the grid of the seams.

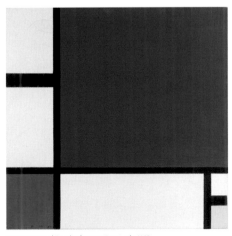

Piet Mondrian called his abstract painting Neo-Plasticism, describing it as an idea that "should find its expression . . . in the straight line and the clearly defined primary color," as seen in his painting *Composition with Red, Blue, and Yellow, 1930.*

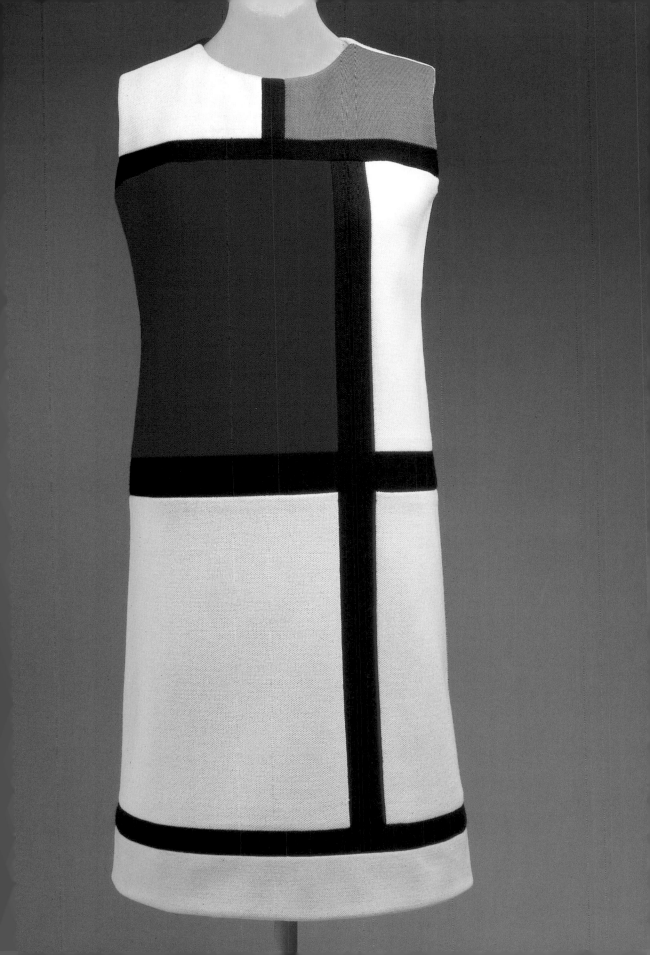

Evening Dress
Fall/Winter 1965–66

Cristóbal Balenciaga, French, b. Spain, 1895–1972

Cristóbal Balenciaga's propensity for lace ruffles is generally taken to be an allusion to the tiered flamenco skirts of the designer's Spanish heritage, as well as the imagery of Francisco de Goya (1746–1828). Indeed, Spanish art was a recurrent source of inspiration for the designer. Even as he extrapolated ideas from the fit of the flamenco to the swaying cone of the baby-doll silhouette, Balenciaga employed the ruffle tiers—which are reinforced by loosely woven horsehair—as an attenuated memory of Goya and fashion history.

This short black lace evening dress consists of three layers. The first layer is a built-in bra supported by six bones. The second layer is a slip of cream-colored silk with a sheer black chiffon overlay. The slip is shaped like a sheath and has a wide band of lace at the hem. The outer layer consists of a loose-fitting baby-doll dress with a triple tier of ruffles on the skirt. The dress has a boat neckline accented by shoulder straps of black satin ribbon finished in bows.

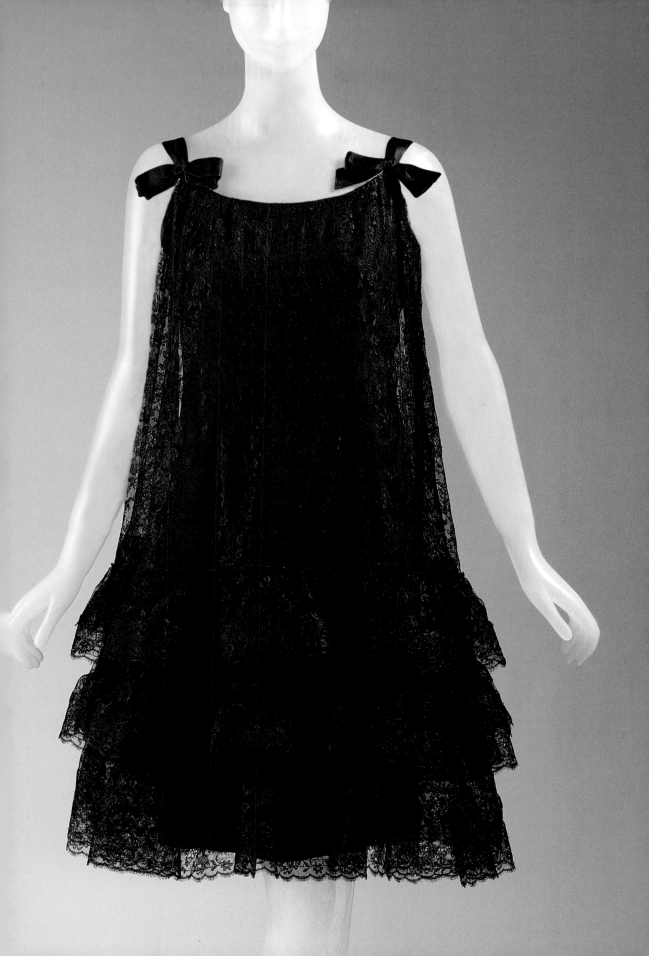

Dress
1966–69

Paco Rabanne, French, b. Spain, 1934

In 1966, Paco Rabanne opened a fashion house in Paris and broke new ground with the use of materials such as plastic and aluminum to make clothing. His flamboyant designs included large, colorful plastic jewelry and dresses made of metal-linked plastic shapes, such as the squares and rectangles seen in the minidress shown here and in his designs for the 1968 film *Barbarella*, starring Jane Fonda. Rabanne later carried his linked-disc theme into designs that juxtaposed the different textures of knits, leather, and fur.

Jane Fonda wears a metal-linked costume designed by Paco Rabanne for the 1968 film *Barbarella*.

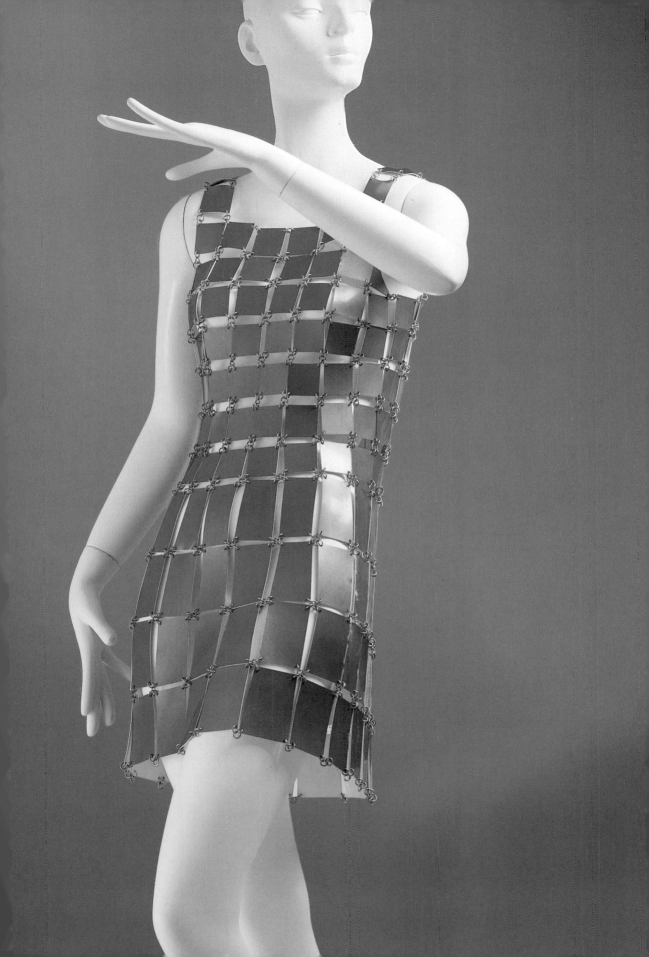

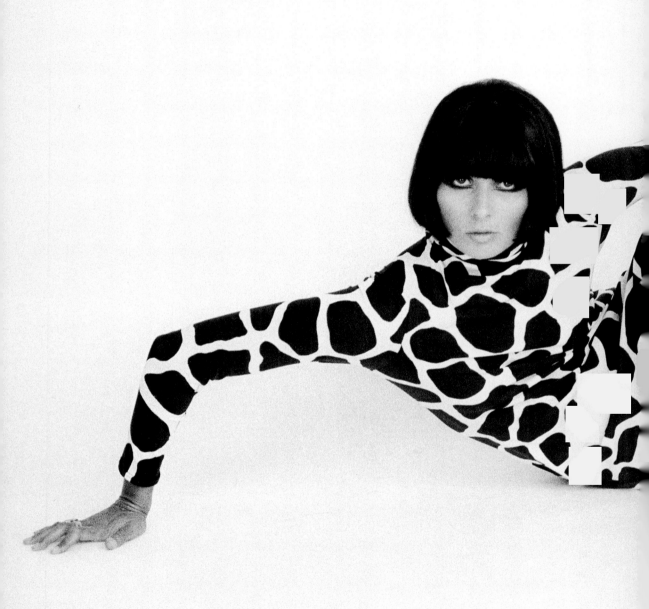

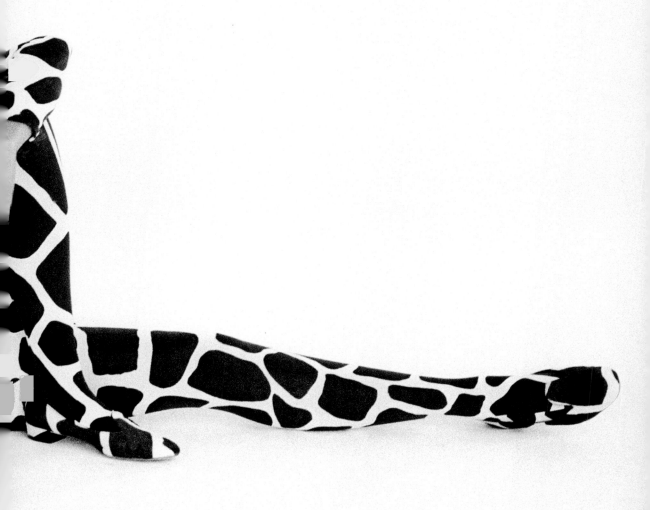

In 1966, Dennis Hopper
(American, b. 1936)
photographed model
Mary Léon Bing wearing
an ensemble designed
by Rudi Gernreich.

Ensembles
1967

Rudi Gernreich, American, b. Austria, 1922–1985

Among visionary designer Rudi Gernreich's once-controversial inventions are the monokini (a topless bathing suit) and "no-bra bra" (a see-through bra without padding or boning) of 1964 and the unisex look, introduced in 1970. He also raised skirts well above the knee, used bright and unusual color combinations, and advocated the "Total Look," the coordination of hair and makeup with the clothes one wore. Each ensemble shown here included a knit minidress inset with transparent plastic bands and its coordinating underpants, leggings, and shoes.

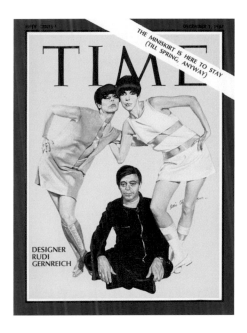

Rudi Gernreich and his designs, worn by models Mary Léon Bing and Peggy Moffit, were featured in the cover story of the December 1, 1967, issue of *Time* magazine.

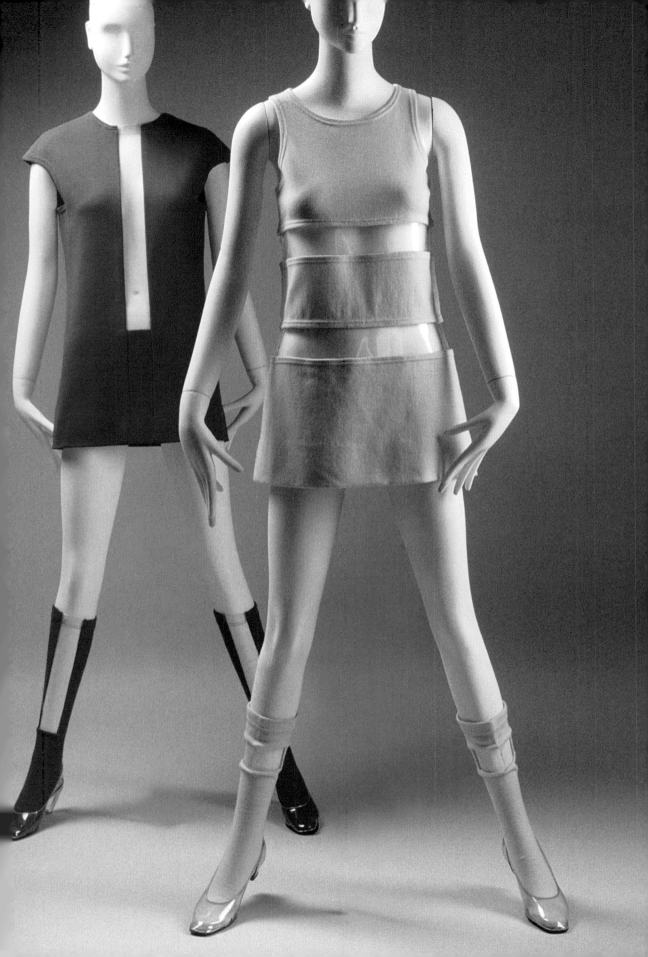

Evening Gown
ca. 1968

Hubert de Givenchy, French, b. 1927

T he matching salmon-colored feathers on Hubert de Givenchy's silk evening gown are stripped down to the tip to create an artificial profile. Indicative of couture in seeking to make an improvement even on nature, the contrived feathers elaborate on the feather's natural shaping to create a self-conscious artifice. Shorter feathers have been anchored into an overlapping scallop pattern that imitates a bird's natural covering, but they are tipped upward to create a more dramatic dimensionality. The longer plumes are affixed by their stemlike spine so that they are *tremblant* and animated on the dress.

Under the influence of his great friend and mentor, Cristóbal Balenciaga, Givenchy explored the possibilities of a reductive use of seaming in his designs. This gown, like a sari, spirals around the body and is cut of one continuous length of sumptuous silk crêpe. As in much of his oeuvre, however, the designer's rigorous structural minimalism has been mediated by an impulse to feminize through ornament and embellishment.

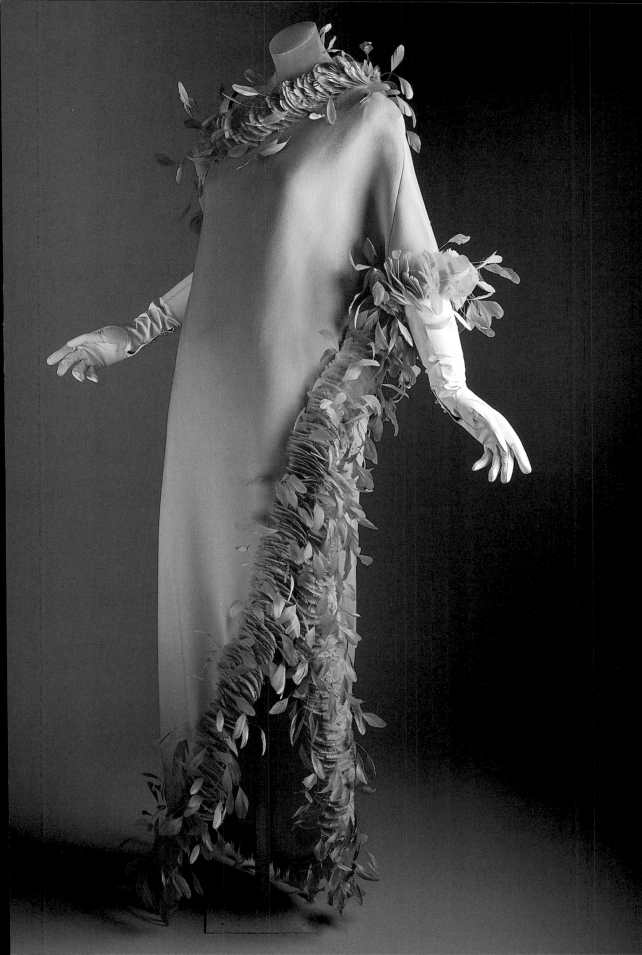

Evening Dress
ca. 1974

Halston (Roy Halston Frowick), American, 1932–1990

Halston's most profound contributions to fashion have been as the proponent of a luxurious minimalism. His sportswear-inflected designs have been the benchmark for elegance and exquisite taste for two decades. Halston's work is hailed for its simplicity, but the construction is rarely that. Knots, ties, wraps, and layers are all commonplace in the designer's highly sophisticated evening gowns.

The pink iridescent sequins that completely cover the stretch jersey evening dress shown here would have sparkled in the light with every move made by the woman wearing it. Though Halston's designs exude a pared-down beauty, they should not be underestimated. His signature pieces are modernist design objects and were uniforms of progressive late twentieth-century women.

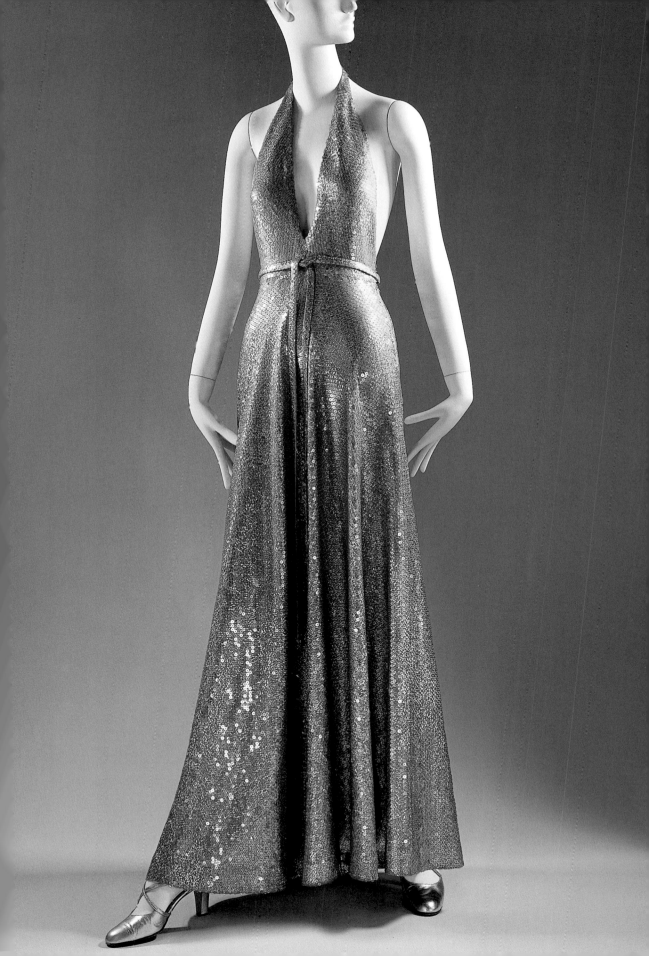

Evening Gown with Wrap
1974

Halston (Roy Halston Frowick), American, 1932–1990

In classical Greece, the shawl-like himation was considered obligatory for the public appearance of any respectable matron. However, it also functioned as a status symbol, communicating wealth, prestige, and luxury through its amplitude and the quality of its weight and weave.

In Halston's evening ensemble, a pleated double-tiered cape, composed of yards and yards of chiffon, functions in the same way as the himation. The simply constructed cape can be worn in a variety of ways to provide decorous coverage for the gown underneath. Also pleated, the travertine-colored halter gown, with its plunging neckline and completely bared back, is essentially a fluted Greek column.

This bronze dancer from the Hellenistic period is swathed in a voluminous himation of a material so light that the folds and drape of the garment underneath are visible.

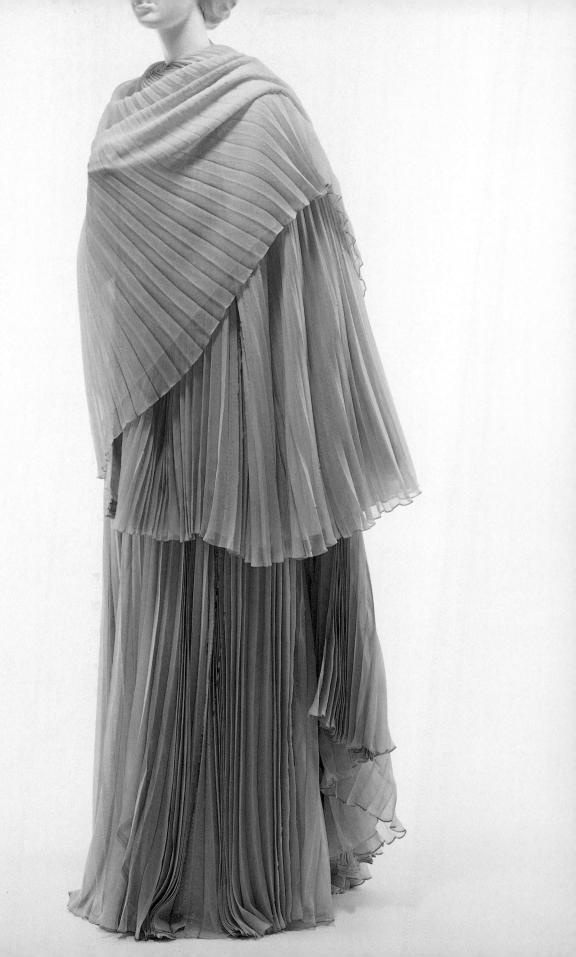

Evening Ensemble
Fall/Winter 1976–77

Yves Saint Laurent, French, b. Algeria, 1936–2008

The political and social upheaval of the 1960s, the emergence of creative ready-to-wear designers, and the increasing preference for a sportswear approach to dressing were among the shifts in lifestyles and taste that appeared to sound the death knell of the *maisons de couture*. Then, in 1976, Yves Saint Laurent mounted his own counterrevolution with a collection of unrivaled fantasy and luxury, which he called his "Russian Collection."

Inspired by the Ballet Russes costumes designed by Léon Bakst (Russian, 1866–1924), each ensemble appeared to be a repudiation of the informal, pared-down, and functional looks of the street. By employing all the techniques of the *petites mains*—workshops of embroiderers, *passementerie* makers, lace weavers, feather workers, and jewelry makers—Saint Laurent revived the taste for elegant excess.

Evening Ensemble
Spring/Summer 1980

Yves Saint Laurent, French, b. Algeria, 1936–2008

While a long, lean body remained the ideal in the 1980s, a new, wide shoulder began to be appended to the silhouette. To a degree, this was a revival of 1940s fashion. Ornately rendered here by Yves Saint Laurent, the shoulders provided a foundation from which fabric could be draped down to a contrastingly narrow waist.

French writer and director Marguerite Duras (1914–1996) wrote in appreciation of Saint Laurent's synthesizing imagination, "I tend to believe that the fabulous universality of Yves Saint Laurent comes from a religious disposition toward garnering the real—be it manmade—the temples of the Nile—or not manmade—the forest of Telemark. . . . Saint Laurent invents a reality and adds it to the other one, the one he has not made." In this case, Saint Laurent invents a mysterious East and adds it to the valor of formal military dress.

The heavy embroidery in gold beading, gold metallic thread, and silver sequins continues over the shoulders and on to the back of the jacket.

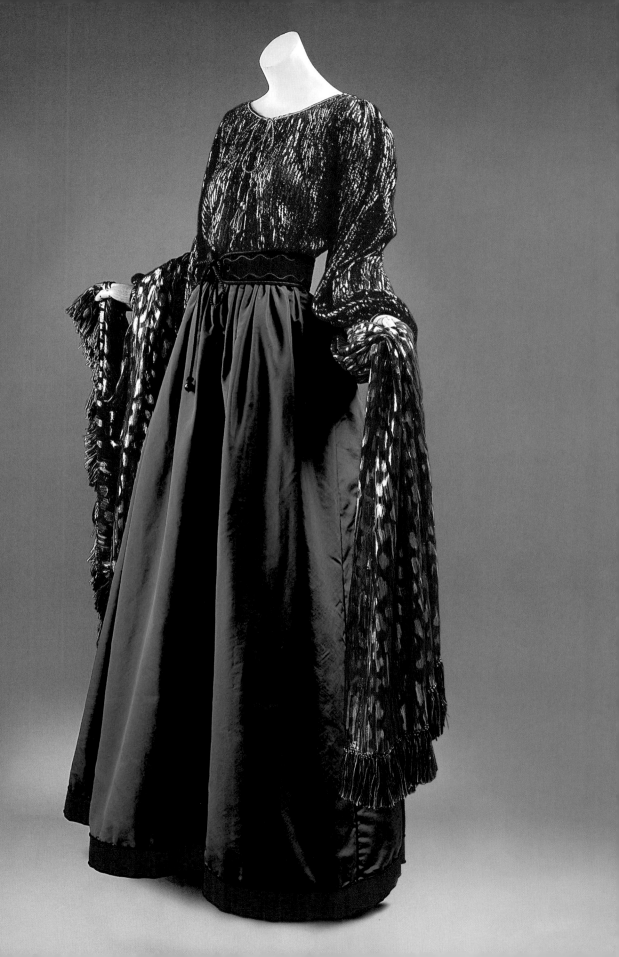

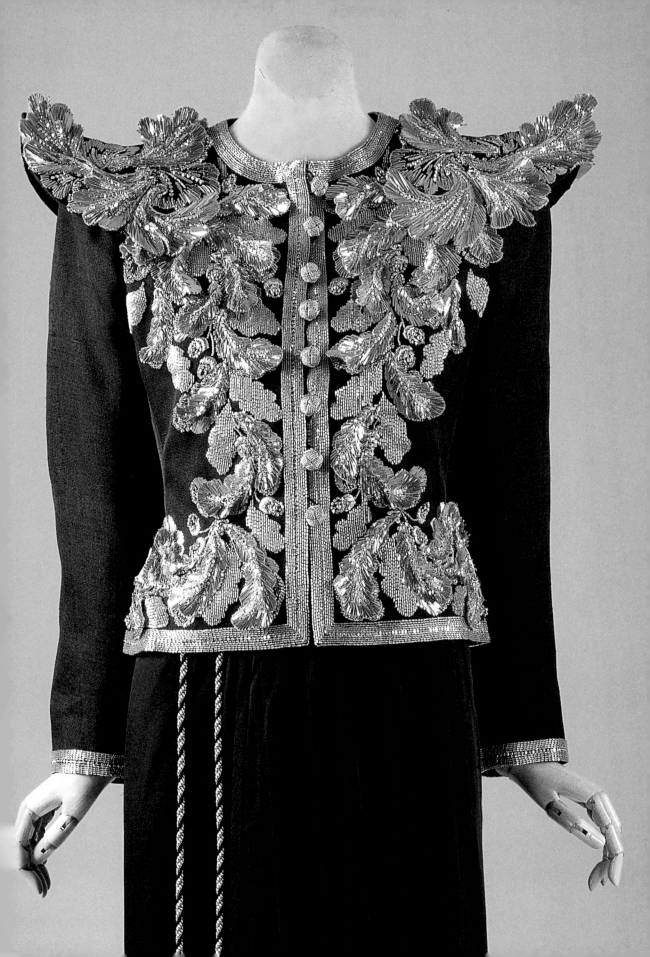

Evening Ensemble
Early 1980s

Madame Grès (Alix Barton), French, 1903–1993

Madame Grès's sublime, sensuous design reflects a dynamic between austere line and exaggerated contour. Its draped and supplely fitted bodice explodes from the waist in a voluminous bubble peplum, whose undulating volume is in dramatic opposition to the columnar skirt below. (To achieve the desired fullness, the former owner of the dress would stuff the peplum with tissue.)

Since Grès's working method was devoid of preparatory sketches and patterns, her concepts originated in the three-dimensional drape, twist, and pleat of fabric on a live model. The resulting designs are timeless solutions to controlled explorations combining figure and cloth. This dynamic silhouette—the bifurcated tunic worked of *changeant* rose faille juxtaposed with iridescent navy blue shantung and the skirt of matching navy shantung—is further activated by the interplay of vibrant color.

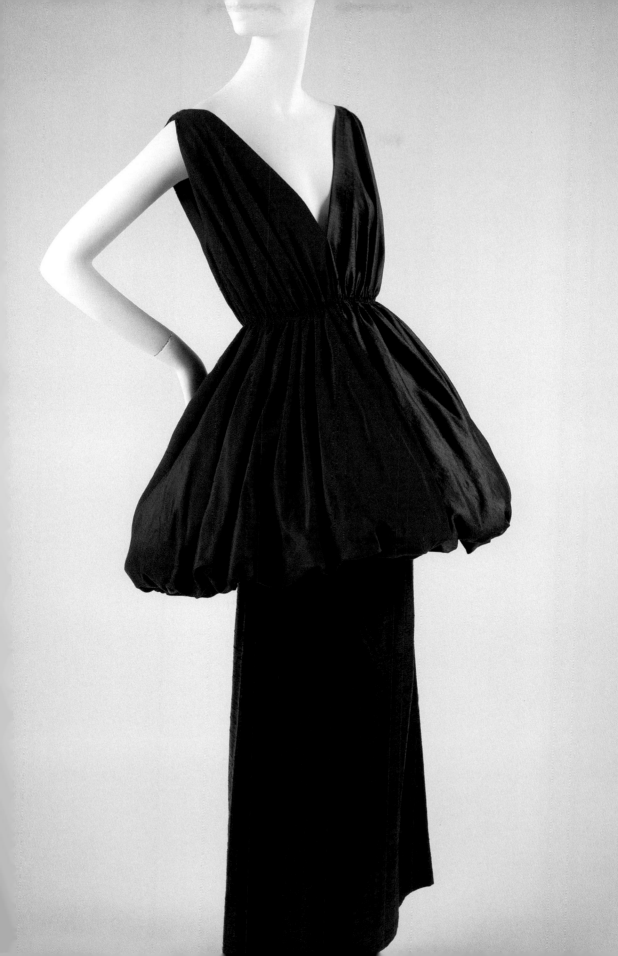

Dress
1983

Comme des Garçons, Japanese, founded 1969
Rei Kawakubo, Japanese, b. 1942, designer

The impact of Rei Kawakubo's designs in Paris in 1983 was groundbreaking. Her runway presentation, with its models wearing body-obscuring layers rendered in coarsely textured materials, was received as antifashion. Some critics saw Kawakubo's designs as nihilistic, and a few even characterized them as misogynistic. But, as Kawakubo said at the time, she had merely wanted to make a statement that was "strong."

With this jersey chemise, she tested the limits of what is defined as beautiful or ugly, diminishing or enhancing. Adopting Chanel's strategy of reverse chic, Kawakubo transfigured lowly black wool jersey into a designer dress, an item of value. The knowing client responds not to the seduction of rich effects and materials but to the subtle finishes and detail as well as to a mode of self-presentation that seeks to avoid any suggestion of ostentation.

Rei Kawakubo's interweaving of sleevelike bands across the torso recalls the body harnesses of Punk bondage apparel.

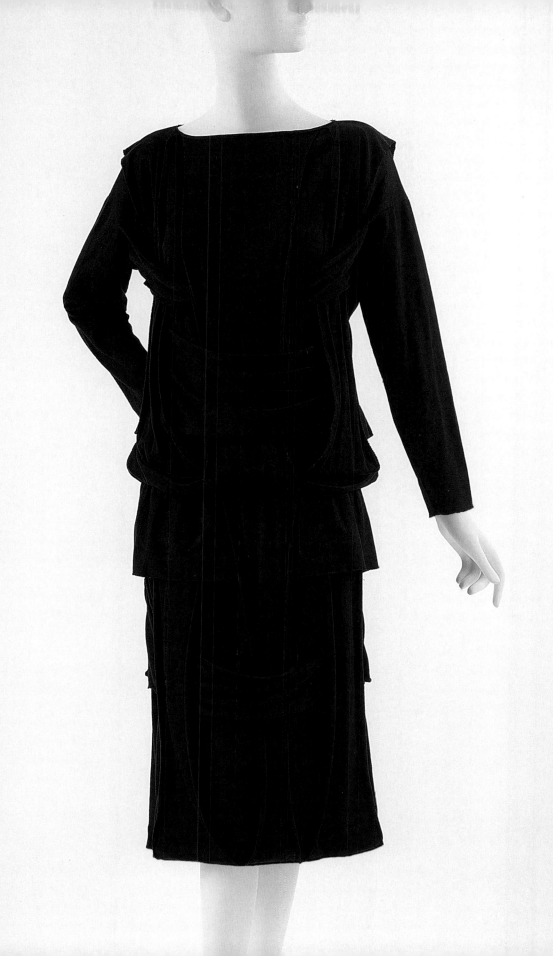

Dress
1983–84

Geoffrey Beene, American, 1927–2004

Although he abandoned medical school for fashion design, Geoffrey Beene informed his work with surgical precision. Signature Beene gestures include his anatomical cut, piped finishes, a harnessed torso, and beginning in the late 1980s, the play of apertures in the fabric over the body.

In this floor-length silk and wool evening dress, the gold curvilinear pattern highlights and complements the curves of the female form. In making the dress, Beene used the difficult technique of piecing and seaming, sewing together the pieces of the gold body, which was then fitted into—rather than appliquéd onto—the black dress.

This close-up clearly shows the seams piecing together the sections of the gold body as well as the gold body and the black dress.

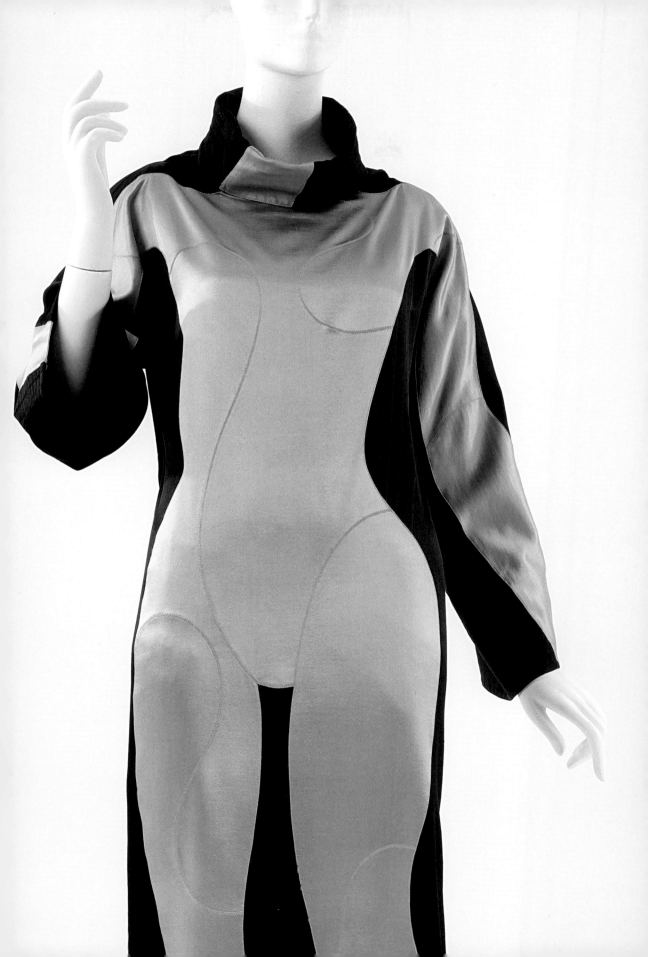

Evening Gown
1987

House of Patou, French, founded 1919
Christian Lacroix, French, b. 1951, designer

Most famous for his eighteenth-century-inspired *pouf* silhouette, Christian Lacroix made the most inflated version of this style when he was designing for Patou. There and at his own house, Lacroix combined luxury and insouciance, enamored as he is of handworked effects, including fringe, bead, and embroidery. The opulence of Lacroix's designs is attained by his strong sense of vibrant color—as seen in this raspberry silk taffeta evening gown and its contrasting black faille lacing and bow—and, in much of his work, the employment of all the possibilities of couture technique. His historicism is often playful rather than literal, but even in his most lighthearted conflation of past styles, Lacroix prizes and exacts the highest refinements of the couture worker's artisanal virtuosity.

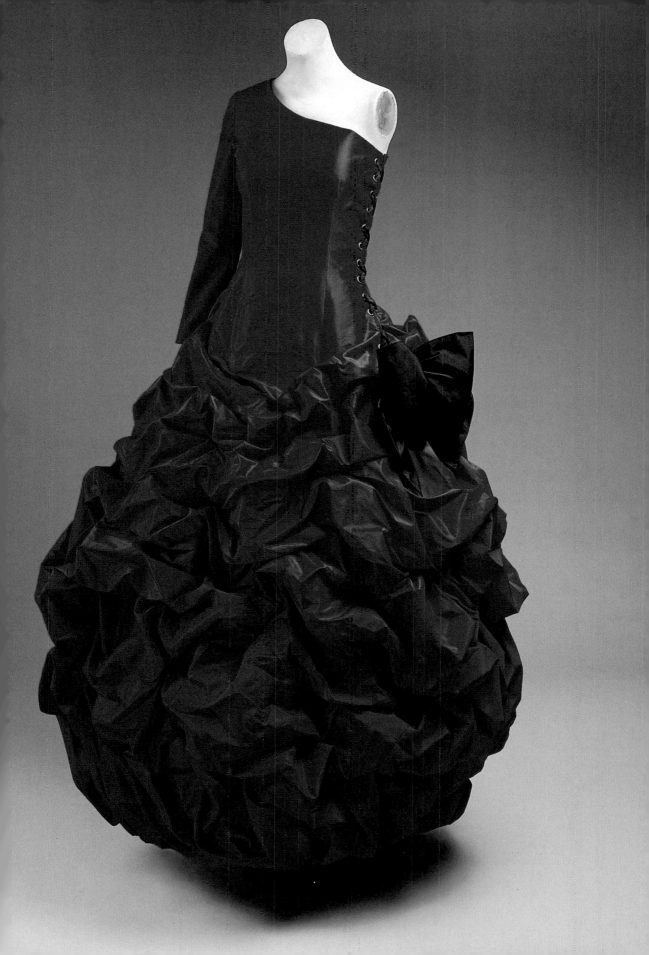

"Careme" Evening Ensemble
Fall/Winter 1987–88

Christian Lacroix, French, b. 1951

In 1987, Christian Lacroix launched his own couture collection, including his signature *pouf* silhouette. Though the broad, supported skirt could be taken to manifest the 1860s of Scarlett O'Hara, and the flared skirt and corseted body could seem so innately Belle Époque, the *pouf* was much more closely aligned with eighteenth-century style. The lavish lace, dotted net, and ribbon appliqué of Lacroix's "Careme" evening ensemble are convincing evidence of his love of exquisite ornamentation and exuberant effects.

Christian Lacroix at his 1988 spring line launch.

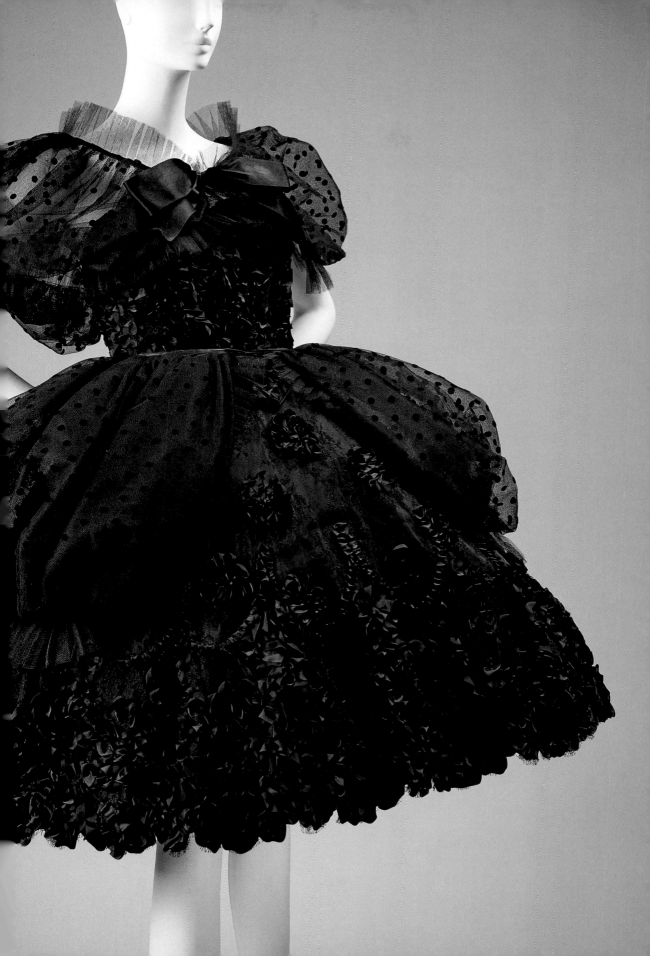

Dress
Fall/Winter 1987–88

House of Chanel, French, founded 1913
Karl Lagerfeld, French, b. Germany, 1938, designer

C reated by Coco Chanel in 1926, the little black dress was translated to ready-to-wear as a staple of late afternoon and cocktail hours. Black had been used for formal and semiformal occasions in preceding decades, but when Chanel administered her sporty chemise silhouette, her little black dress was immediately dubbed the "Ford of Fashion" by *Vogue*. It soon became a minimalist canvas for day, cocktail, and evening accessories, including hats, gloves, pocketbooks, and above all else, costume jewelry.

Though the originals were constructed in reserved black wool jersey or silk crêpe, Karl Lagerfeld, who became head designer for the House of Chanel in 1983, executed his version in a fetishistic black vinyl and black polyester jersey combination. Lagerfeld infused a controversial, modern persona into the 1920s silhouette (with dropped waistline, flounced knee-length skirt, and modest cocktail neckline) that first brought Chanel fame. Lagerfeld's design embodies the irony of the late twentieth-century "cocktail" outfit, professing nostalgia for submissive femininity but parading a tongue-in-cheek dominatrix allure.

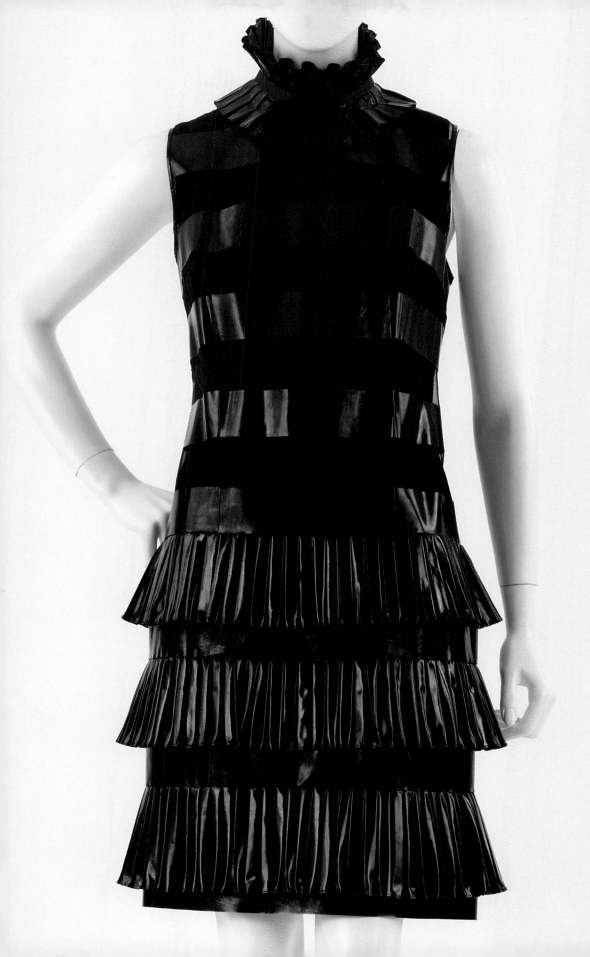

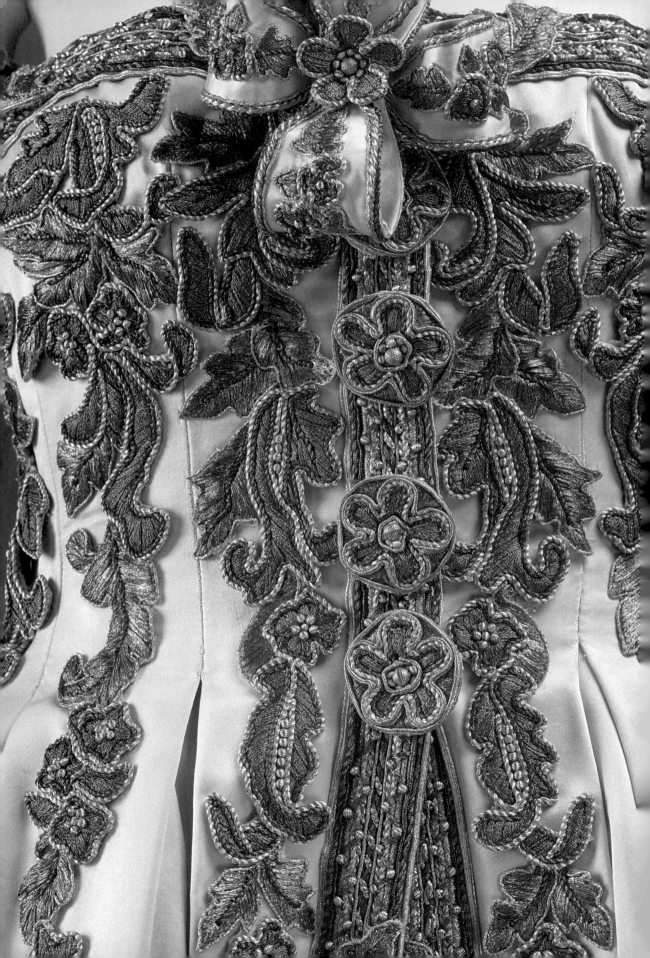

Evening Ensemble
ca. 1990

House of Chanel, French, founded 1913
Karl Lagerfeld, French, b. Germany, 1938, designer

K arl Lagerfeld has taken the eighteenth century as a leitmotif of his art and life, from residences and domestic interiors to fashion—and even to a brief whim of powdering his hair. Here, he has seized the bravura assertion from the court gown, opening up at center front to reveal not a long petticoat but a very short underskirt and thigh-high boots. For Lagerfeld, the condensed and ironic image is both Versailles and red carpet, aristocracy and showgirl. Other Lagerfeld for Chanel references to the eighteenth century include his 1980s Watteau-back gowns and the 1985 "Pierrot," or "Gilles," suit derived from the painting of the same name by Jean Antoine Watteau (French, 1648–1721).

"Rothola" Crayon Dress
ca. 1990

Christian Francis Roth, American, b. 1969

S oon after Christian Francis Roth showed his first collection at the age of twenty-one, *Women's Wear Daily* published an article called "Word Is Out: SA [Seventh Avenue] Has a New Boy Wonder." Among his early designs were his "Rothola" crayon dresses, in which he provided both the means and end of graphic expression. The dresses not only refer to the instruments of youthful mark making but also incorporate the graphic scrawl that is the first symbol or character in a child's writing and art. Like the easily perceived bravado in the graffiti-inspired icons of Keith Haring (American, 1958–1990) in the 1980s, Roth's form-bestowing innocence begins with a child's intuitive perception.

Christian Francis Roth fitting a suit jacket with lip-shaped lapels in 1989.

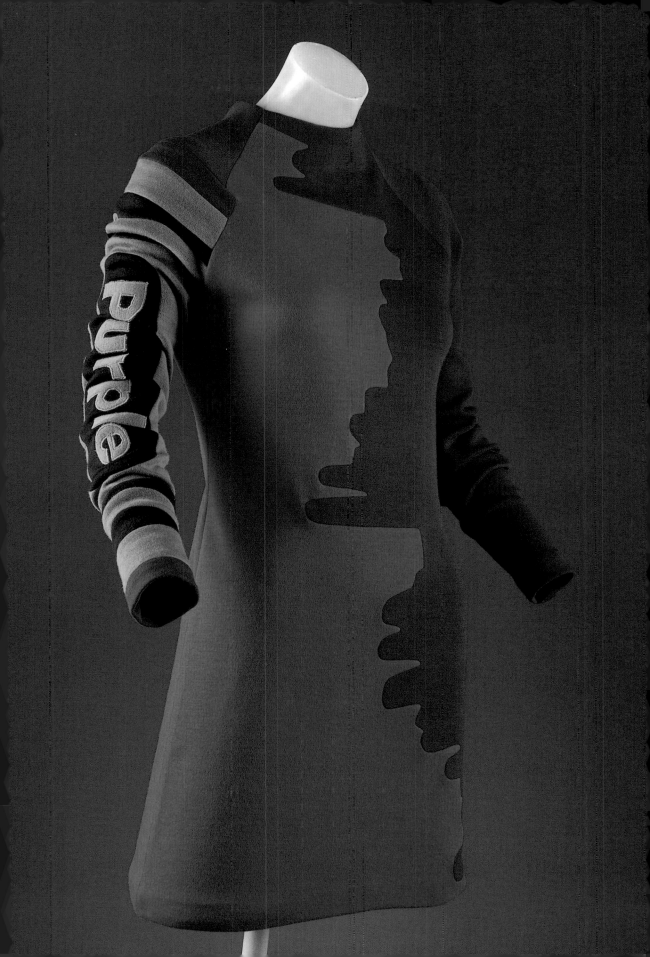

Evening Ensemble
ca. 1990–92

Emanuel Ungaro, French, b. 1933

Emanuel Ungaro's classical gown, like the Hellenic world's ubiquitous chiton and capacious himation befitting the noblest Olympian goddess, is discreet in its coverage. With the attributes of the Greek gods so clearly defined, it is possible to ascribe mythic attributes to contemporary garments even in the absence of explicit identifications. That the dress of people 2,500 years in the past can imbue a late twentieth-century design such as Ungaro's with the aura of myth and timeless beauty suggests that the classical mode, like Penelope's weaving, is continuous and without end.

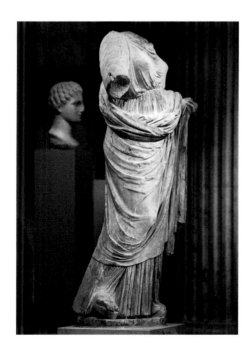

The drape of Emanuel Ungaro's evening ensemble is reminiscent of the draped himation in this Greek statue from the second half of the fourth century BC.

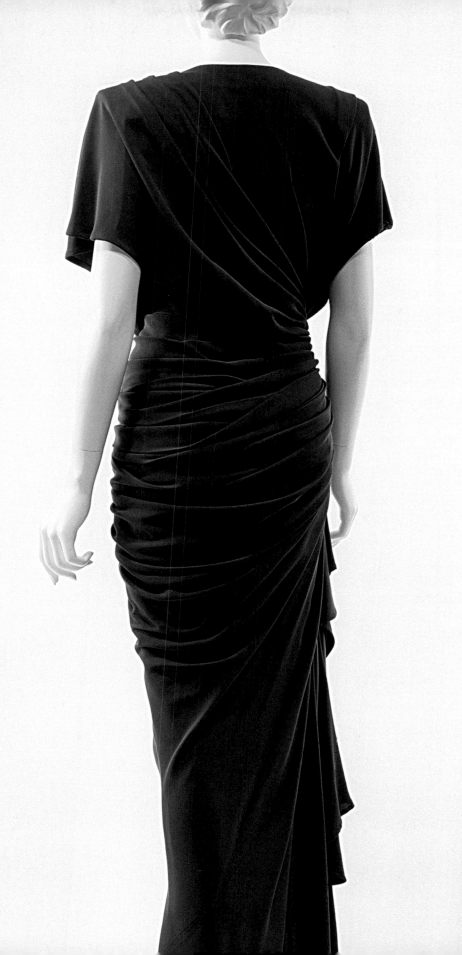

Evening Gown
Spring/Summer 1991

Gianni Versace, Italian, 1946–1997

Widely influenced by the florid shapes and colors of print artists like Sonia Delaunay (French, 1885–1979) and Raoul Dufy (French, 1877–1953), both of whom collaborated with fashion artists during the course of their careers, Gianni Versace frequently referenced art historical and cultural aesthetic phenomena. His classical allusions range from the inclusion of the Medusa as part of the Versace logo to the Greek key pattern as a motif in both men's and women's collections, though an attraction to both Surrealism and Pop Art is equally obvious in his fabric choices. This piece, printed with the iconic faces of Marilyn Monroe and James Dean, is a testament to Versace's fascination with the ironic and sometimes morbid depictions of Andy Warhol (American, 1928–1987) as well as a signifier of Versace's self-proclaimed persona as the celebrity couturier.

Supermodel Naomi Campbell wears Gianni Versace's evening gown in a 1991 fashion show in Los Angeles, California.

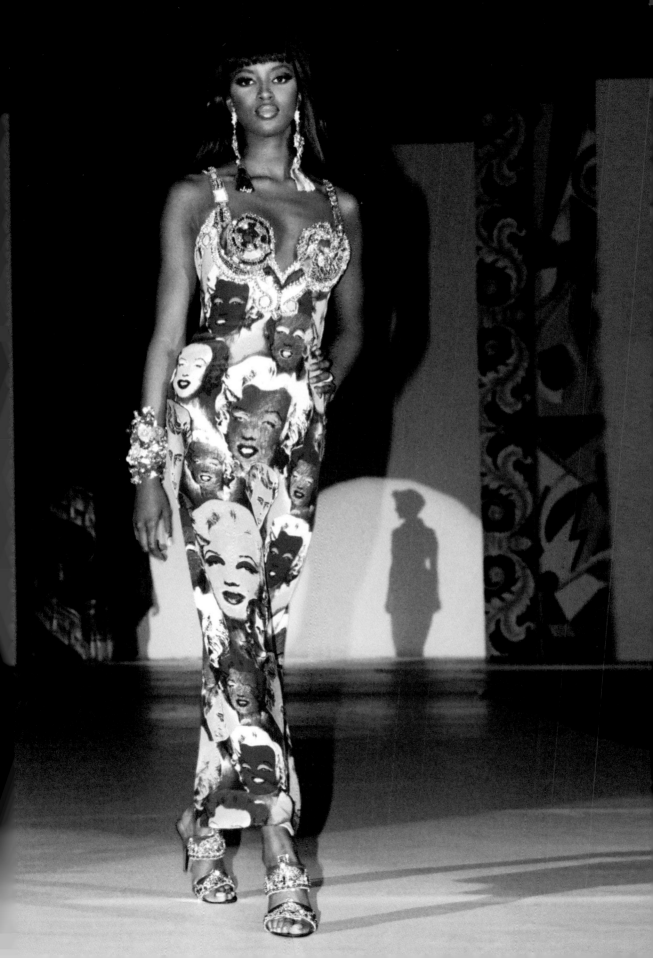

Evening Dress
Fall/Winter 1991–92

Gianni Versace, Italian, 1946–1997

S etting the most complex and concentrated tasks for the expertise of the couture ateliers, Gianni Versace here brought satin in trapunto into immediate conjunction with floral-patterned lace. Delighting in applying a second unexpected effect, Versace took lace, which is customarily worked as a flat panel—as in the midriff of the bodice here, where it is set off by quilted bands trimmed with gold-colored studs and grommets set with pale blue rhinestones—and creased it into narrow pleats in the short skirt. Always inclined, even in his ready-to-wear, to challenge the possibilities of the medium, Versace's couture work summoned its own tests of technique.

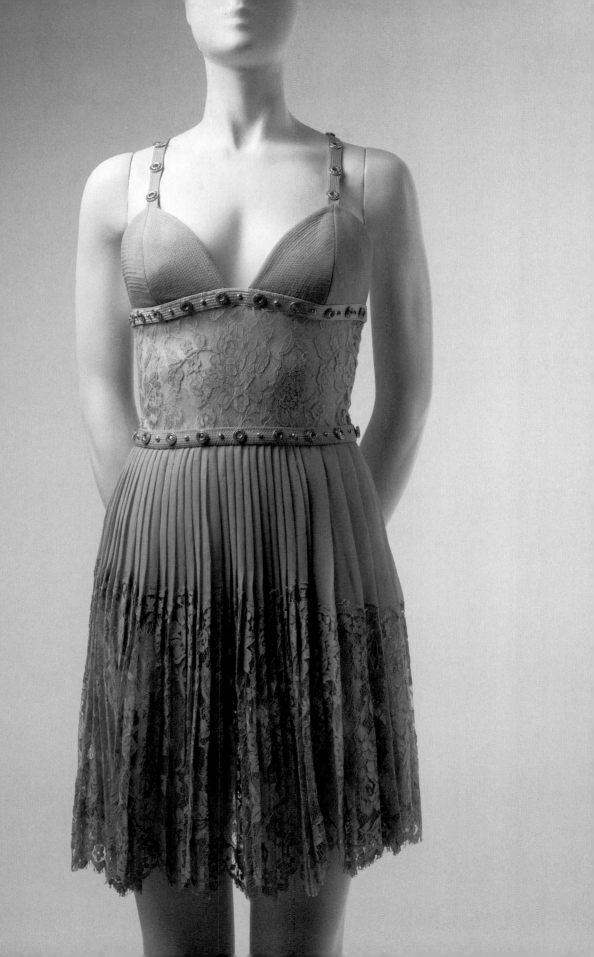

"Flying Saucer" Dress
Spring/Summer 1994

Issey Miyake, Japanese, b. 1938

With the vocabulary of pleats that he introduced in 1990, Issey Miyake offered wholly new possibilities for dress that celebrate the vitality and movement of the human body. As timeless as the paper lanterns of countless summer parties around the world, this dress sways in counterpoint to the movement of the wearer. The almost weightless rolling discs can be compressed or extended for wear and flattened completely for packing.

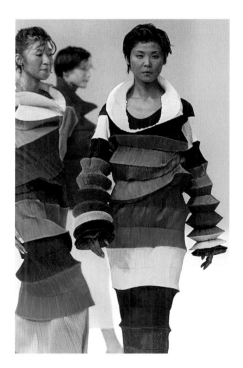

Models wearing Issey Miyake's designs at the Paris showing of his 1994 Spring/Summer Ready-to-Wear Fashion Collection.

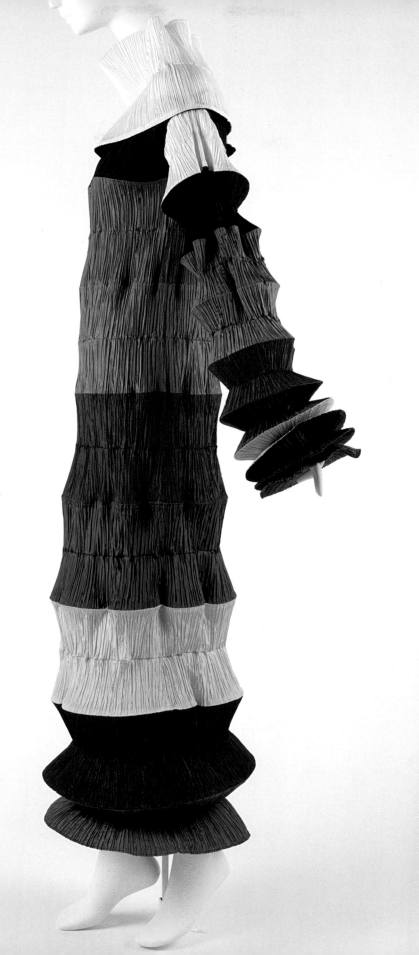

"Staircase" Dress
Fall/Winter 1994–95

Issey Miyake, Japanese, b. 1938

In the mid-1970s, Issey Miyake inaugurated his APOC, or "A Piece of Cloth," concept for apparel design. By the 1990s, many of his garments took on increasingly bold geometries on the body while still asserting the planarity of their pattern pieces. Of his signature pleated polyester works, the "Staircase" dress is particularly representative of Miyake's fascination with the sculptural possibilities of cloth. Even with the ziggurat-like form of the dress, the designer underscores the essential flatness of each of the four panels that constitute the body of the garment by exploiting the pleated structure of the cloth to flute and furl like paper.

Women's Wear Daily noted in its positive review of the collection, "The fact that no one's going to be wearing pleated pyramids with precision-cut staircases up each side goes without saying." Clearly, the fashion daily did not consider the likes of Muriel Kallis Newman, the noted collector of Abstract Expressionist art, who wore this piece with great panache to one of The Costume Institute's opening events.

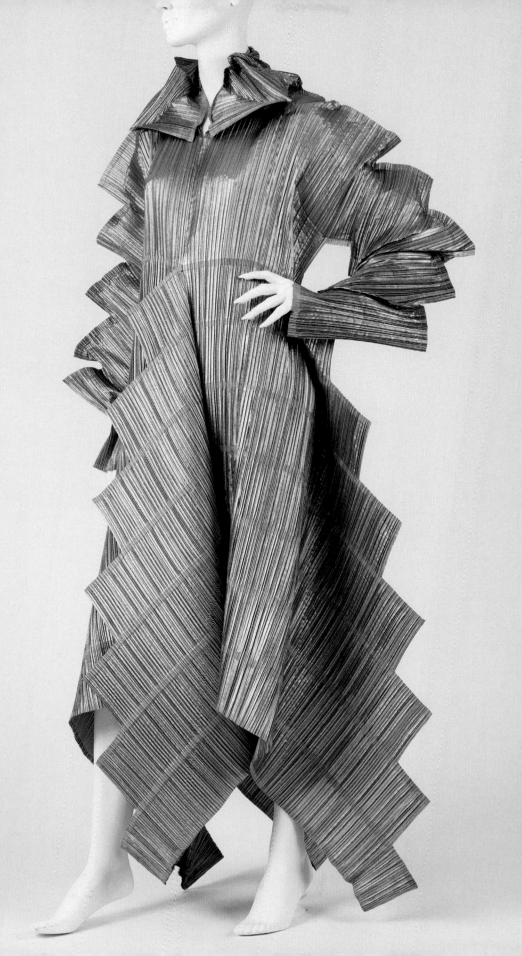

Evening Gown
Spring/Summer 1996
Gianni Versace, Italian, 1946–1997

Gianni Versace's love of classical themes is evident in the Medusa-head logo that established his atelier's identity. In Versace's imagination, classical dress was an opportunity for body-revealing drape and incandescent effects.

The silver satin of the gown shown here sheathes the torso, then opens up to fanning pleats at the skirt. Inserts of silver gauze, with iridescent paillettes and crystal beads densely embroidered at their crest, waft over the wearer's legs in a wavelike undulation, opening the gown and exposing the body beneath. In repose, the satin pleats endow the wearer with a columnar dignity, but in motion, the disclosure of the body and the liquid drift of the sheer fabric suggest Venus emerging from the sea.

Gianni Versace at his home in Miami, Florida, in 1996.

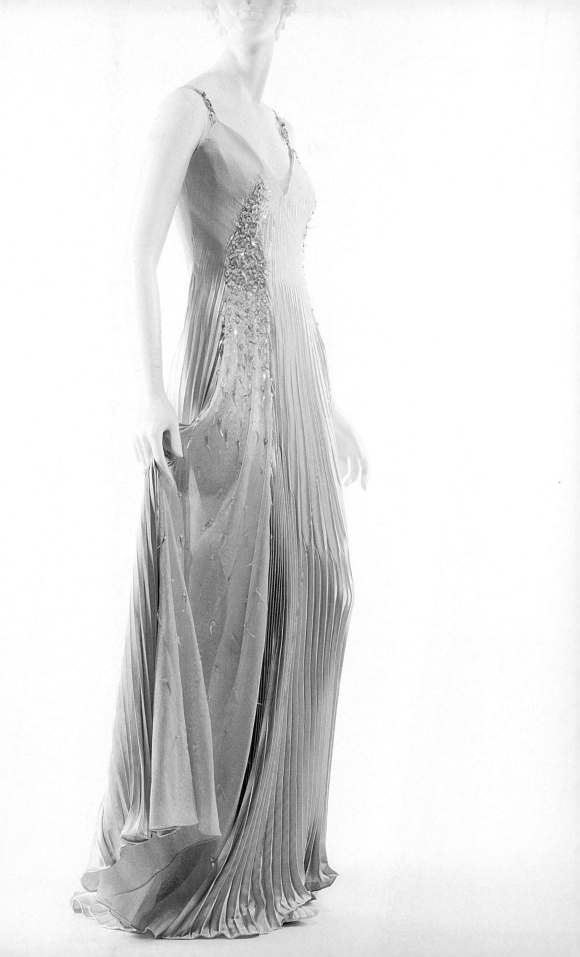

Evening Ensemble
1996–97

Gucci, Italian, founded 1906
Tom Ford, American, b. 1961, designer

The marketing genius and creative vision of Tom Ford, named head designer at Gucci in 1994, have helped the company prevail in the luxury goods market. Ford revived signature Gucci handbag lines featuring the now iconic double-G logo fabric and the exquisite bamboo handle, but he also catalyzed a new image for Gucci by producing couture-quality garments that find classical or historical referents in their construction and silhouette. This slinky jersey gown, designed with more than a nod to Halston, also suggests the strong influence of the 1930s, first of Paris styles and then of Hollywood versions, while the cutouts on the torso at the sides and midriff exemplify the raw sex appeal that has become linked to Ford's aesthetic.

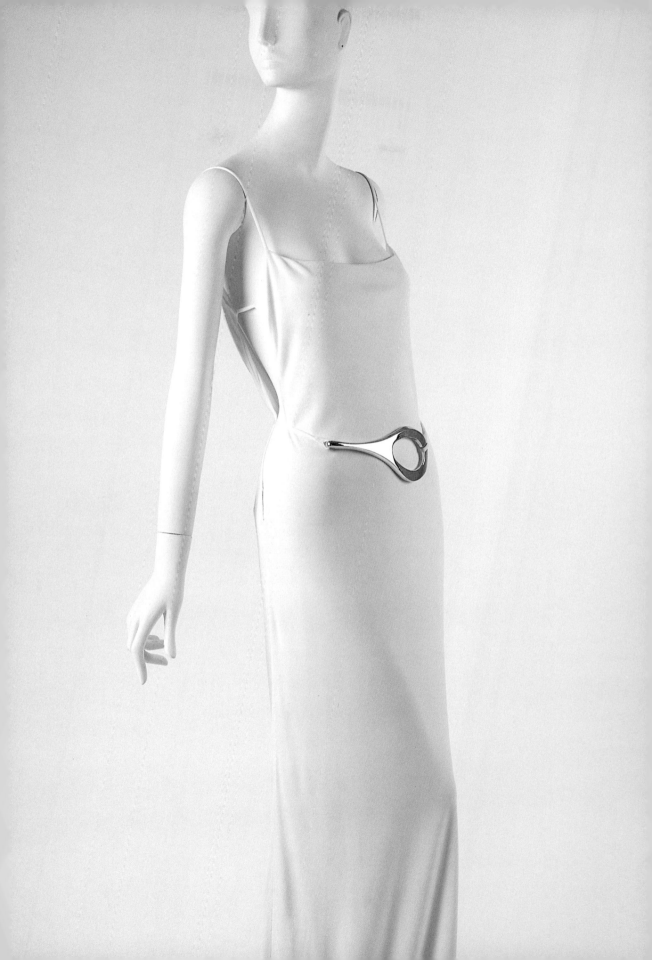

Dress
Fall/Winter 1996–97

John Galliano, British, b. Gibraltar, 1960

For his fall/winter 1996–97 collection, John Galliano cited the Native American as his inspiration. Setting his *défilé,* or runway presentation, at the Polo de Paris riding stable with bales of hay, strewn feathers, oil barrels, old tires, and a Cadillac bumper with Wyoming plates sticking up from the soil established the mood for his models, who wore war paint instead of blush. "Could you get any further from what Paris Fashion Week was expecting . . . ?" said Galliano. "It was a mix of the Duchess of Windsor meets the Hopi Indians!" For this and other dresses in the collection, Galliano took the idea of deerskin suede garments and applied laser cutting to create what *Women's Wear Daily* called "suede string shimmy dresses."

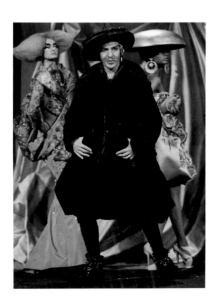

John Galliano's fashion presentations, such as this 2008 show, are typically theatrical extravaganzas, and his themes are often wild syntheses of anachronistic juxtapositions and geographically conflated narratives.

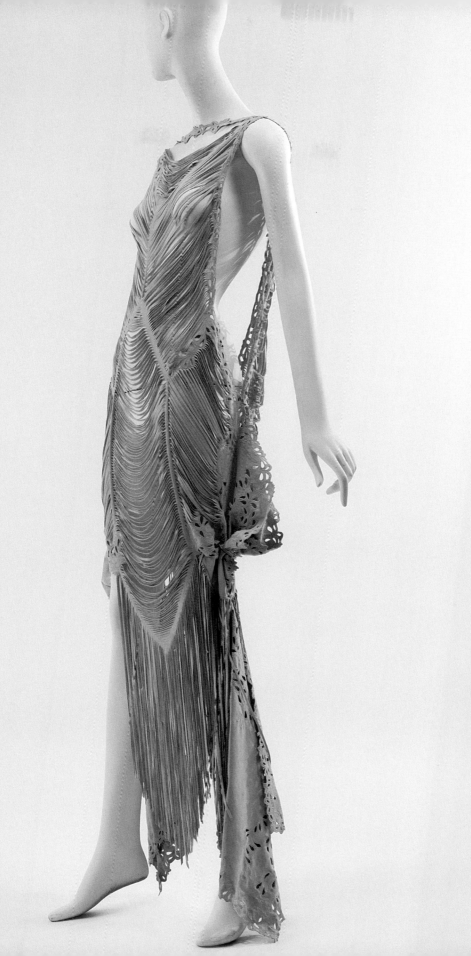

"Maria-Luisa (dite Coré)" Gown
Spring/Summer 1998

House of Dior, French, founded 1947
John Galliano, British, b. Gibraltar, 1960, designer

The wide-skirted eighteenth-century *robe à la française* had a decorative bodice insert called a stomacher and an underskirt, or petticoat, showing beneath the splayed drapery of the overskirt. In the 1830s, skirts achieved a fashionable bell-shaped volume through a layering of petticoats. By the 1850s, wired hoops connected by canvas tapes allowed for a previously unattainable volume, which by the 1860s, had reached breathtaking proportions. In 1998, John Galliano combined the stomacher of the *robe à la française* with the crinolined silhouette of the mid-1800s to create a ball gown with a skirt nine feet wide and a train that extends it even farther.

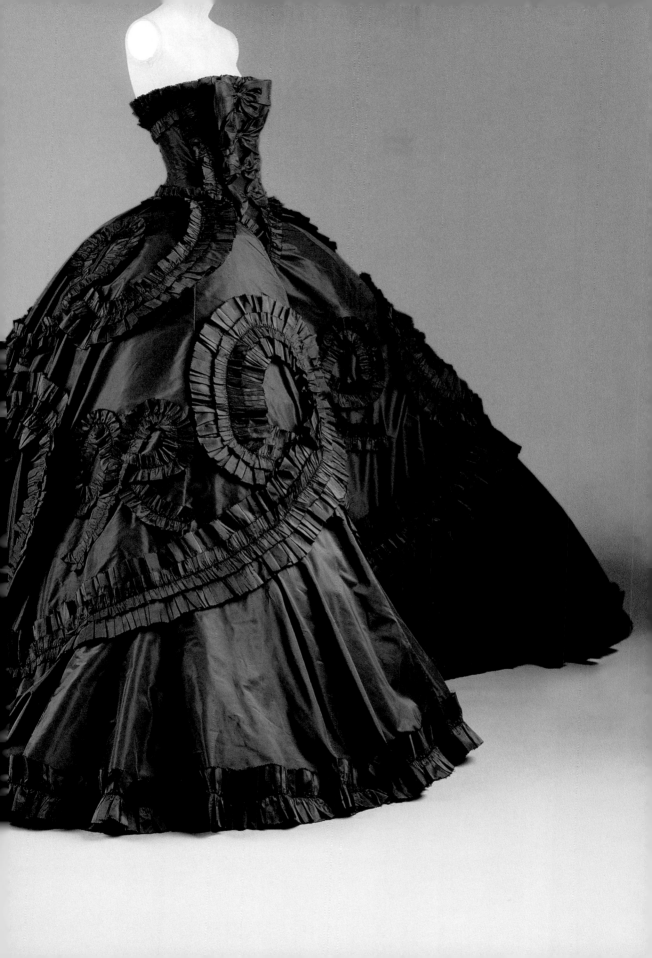

Evening Gown
Spring/Summer 1999

Gianni Versace, Italian, founded 1978
Donatella Versace, Italian, b. 1955, designer

Worn by Madonna at the "Fire and Ice Ball," a charity event featuring Donatella Versace and her spring/summer 1999 collection, the Punk- and Goth-inspired leather evening gown introduces provocative fissured seaming and a spiraling revelation of the body. Most important, Donatella Versace has taken one of her brother's signatures—the dress with zones of see-through plastic—and expanded it into a more extravagant creation of her own.

Madonna, wearing the Donatella Versace gown, poses for a photograph with the designer at the December 1998 "Fire and Ice Ball" in Los Angeles.

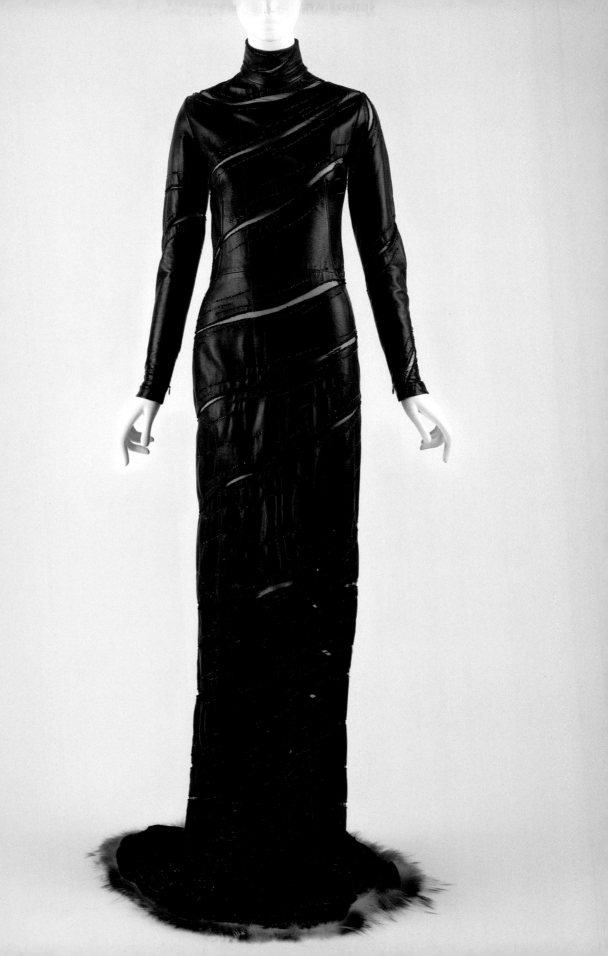

Evening Gown
Spring/Summer 2000

House of Dior, French, founded 1947
John Galliano, British, b. Gibraltar, 1960, designer

In this gown from John Galliano's "Hobo" collection, extravagant, changeable silk taffeta is whipped into a spiraling vortex. The naturally stiff "hand" of taffeta and the virtuosity of the Dior atelier contribute to this illusion of fabric come to life. From neckline to train, four parallel panels, each longer than the next, are angled into a body-conforming bias recalling the aerodynamic sleekness of the 1930s.

Over the years, whether his references have been to *les Merveilleuses* of the late eighteenth century, the courtesans of the Belle Époque, or the sophisticates of between-the-wars café society, Galliano has consistently assimilated the styles and sensibilities of the past into convincing contemporary glamour. While his creations are generally apolitical and ahistorical—the result of an intuitive, primarily visual synthesis—an implicit social critique may be read in this confection of haute couture, inspired by the rag-swaddled image of a Parisian tramp.

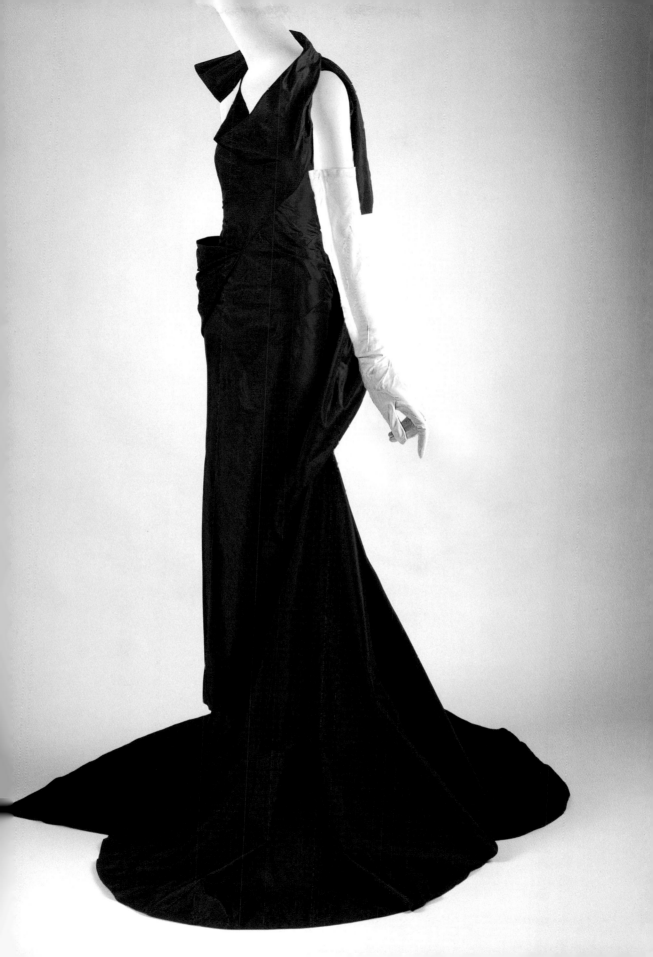

"Airplane" Dress
Spring/Summer 2000 (remade 2006)

Hussein Chalayan, British, b. Cyprus, 1970

Hussein Chalayan's collections are an articulation of his immediate conceptual and philosophical preoccupations as well as his fascination with materials and techniques as they might be applied to his métier. His extraordinary intellectual rigor is supported by an equally vigorous pursuit of perfected technique.

Chalayan called the "Airplane" dress one of his "monuments"—designs in which he explored ideas about the relationship between nature, culture, and technology. Like the original dress, the edition in The Costume Institute's collection is made of a composite material created from fiberglass and resin cast in a specially designed mold. Also like the original, it has side and rear flaps that open to reveal a mass of frothy pink tulle. While the flaps in the Museum's model are operated manually, the flaps in the original version were operated by remote control. In Chalayan's words, "The idea of directing living beings with a simple remote-control system was a lighthearted hint at the human tendency to want to control life as well as our sometimes exaggerated expectations of technology."

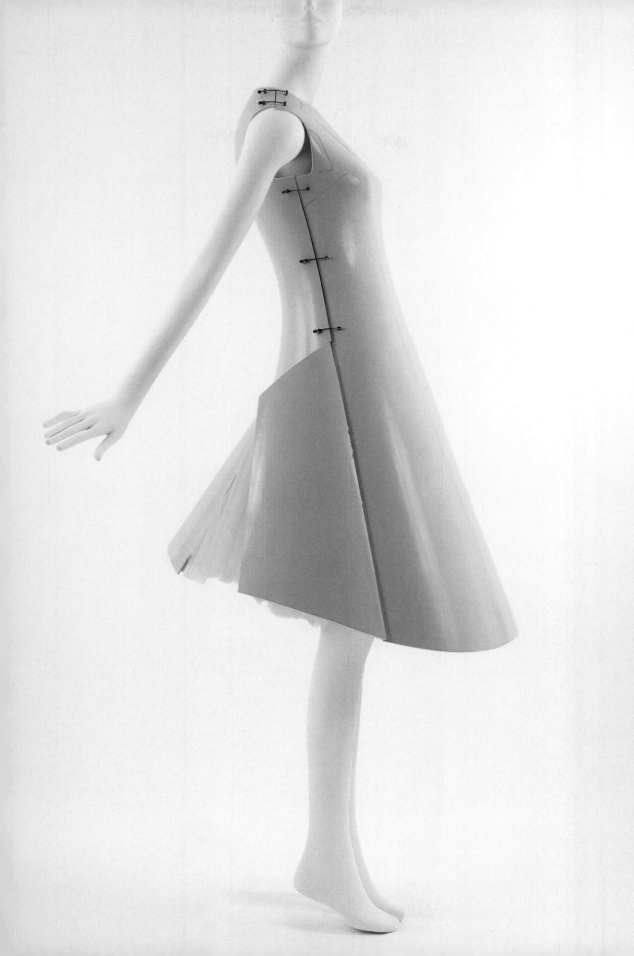

Wedding Dress
Spring/Summer 2000

Yohji Yamamoto, Japanese, b. 1943

This unconventional wedding dress concluded a presentation by Yohji Yamamoto that, according to Robin Givhan of the *Washington Post*, "pushed one to think about construction." Right from the first model's muslin sheath decorated solely with dressmaker's marks, Yamamoto sought to establish his interest in the fundamental principles of dressmaking.

The details of creating a toile, or sample in muslin, from which the final pattern for a garment is taken, is made especially legible in the designer's use of inexpensive cotton. The large basting seam stitches in natural, black, and red thread that establish the grain lines of the cloth, the spiraling of the fabric indicating the draper's process, and the control of fullness through the use of tucks and darts evoke a work in progress. Fusing brash, hasty underpinnings with couture detail, Yamamoto created a garment that is at once modern and traditionally elegant.

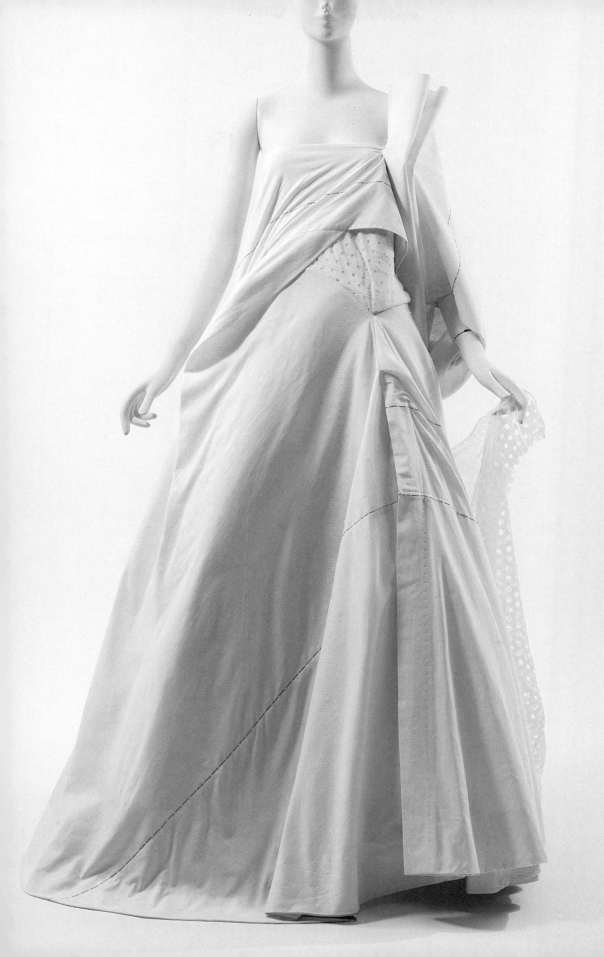

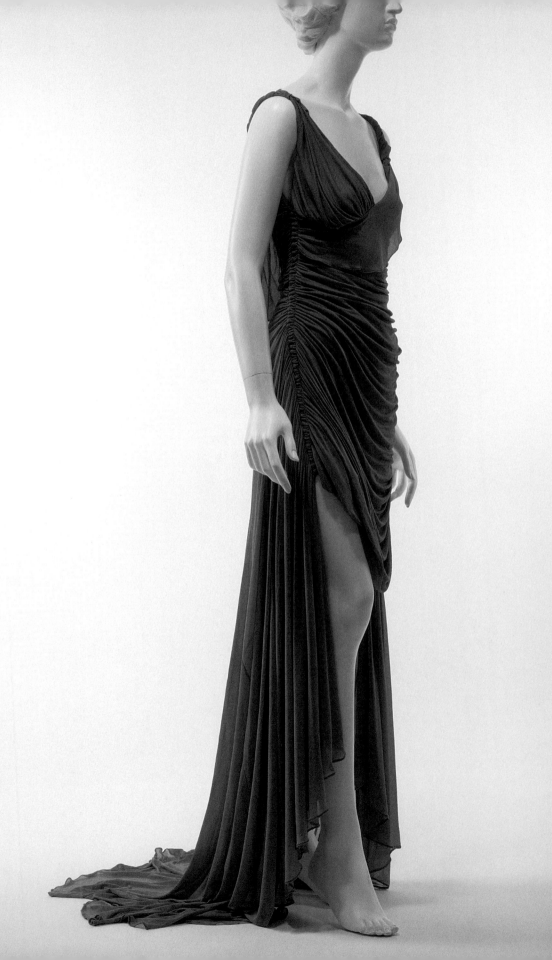

Dress
Spring/Summer 2003

Gucci, Italian, founded 1906
Tom Ford, American, b. 1961, designer

T oday's ideas of classical dress are based on the original treatments of antique models, the adaptation of early methods to twentieth-century forms, and, in this example, the mythic iconography that accrued to the original styles over time by artistic convention. The body-exposing drape of Tom Ford's gown is easily associated with Aphrodite, the goddess of love and beauty.

Well versed in contemporary art and architecture, Ford takes his cue from deconstructivist theory, revealing the intrinsic components of the garment's making: narrow cords like Grecian harnesses and bands of fabric draped, rather than shaped by cutting, to fit the contours of the body. This piece is an important example of neoclassicism in early twenty-first century clothing and a nod to the timeless design sensibility of Ford as Gucci's head designer.

"Oyster" Dress
Spring/Summer 2003

Alexander McQueen, British, 1969–2010

One of the most conceptual fashion designers of the early twenty-first century, Alexander McQueen is celebrated for his love of tactile exploration and dramatic visual representations. The premise of his spring/summer 2003 presentation was a shipwreck at sea and a consequent landfall in the Amazon. *Women's Wear Daily* lauded McQueen for his designs, noting, "Fabulous though this presentation was, the clothes are better up close, revealing a mind-boggling degree of creativity and work."

Attached to a beautifully fitted and boned corset, the voluminous skirt of the "Oyster" dress is composed of hundreds of graduated layers of ivory silk organza. The resulting *mille-feuille* ridging and the wavy hemline impart a seashell quality to the dress. But unlike the pristine scallop that bore Aphrodite to shore, McQueen's dress, with its unfinished edges and trailing piecework, is a deconstructing oyster, the tumbled survivor of the violent action of the waves.

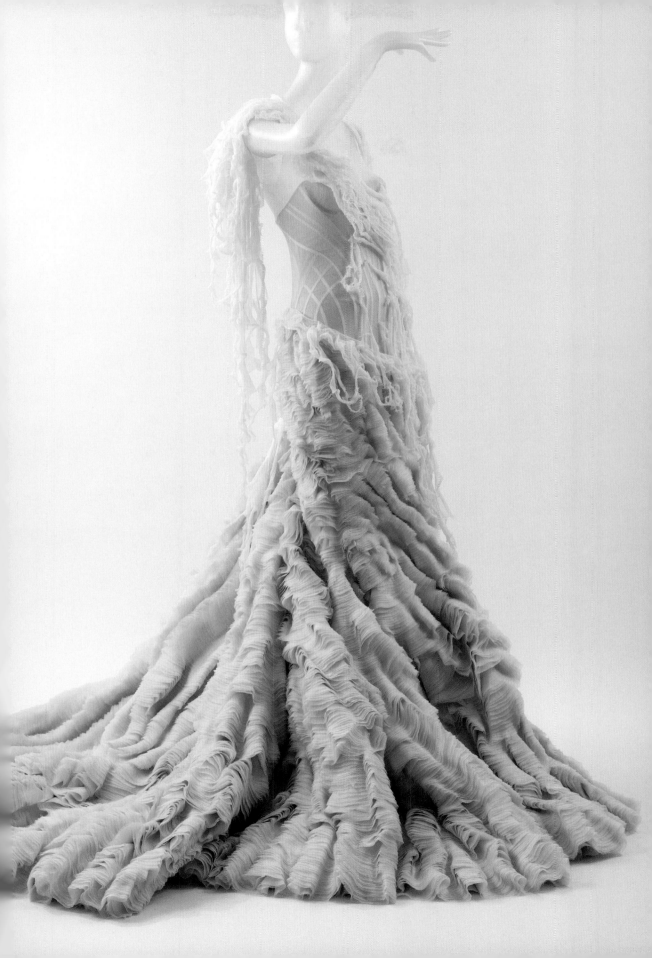

Dress
Spring/Summer 2005

Yohji Yamamoto, Japanese, b. 1943

When asked about the inspiration for his beautifully pleated gowns, Yohji Yamamoto replied equivocally, "Maybe Madame Grès—maybe." Over the last twenty years, Yamamoto has moved from a style characterized by a radical upending of the conventions of Western dress, both in his aesthetics and in his construction techniques, to a quieter, contemplative questioning of the great traditions of fashionable attire. Clearly, his research into the masters of twentieth-century couture dressmaking and bespoke tailoring has informed his astonishing recent collections, which are at once historicizing and avant-garde.

This pleated gown both honors and advances the work of Grès. While the technique reprises the approach evolved by the iconic couturiere, Yamamoto introduces three-dimensionality to the pleated relief of the silk, which was rare in designs by Grès.

At the neckline, Yohji Yamamoto alludes to nature in his pairing of pleated donutlike shapes that recall sea anemones in retraction or coral formations.

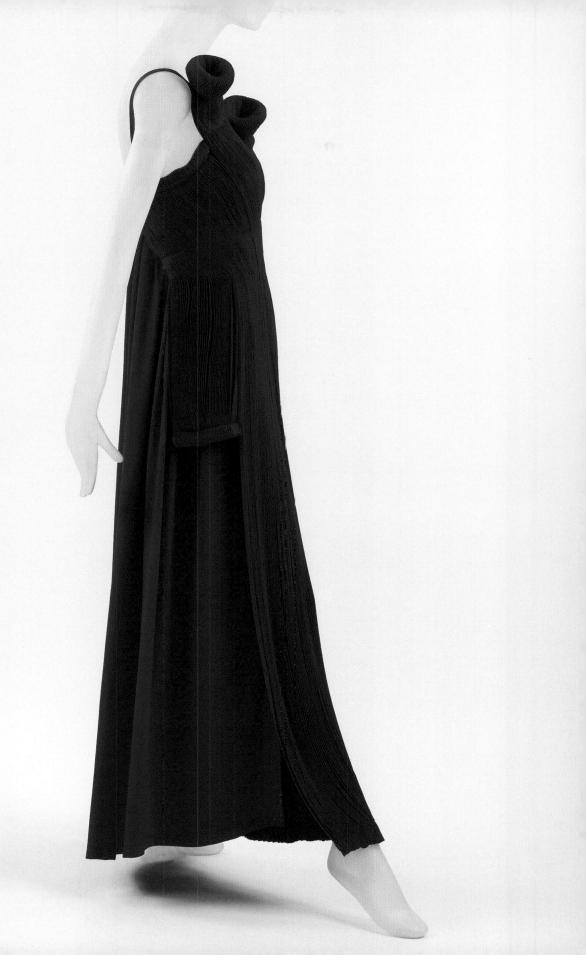

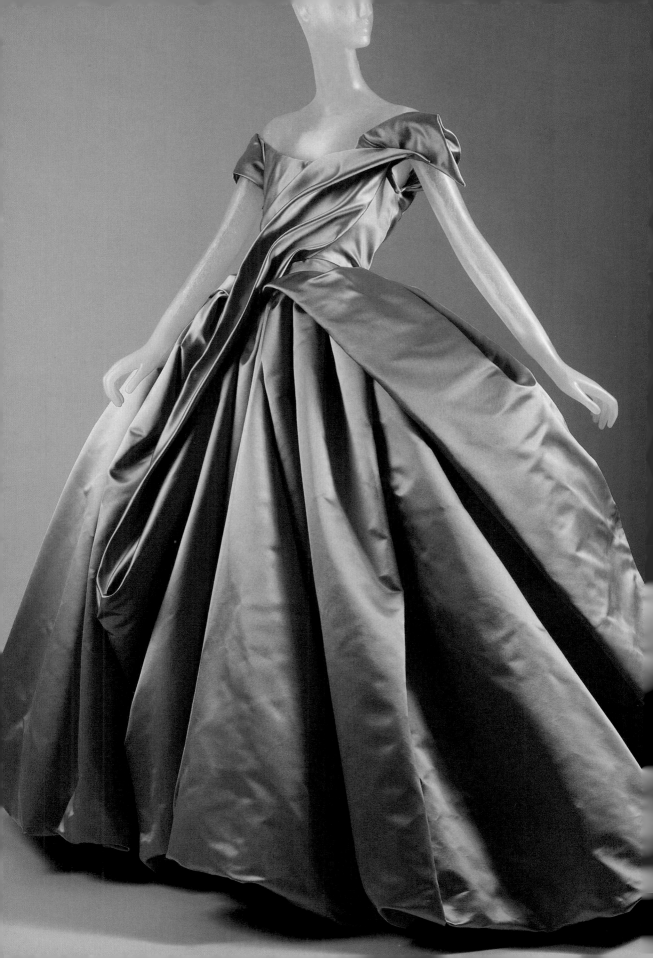

"Propaganda" Dress
Fall/Winter 2005–06

Vivienne Westwood, British, b. 1941

Vivienne Westwood revels in incendiary provocation and a defiance of convention but nonetheless finds beauty and inspiration in the past. Thus it is not surprising that the designer so associated with Punk rock, torn T-shirts, and bondage jackets 's also capable of creating rigorous examples of tailoring and dressmaking.

An aesthetic marvel, the "Propaganda" dress has been draped, fitted, and spiraled around the body in one unbroken length. While the gown evokes French haute couture of the 1950s, Westwood imbues it with an element of subversion in her break with prior conventions of draping and dressmaking.

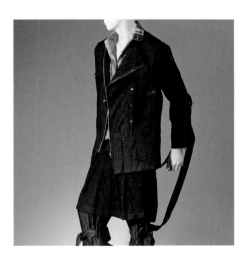

An example of Vivienne Westwood's early work is this 1970s "Bondage" suit—one of the most iconic garments of Punk style—designed in collaboration with her partner at the time, Malcolm McClaren (British, 1946–2010).

"Creation" Ensemble
Fall/Winter 2005–06

House of Dior, French, founded 1947
John Galliano, British, b. Gibraltar, 1960, designer

John Galliano's "Creation" looks like a garment in the process of becoming. The muslin bodice suggests tailors' forms, while layers of fabric attached provisionally to the corset suggest the initial stages of the design process. Traditionally hidden interior details, such as grosgrain waist tapes, bust pads, and tulle underskirts, are exposed, transforming structure into ornament. Galliano's shifting of a padded bra cup from the bust to the hip is an ironic reference to Dior's 1950s "New Look" silhouette, which relied on the padding of the bust and hips, as well as on the cinching of the waist, for its pronounced curvilinear silhouette.

In a Surrealist displacement, the humble pincushion worn by fitters is transfigured into a bracelet when Galliano's creation is worn on the runway.

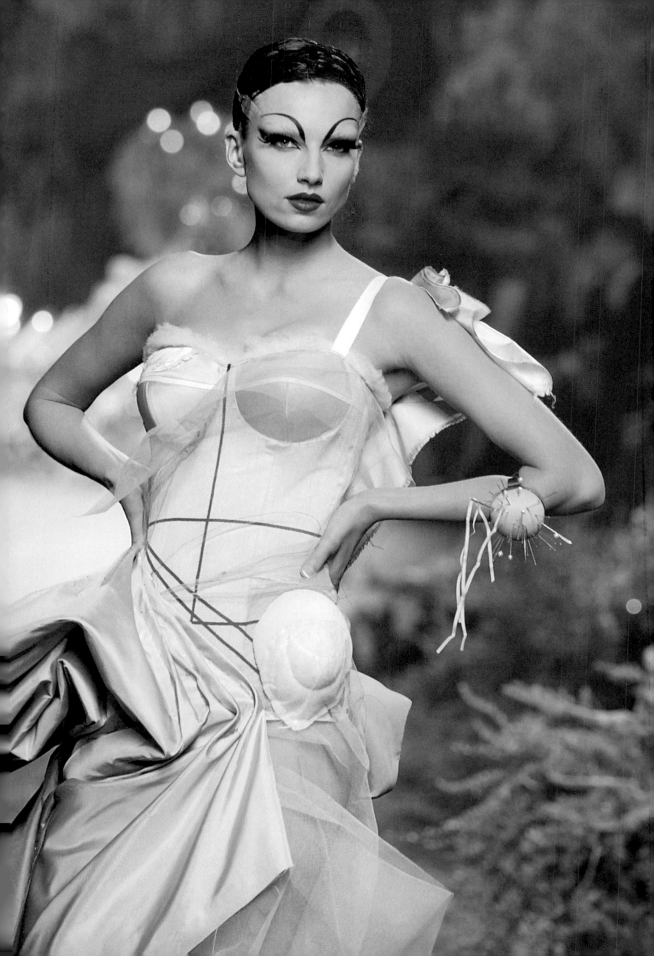

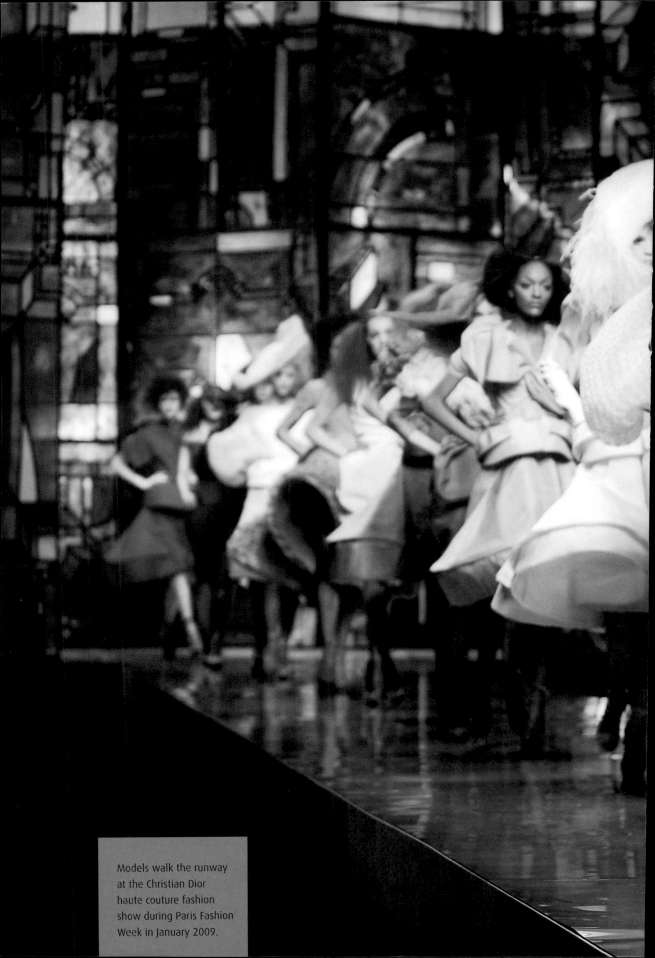

Models walk the runway at the Christian Dior haute couture fashion show during Paris Fashion Week in January 2009.

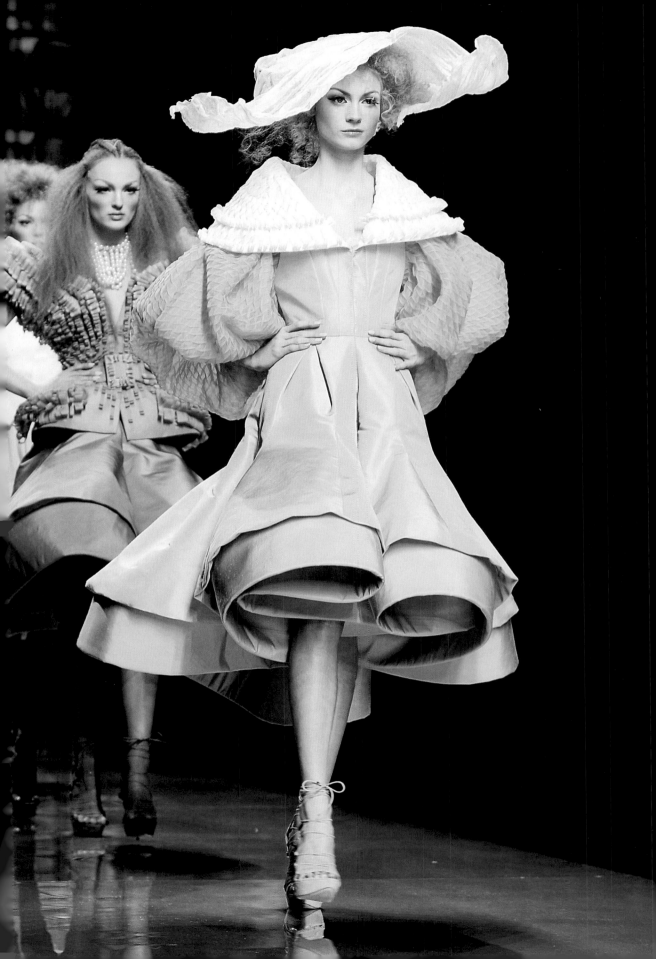

Glossary

A

à la disposition: The weaving of fabric in predetermined pattern shapes that will each become a specific part of a costume, thereby making the design of the fabric intrinsic to the design of the finished clothing

appliqué: To cut out fabric pieces and sew them to a larger piece of material for decoration; also, the individual cutout fabric pieces

B

bespoke: Custom-made, made to order

bias: A diagonal line cut across the grain of a fabric, particularly a line that crosses the fabric at a forty-five degree angle to the selvedge, which introduces greater elasticity to the drape of a fabric

bolero: A waist- or rib-length, open-fronted jacket

bone: A strip of sturdy material (formerly whalebone, now usually metal or plastic) used to stiffen or shape a garment such as a corset, petticoat, or strapless gown

bowknot: A decorative knot tied in a bow

brocade: A textile of any material woven with a raised pattern that is not reversible

bustle: A protruding support structure worn at waist level under the back of a skirt or dress in the late nineteenth century. Bustles were usually fabric-covered padded cushions or basketlike tubes of cane, wire, or whalebone attached to a waistband. Also describes the silhouette that results from the wearing of this structure.

C

changeant: A changeable effect attained by using threads of different colors in the warp and weft

chemise: Historically, a woman's undergarment usually made of linen or muslin; also, in the early nineteenth and twentieth centuries, a loose dress with a generally columnar silhouette

chiffon: A sheer, lightweight fabric woven with tightly twisted or crêped yarns, usually silk but also can be of polyester

chiton: In ancient Greece, the open-sided tunic worn by men in a knee-length form and by both men and women in a floor-length version. Constructed of two large rectangles of linen, cotton, or wool, the chiton was seamed at the sides and hung in folds from the shoulders where it was pinned together with fibulae

chlamys: A short cloak, or mantle, worn by men in ancient Greece

crêpe: Describes a wide variety of fabrics woven of highly twisted yarns to produce a crinkled or pebbled surface

crêpe de chine: A very fine, lightweight silk crêpe fabric

crinoline: A stiff fabric originally woven of horsehair and linen and used to support a skirt or dress; also called a petticoat or a cage crinoline (hoopskirt), an underskirt frame made with whalebone, cane, or steel hoops

D

damask: A reversible fabric woven with a flat pattern

dart: A tapering, stitched-down fold intended to give shape and fit to a garment

défilé: A procession, as of runway models in a fashion show, or défilé de mode

drawnwork: Decorative needlework that involves removing some threads from a fabric and stitching the remaining threads to form an openwork pattern

E

embroidery: Decorative needlework

F

faille: Closely woven cotton, rayon, or silk fabric with a slight ribbing in the weft threads

fashion plate: An illustration of a fashionable clothing style; also, a person who always wears the latest fashions

fibulae: In ancient Greece, broochlike pins or clasps that were used at the shoulders of the peplos and chiton to attach the back to the front and form the neckline and armholes

fichu: A lightweight muslin scarf, either triangular or square and folded into a triangular shape, that is draped over the shoulders and fastened at the front or tucked into the top of the bodice to fill in a low neckline

G

georgette: A thin, lightweight silk crêpe fabric

gigot: A sleeve that is puffed out along the upper arm and fitted from elbow to wrist. A style fashionable in the 1830s and 1890s, it was sometimes worn with a sleeve support (cotton- or down-filled pillows or fabric-covered ribs of whalebone, cane, or wire) for the upper arm. Also called a leg-of-mutton sleeve.

gore: A triangular or tapering panel of cloth inserted into a skirt or other garment, to add fullness at the bottom

grosgrain: A strong, closely woven ribbon with a ribbed, or corded, appearance

H

hand: The feel of a fabric

himation: The wide rectangular wool or linen mantle worn by both men and women in ancient Greece

I

ikat (Malay): A technique in which yarns are tie-dyed before weaving, creating a blurred pattern

J

jersey: A soft, stretchy knit fabric

L

la garçonne: The feminine archetype of modernism as seen in the boyish silhouette that appeared in the 1920s and was most notably embodied in the "flapper" dress

lamé: A fabric woven with metallic threads, usually silver or gold

leg-of-mutton sleeve: See gigot

leno weave: A type of open weave in which two or more warp threads cross over each other, locking the weft threads in position to create a sheer yet strong fabric

les Merveilleuses: The name for ultrafashionable women in the last few years of the eighteenth century; their male counterparts were called *les Incroyables*

M

mantua: A type of open robe dress first introduced in the late seventeenth century as an alternative to the heavily structured dress required for attendance in the court of Louis XIV. The mantua was split in front, to be worn over an exposed petticoat, with a fitted bodice and elbow-length sleeves; later, as it became a more formal gown, a stomacher was added.

mille-feuille: The French term for 1,000 leaves or sheets of paper

moiré: A finishing technique that gives fabric a lustrous water pattern

monobosom: Aspect of the S-curve silhouette popular during the early twentieth century that was achieved by wearing a lightly boned bust bodice over the corset to create a pouch from the bosom to the waist; also known as "pouter pigeon"

mull: Soft, lightweight cotton in leno weave

N

"New Look": A term applied by the American press to the designs featuring wasp waists, hip pads, and full skirts that were first presented by Christian Dior in 1947. Later, the term was also applied to the fashionable Dior posture, which was slightly hunched, with the back curved, the buttocks tucked under, and the pelvis pushed forward.

O

ombré: An effect produced by the use of colors that are graduated in tone from light to dark

open robe: Description of a dress with an overskirt that opens in front to reveal the petticoat, or underskirt

organza: A lightweight fabric that is sheer yet crisp, and is made from silk or synthetic yarns

P

paillette: A usually round spangle of metal or plastic, larger than a sequin, used to trim fabric

pannier: An oblong cage made of cane, metal, or wood to support the sides of the skirt, creating a silhouette that was extended at the hips but flattened in front and back. Panniers first appeared in France in 1718 and persisted with minor variations until the 1780s.

passementerie: Corded dress trimmings of braids, fringe, tassels, etc.

pelerine: A short cape that emphasized the triangular silhouette of the upper body fashionable during the 1830s. Fichu-pelerines had long, tapering ends that could be tied in the front or crossed in the front and tied in the back.

pentimenti: The visible traces in a drawing or painting of a design that has been altered and covered over

peplos: In ancient Greece, a garment that was formed by folding a large rectangular piece of cloth in half to form a cylinder (which was usually sewn closed) and then folding down a second time along the top to form an overfold. Fibulae were used to attach the back to the front of the garment at the shoulders, forming the neckline and armholes of the peplos.

peplum: A short, flared section of fabric extending from the waistline of a bodice or jacket

petites mains: Artisans or artisanal workshops that specialize in handwork, such as embroidery and lace making

picot: A decorative edging of small loops along the selvedge of fabric or lace; also a similar finished edge of cut fabric

piecing: Stitching separate pieces together to make a whole

piping: Fabric-covered cord sewn into seams or along edges for added strength or decoration

piqué: A tightly woven cotton, rayon, or silk fabric with a ribbed waffle pattern

plastron: Decorative panel set into the front of a bodice; see *stomacher*

princess-seam dress: A dress with a close-fitting, vertically seamed bodice unbroken by a waist seam, and a flaring skirt

R

robe à l'anglaise: An open robe of the eighteenth century that consisted of a fitted bodice cut in one piece with a rounded overskirt that was parted in front to reveal a matching petticoat

robe à la française: An eighteenth-century robe with a fitted bodice open at the front to reveal a stomacher and an overskirt parted in the front to reveal a matching petticoat. The back of the robe typically had two double box pleats sewn in at the center of the neckline and falling to the hem. The skirts of the most formal robes were supported by panniers that eventually reached widths of several feet.

robe à la polonaise: A late eighteenth-century robe with a close-fitting bodice and a skirt. The back of the skirt would be gathered up into three puffed sections by the use of ribbon ties or cords, which could be adjusted to achieve different looks.

robe de style: Credited to Jeanne Lanvin, this 1920s style featured a chemiselike bodice, dropped waist, and a wide, pannier-supported, ankle-length skirt

robe volante: An early eighteenth-century robe, worn without an underskirt, with elbow-length sleeves ending in wing cuffs and in the back, two double box pleats that spread out in a widening flow from neckline to hem

rouleau: A roll made by looping a long, narrow strip of fabric around itself or around cording or another tubular shape

S

sack dress: An unfitted dress that hangs straight from shoulders to hem, or more generally, a loose-fitting dress or gown

satin: A fabric with a smooth, lustrous surface on one side

seaming: To join together by sewing

selvedge: Either of the lengthwise loom-finished woven edges of a fabric

serge: A sturdy wool twill suiting fabric

shantung: Fabric with a slubbed irregular surface resulting from the use of yarn with uneven diameters, originally made from wild silk

sheath: A close-fitting dress

shirr: To gather fabric into tight parallel rows, secured by parallel stitching

side drape: A length of fabric gathered and draped at one side of a garment

soutache: A narrow, generally flat, decorative braid

stays: Historically, a corset; also the boning used to stiffen a corset

stomacher: A decorative, triangular bodice insert that covered the corset

T

taffeta: A crisp plain-weave fabric with a smooth, lustrous surface

tent dress: A loose-fitting dress that hangs from the shoulders and gradually widens toward the hem

toile: A muslin mock-up of a garment that is used to test fit and create a pattern

trapeze: A dress that continuously widens from narrow shoulders to hem, resulting in a conelike silhouette

trapunto: Decorative quilting that creates a raised effect

tremblant: Trembling or fluttering

tuck: A small stitched fold that is used to shape or decorate fabric

tulle: A fine, lightweight netting that may be left soft or starched

tunic: A columnar over-the-hip, slip-on overblouse, dress, or jacket

tussah: A coarse, irregular silk fabric made from wild silkworm; also refers to the yarn itself

V

velvet: A soft fabric with a short, densely woven cut pile

W

waistcoat: Contemporarily referred to as a vest, the waistcoat first appeared toward the end of the 1660s. In England, King Charles II exploited the waistcoat for its decorative possibilities, and the garment soon became a focus of men's dress, often richly embellished and made from the finest materials.

warp: The threads that make up the lengthwise grain in a woven fabric

warp printing: The process of printing a pattern onto the warp threads prior to weaving

Watteau-back: The center box pleats, such as those in a *robe à la française*, that flow unbroken down the back of a dress from the neckline to the hem, as seen in certain paintings by Jean Antoine Watteau (French, 1684–1721)

weft: The threads that are set at a 90-degree angle to the warp threads in a woven fabric and run from selvedge to selvedge

wet-drapery: A term used to describe cloth that appears to cling to the body in animated folds while revealing the contours of the form beneath, particularly evident in Greek sculpture from the Hellenistic period (ca. 323–31 BC)

wing cuffs: Cuffs folded back with points pressed to stick out so the cuffs resemble "wings"

Credits

FRONT COVER AND TITLE PAGE DETAIL:
"Propaganda" Dress
Vivienne Westwood, British, b. 1941
Silk satin, Fall/Winter 2005–06
Purchase, Friends of The Costume Institute Gifts, 2006
2006.197a–d

BACK COVER:
Dovima wearing Molyneux Evening Dress (C.I.42.33.3) (detail),
February 1953
Cecil Beaton, British, 1904–1980
Photograph: Sotheby's Picture Library/Cecil Beaton Studio Archive

PAGE 4:
Evening Dress (detail)
Attributed to House of Chanel, French, founded 1913;
Gabrielle "Coco" Chanel, French, 1883–1971, designer
Silk, metallic thread, sequins, ca. 1926–27
Gift of Mrs. Georges Gudefin, in memory of Mrs. Clarence Herter,
1965 C.I.65.47.2a,b

PAGE 7:
Evening Ensemble (detail)
Maisons Agnès-Drecoll, French, 1931–1963
Wool, silk, coral, silver, rhinestones, ca. 1936
Gift of Miss Julia P. Wightman, 1990 1990.104.11a–c

PAGES 8–9:
Mantua
British, late 17th century
Wool, metal thread
Rogers Fund, 1933 33.54a,b

PAGE 10:
The Garter
Jean François de Troy, French, 1679–1752
Oil on canvas, 25¼ x 21⅛6 in., 1724
PRIVATE COLLECTION, New York

PAGES 10–11:
Robe Volante
French, 1735–40
Silk, flax
Gift of Mary Tavener Holmes, 1983 1983.399.1

PAGE 12:
Les Adieux
After Jean-Michel Moreau, called le Jeune, French, 1741–1814;
Robert Delaunay, French, 1749–1814, engraver
Etching and engraving plate from *Le Monument du Costume*,
17½ x 14⅛ in., 1777
Purchase, 1934 34.22.1

PAGES 12–13:
Court Dress (Robe à la française)
British, ca. 1750
Silk, metallic thread
Purchase, Irene Lewisohn Bequest, 1965 C.I.65.13.1a–c

PAGE 14:
Seamstresses' Workshop in Arles (L'Atelier de couture à Arles)
Antoine Raspal, French, 1738–1811
Oil on canvas, ca. 1760
MUSÉE RÉATTU, Arles, France
Photograph: Erich Lessing/Art Resource, New York

PAGES 14–15:
Robe à la française
French, 1760–70
Silk
Purchase, Irene Lewisohn Bequest, 1960 C.I.60.40.2a,b

PAGES 16–17:
Robe à l'anglaise
American, ca. 1775
Silk
Purchase, Irene Lewisohn Trust Gift, 1994 1994.406a–c

PAGES 18–19:
Robe à la polonaise
American, 1780–85
Silk
Gift of Heirs of Emily Kearny Rodgers Cowenhoven,
1970 1970.87a,b

PAGES 20–21:
Dress
European (probably), ca. 1798
Cotton, silk
Purchase, Irene Lewisohn and Alice L. Crowley Bequests, 1992
1992.119.1a–c

PAGES 22–23:
Evening Dress
French, 1804–05
Cotton
Purchase, Gifts in memory of Elizabeth N. Lawrence, 1983
1983.6.1

PAGE 23:
Madame Jerome Bonaparte (Elizabeth Patterson)
Attributed to Thomas Sully, American, 1783–1872,
after Gilbert Stuart, American, 1755–1828
Watercolor on ivory, 3¹³⁄₁₆ x 3½ in., ca. 1805–10
Purchase, Dodge Fund and funds from various donors, 2000
2000.359

PAGE 24:
Walking Dress
American, ca. 1835
Silk
Gift of Mrs. James Sullivan, in memory of Mrs. Luman Reed, 1926
26.250.1a,b

PAGE 25:
Susan Walker Morse (The Muse) (detail)
Samuel F. B. Morse, American, 1791–1872
Oil on canvas, 73¾ x 57⅝ in., ca. 1836–37
Bequest of Herbert L. Pratt, 1945 45.62.1

PAGES 26–27:
Ensemble
American or European, ca. 1855
Silk
Gift of James R. Creel IV and Mr. and Mrs. Lawrence G. Creel, 1992
1992.31.2a–c

PAGE 29:
Day Dress
American, ca. 1857
Silk
Gift of Lee Simonson, 1938 C.I.38.23.56

PAGES 30–31:
*Empress Eugénie, Surrounded by the Ladies of Her Court
(L'impératrice Eugénie entourée de ses dames d'honneur)* (detail)
Franz Xaver Winterhalter, German, 1805–1873
Oil on canvas, 9 ft. 10¼ in. x 13 ft. 9½ in., 1855
MUSÉE NATIONAL DU CHÂTEAU DE COMPIÈGNE, France
Photograph: Réunion des Musées Nationaux/Art Resource,
New York

PAGES 32–33:
Ball Gown
American, 1861–62
Silk
Gift of Russell Hunter, 1959 C.I.59.35.4a,b

PAGE 34:
Women in the Garden (Femmes au jardin) (detail)
Claude Monet, French, 1840–1926
Oil on canvas, 10¹⁄₁₆ x 8¹⁄₁₆, 1866
MUSÉE D'ORSAY, Paris
Photograph: Réunion des Musées Nationaux/Art Resource,
New York

PAGES 34–35:
Promenade Dress
American, 1862–64
Cotton
Gift of Chauncey Stillman, 1960 C.I.60.6.11a,b

PAGES 36–37:
At-Home Gown
American, 1876–78
Wool, silk
Gift of Mrs. Charles Edward Freet, 1939 C.I.39.68

PAGES 38–39:
Wedding Ensemble
American, 1880
Silk, leather
Gift of Mrs. H. Lyman Hooker, 1936 36.117a–e

PAGE 40:
Evening Gown
Attributed to Liberty of London, British, founded 1875
Silk, early 1880s
Purchase, Gifts from Various Donors, 1985 1985.155

PAGE 41:
Statue of Eirene (personification of Peace)
Roman (early Imperial, Julio-Claudian), AD 14–68, copy of a
bronze statue by Kephisodotos, Greek, 375/74–360/59 BC
Marble, H. 69¾ in.
Rogers Fund, 1906 06.311

PAGE 42:
The Bustle—1870s
Bernard Rudofsky, American (b. Austria), 1905–1988;
modeled by Costantino Nivola
Plaster, 28¼ x 8¼ x 11½ in., ca. 1944
BROOKLYN MUSEUM, New York
Gift of the artist 48.106.1
Photograph: Courtesy Brooklyn Museum

PAGE 43:
Evening Dress
American or European, ca. 1884–86
Silk
Gift of Mrs. J. Randall Creel IV, 1963 C.I.63.23.3a,b

PAGE 44:
Andrew and Louise Whitfield Carnegie, 1887
Photograph: Courtesy of the Carnegie Corporation of New York

PAGE 45:
Wedding Ensemble
Herman Rossberg, American, active 1880s
Wool, 1887
Gift of Mrs. James G. Flockhart, 1968 C.I.68.53.5a–h

PAGE 46:
Visiting Dress
American, ca. 1895
Silk
Purchase, Irene Lewisohn Bequest, 1981 1981.21.2a,b

PAGE 47:
"Nouveautés Parisiennes." January 1896
Reprinted in *Modes & Manners of the Nineteenth Century as
Represented in the Pictures and Engravings of the Time*
(London: J. M. Dent & Sons; New York: E. P. Dutton & Co., 1927)
Thomas J. Watson Library

PAGES 48–49:
Evening Dress
House of Worth, French, 1858–1956
Silk, 1898–1900
Gift of Miss Eva Drexel Dahlgren, 1976 1976.258.1a,b

PAGE 50:
Afternoon Dress
American, 1901
Cotton
Gift of Winifred Walker Lovejoy, in memory of Winifred Sprague
Walker Prosser, 1980 1980.590.1

PAGES 50–51:
*Winifred Sprague Walker Prosser wearing
Afternoon Dress* (1980.590.1)
Photograph, 13 x 9 in.
Gift of Winifred Walker Lovejoy, in memory of
Winifred Sprague Walker Prosser, 1980

PAGE 52:
Tea Leaves (detail)
William McGregor Paxton, American, 1869–1941
Oil on canvas, 36⅛ x 28¾ in., 1909
Gift of George A. Hearn, 1910 10.64.8

PAGE 53:
Dress
American, 1902–04
Cotton
Gift of Mrs. Oscar de la Renta, 1994 1994.192.18a–c

PAGES 54–55, 220:
Evening Gown
Callot Soeurs, French, 1895–1937
Cotton, silk, metal, 1910–14
The Jacqueline Loewe Fowler Costume Collection,
Gift of Jacqueline Loewe Fowler, 1981 1981.380.2

PAGE 57:
"Théâtre des Champs-Élysées" Gown
Paul Poiret, French, 1879–1944
Silk, leather, rhinestones, 1913
Purchase, The Paul D. Schurgot Foundation Inc. Gift, 2005
2005.193a–g

PAGE 58:
Raymond Duncan, Paris, ca. 1915–20
Photograph: Roger Viollet/Getty Images

PAGE 59:
Ensemble
Raymond Duncan, American, 1874–1966
Silk, 1920s
Isabel Shults Fund, 1990 1990.152

PAGE 61:
Evening Gown
House of Fortuny, Italian, founded 1906; Mariano Fortuny,
Italian (b. Spain), 1871–1949, designer
Silk, glass, 1920s
Gift of Estate of Lillian Gish, 1995 1995.28.6a,b

PAGE 63:
Afternoon Dress
Paul Poiret, French, 1879–1944
Silk, ca. 1923
Gift of Mrs. Muriel Draper, 1943 C.I.43.85.2a,b

PAGE 65:
"Irudrée" Evening Gown
Paul Poiret, French, 1879–1944
Silk, metal, ca. 1923
Purchase, Friends of The Costume Institute Gifts, 2007 2007.146

PAGES 66–67:
Twenties Glamour, London, 1925
Photograph: Getty Images

PAGE 68:
Jeanne Lanvin robe de style
Eduardo García Benito, Spanish, 1891–1962/*Vogue*;
© Condé Nast Publications

PAGE 69:
Robe de style
House of Lanvin, French, founded 1889; Jeanne Lanvin, French,
1867–1946, designer
Silk, metallic thread, glass, Spring/Summer 1924
Gift of Mrs. Albert Spaulding, 1962 C.I.62.58.1

PAGES 70–71:
Evening Dress
Attributed to House of Chanel, French, founded 1913;
Gabrielle "Coco" Chanel, French, 1883–1971, designer
Silk, metallic thread, sequins, ca. 1926–27
Gift of Mrs. Georges Gudefin, in memory of Mrs. Clarence Herter,
1965 C.I.65.47.2a,b

PAGES 72–73:
Dovima wearing Molyneux Evening Dress (C.I.42.33.3) (detail),
February 1953
Cecil Beaton, British, 1904–1980
Photograph: Sotheby's Picture Library/Cecil Beaton Studio Archive

Evening Dress
Edward Molyneux, French (b. Britain), 1891–1974
Silk, 1926–27
Gift of Mrs. Adam Gimbel, 1942 C.I.42.33.3

PAGES 74–75:
Day Ensemble
House of Chanel, French, founded 1913; Gabrielle "Coco" Chanel,
French, 1883–1971, designer
Silk, wool, ca. 1927
Isabel Shults Fund, 1984 1984.31a–c

PAGES 76–77:
Evening Dress
Louiseboulanger, French, 1878–1950
Silk, feathers, 1928
Gift of Mrs. Wolcott Blair, 1973 1973.6a,b

PAGES 78–79:
Court Presentation Ensemble
Boué Soeurs, French, 1899–1933
Silk, metallic threads, 1928
Gift of Mrs. George Henry O'Neil, 1968 C.I.68.48a–e

PAGE 81:
Cape and Dress
House of Patou, French, founded 1919; Jean Patou, French,
1887–1936, designer
Silk, ca. 1931
Gift of Madame Lilliana Teruzzi, 1972 1972.30.17a,b

PAGES 82–83:
Model wearing Madeleine Vionnet evening pajamas
George Hoyningen-Huene, American (b. Russia), 1900–1968/
Vogue; © Condé Nast Publications

PAGE 84:
Coco Chanel (detail)
Adolph de Meyer, American (b. France), 1868–1949
Gelatin silver print, 8¹¹⁄₁₆ x 7⅜ in., 1930s
Rogers Fund, 1974 1974.529

PAGE 85:
Evening Ensemble
House of Chanel, French, founded 1913; Gabrielle "Coco" Chanel,
French, 1883–1971, designer
Silk, feathers, 1933–35
Gift of Miss Isabel Shults, 1944 C.I.44.64.8a–c

PAGES 86–87:
Evening Ensemble
Maisons Agnès-Drecoll, French, 1931–1963
Wool, silk, coral, silver, rhinestones, ca. 1936
Gift of Miss Julia P. Wightman, 1990 1990.104.11a–c

PAGES 88–89:
Wedding Ensemble
Mainbocher, American, 1890–1976
Silk, leather, straw, coq feathers, 1937
Gift of the Duchess of Windsor, 1950 C.I.50.110a–j

The Duke and Duchess of Windsor, Chateau de Conde, Monts,
France, 1937
Photograph: Getty Images

PAGE 91:
Evening Dress
House of Chanel, French, founded 1913; Gabrielle "Coco" Chanel,
French, 1883–1971, designer
Silk, plastic, suede, glass, Fall/Winter 1938–39
Gift of Mrs. Harrison Williams, Lady Mendl, and Mrs. Ector Munn,
1946 C.I.46.4.7a–c

PAGES 92–93:
Evening Dress
Madeleine Vionnet, French, 1876–1975
Rayon, Spring/Summer 1938
Gift of Madame Madeleine Vionnet, 1952 C.I.52.18.4

PAGE 95:
Evening Ensemble
Elsa Schiaparelli, French (b. Italy), 1890–1973
Silk, 1939
Gift of Mrs. Harrison Williams, Lady Mendl, and Mrs. Ector Munn,
1946 C.I.46.4.10a–c

PAGE 96:
Jeanne Lanvin (detail)
Édouard Vuillard, French, 1868–1940
Oil on canvas, 49 x 53¾ in., 1933
MUSÉE D'ORSAY, Paris
© 2010 Artists Rights Society (ARS), New York/ADAGP, Paris
Photograph: Réunion des Musées Nationaux/Art Resource,
New York

PAGE 97:
"Cyclone" Evening Dress
House of Lanvin, French, founded 1889; Jeanne Lanvin, French,
1867–1946, designer
Silk, sequins, beads, 1939
Gift of Mrs. Harrison Williams, Lady Mendl, and Mrs. Ector Munn,
1946 C.I.46.4.18a,b

PAGE 98:
Las Meninas (detail)
Diego Rodríguez de Silva y Velázquez, Spanish, 1599–1660
Oil on canvas, 10 ft. 5¼ in. x 9 ft. ⅝ in., 1656
MUSEO NACIONAL DEL PRADO, Madrid
Photograph: Eric Lessing/Art Resource, New York

PAGES 98–99:
"Velázquez" Evening Dress
House of Balenciaga, French, founded 1937; Cristóbal Balenciaga,
French (b. Spain), 1895–1972, designer
Silk, 1939
Gift of Mrs. John Chambers Hughes, 1958 C.I.58.34.21a,b

PAGE 100:
Valentina, New York, 1944
Photograph: Time & Life Pictures/Getty Images

PAGE 101:
Dress
Valentina, American (b. Russia), 1899–1989
Wool, ca. 1940
Gift of Igor Kamlukin, 1995 1995.245.3

PAGE 103:
"Popover" Dress
Claire McCardell, American, 1905–1958
Cotton, 1942
Gift of Claire McCardell, 1945 C.I.45.71.2a,b

PAGE 104:
Joan Crawford, ca. 1944
Photograph: Getty Images

PAGE 105:
Evening Ensemble
Gilbert Adrian, American, 1903–1959
Silk, 1945
Gift of Eleanor Lambert, 1958 C.I.58.25a–c

PAGE 106:
Gilbert Adrian, ca. 1930
Photograph: Getty Images

PAGE 107:
"Roan Stallion" Dress
Gilbert Adrian, American, 1903–1959
Wool, cotton, 1945
Gift of Gilbert Adrian, 1945 C.I.45.94

PAGE 108:
"Palm Beach" Evening Ensemble
Nettie Rosenstein, American, 1890–1980
Silk, 1945
Gift of Nettie Rosenstein, 1946 C.I.46.57a,b

PAGE 109:
Report from Rockport
Stuart Davis, American, 1892–1964
Oil on canvas, 24 x 30 in., 1940
Edith and Milton Lowenthal Collection, Bequest of
Edith Abrahamson Lowenthal, 1991 1992.24.1
Art © Estate of Stuart Davis/Licensed by VAGA, New York, NY

PAGE 110:
A fashionable woman untying her corset, 1893
Photograph: Getty Images

PAGE 111:
Evening Dress
House of Jacques Fath, French, founded 1937; Jacques Fath,
French, 1912–1954, designer
Silk, Spring/Summer 1947
Gift of Richard Martin, 1993 1993.55

PAGE 113:
"Pisanelle" Cocktail Ensemble
House of Dior, French, founded 1947; Christian Dior, French,
1905–1957, designer
Silk, metal, plastic, Fall/Winter 1949–50
Gift of Mrs. Byron C. Foy, 1953 C.I.53.40.9a–d

PAGE 114:
Christian Dior
Yousuf Karsh, Canadian (b. Armenia), 1908–2002
Gelatin silver print, 13⁹⁄₁₆ x 10¹¹⁄₁₆ in., 1954
Gift of Harry Kahn, 1986 1986.1098.58
© Estate of Yousuf Karsh

PAGE 115:
Dinner Dress
House of Dior, French, founded 1947; Christian Dior, French,
1905–1957, designer
Wool, silk, Fall/Winter 1949–50
Gift of Rosamond Bernier, 1989 1989.130.1a,b

PAGES 116–17:
"Junon" Dress
House of Dior, French, founded 1947; Christian Dior, French,
1905–1957, designer
Cotton, sequins, Fall/Winter 1949–50
Gift of Mrs. Byron C. Foy, 1953 C.I.53.40.5a–e

PAGES 118–19:
Models wearing Fath, 1951
Photograph: Time & Life Pictures/Getty Images

PAGE 121:
"La Cigale" Dress
House of Dior, French, founded 1947; Christian Dior, French,
1905–1957, designer
Silk, Fall/Winter 1952–53
Gift of Irene Stone, in memory of her daughter,
Mrs. Ethel S. Greene, 1959 C.I.59.26.3a,b

PAGES 122–23:
"May" Ball Gown
House of Dior, French, founded 1947; Christian Dior, French,
1905–1957, designer
Silk, Spring/Summer 1953
Gift of Mrs. David Kluger, 1960 C.I.60.21.1a,b

PAGES 124–25:
Evening Gown
Madame Grès (Alix Barton), French, 1903–1993
Silk, Fall/Winter 1954–55
Gift of Mrs. Byron C. Foy, 1956 C.I.56.60.6a,b

PAGE 126:
"Y" Evening Dress
House of Dior, French, founded 1947; Christian Dior, French,
1905–1957, designer; Yves Saint Laurent, French (b. Algeria),
1936–2008, assistant
Silk, Fall/Winter 1955–56
Gift of Mr. and Mrs. Henry Rogers Benjamin, 1965
C.I.65.14.12a,b

PAGE 127:
Yves Saint Laurent sketching on a chalkboard, Paris, 1957
Photograph: Getty Images

PAGES 128–29:
"Eventail" Cocktail Dress
House of Dior, French, founded 1947; Christian Dior, French,
1905–1957, designer
Silk, Fall/Winter 1956–57
Gift of Muriel Rand, 1963 C.I.63.36a–c

PAGE 130:
Anne Fogarty wearing one of her own designs, 1953
Photograph: Time & Life Pictures/Getty Images

PAGE 131:
Day Dress and Coat
Anne Fogarty, American, 1919–1980
Wool, rayon, Fall/Winter 1957–58
Gift of Anne Fogarty Inc., 1963 C.I.63.47.3a,b

PAGES 132–33:
"Lys Noir" Evening Dress
House of Dior, French, founded 1947; Christian Dior, French,
1905–1957, designer
Silk, Fall/Winter 1957–58
Gift of Madame Walther Moreira Salles, 1969 C.I.69.39

PAGES 134–35:
"L'Éléphant blanc" Evening Dress
House of Dior, French, founded 1947; Yves Saint Laurent, French
(b. Algeria), 1936–2008, designer
Silk, metallic thread, glass, plastic, Spring/Summer 1958
Gift of Bernice Chrysler Garbisch, 1977 1977.329.5a,b

PAGE 136:
Evening Dress
House of Balenciaga, French, founded 1937; Cristóbal Balenciaga,
French (b. Spain), 1895–1972, designer
Silk, linen, feathers, ca. 1960–65
Gift of Louise Rorimer Dushkin, 1980 1980.338.6

PAGE 137:
Cristóbal Balenciaga, France, ca. 1927
Photograph: Roger Viollet/Getty Images

PAGES 138–39:
Cocktail Dress
Madame Grès (Alix Barton), French, 1903–1993
Silk, ca. 1960
Purchase, Gifts from Various Donors, 1993 1993.190

PAGES 140–41:
Evening Dress
House of Givenchy, French, founded 1952; Hubert de Givenchy,
French, b. 1927, designer
Metallic thread, crystals, feathers, silk, early 1960s
Gift of Mrs. John Hay Whitney, 1974 1974.184.1a–c

PAGES 142–43, 226:
Evening Gown
House of Givenchy, French, founded 1952; Hubert de Givenchy,
French, b. 1927, designer
Cotton, glass, coral, 1963
Gift of Mrs. John Hay Whitney, 1974 1974.184.2

PAGE 144:
Courrèges in Box, Paris, 1965
William Klein, American, b. 1928
© William Klein/Courtesy Howard Greenberg Gallery, New York

PAGE 145:
Day Ensemble (left)
André Courrèges, French, b. 1923
Wool, synthetic, 1965
Gift of Kimberly Knitwear Inc., 1974 1974.136.9a,b

Coatdress (right)
André Courrèges, French, b. 1923
Wool, silk, 1965
Gift of Kimberly Knitwear Inc., 1974 1974.136.3

PAGE 146:
Composition with Red, Blue, and Yellow, 1930
Piet Mondrian, Dutch, 1872–1944
Oil on canvas, 18⅛ x 18⅛ in.
KUNSTHAUS, Zurich
© 2010 Mondrian/Holtzman Trust c/o HCR International, Virginia
Photograph: Erich Lessing/Art Resource, New York

PAGE 147:
"Mondrian" Day Dress
Yves Saint Laurent, French, founded 1962; Yves Saint Laurent,
French (b. Algeria), 1936–2008, designer
Wool, Fall/Winter 1965–66
Gift of Mrs. William Rand, 1969 C.I.69.23

PAGE 149:
Evening Dress
House of Balenciaga, French, founded 1937; Cristóbal Balenciaga,
French (b. Spain), 1895–1972, designer
Lace, Fall/Winter 1965–66
Gift of Diana Vreeland, 1973 1973.20

PAGE 150:
Jane Fonda as lead in Barbarella, 1968
Photograph: Getty Images

PAGE 151:
Dress
Paco Rabanne, French (b. Spain), b. 1934
Synthetic, metal, 1966–69
Gift of Jane Holzer, 1974 1974.384.33

PAGES 152–53
Mary Léon Bing wearing Gernreich, 1966
Dennis Hopper, American, b. 1936
Photograph: Courtesy Tony Shafrazi Gallery, New York

PAGE 154:
Cover of Time *Magazine featuring Rudi Gernreich,*
December 1, 1967
Photograph: Time & Life Pictures/Getty Images

PAGE 155:
Ensemble (left)
Rudi Gernreich, American, 1922–1985
Wool, synthetic, nylon, 1967
Gift of Léon Bing and Oreste F. Pucciani, 1988 1988.74.2a–e

Ensemble (right)
Rudi Gernreich, American, 1922–1985; Capezio Inc., American,
founded 1887
Wool, synthetic, leather, 1967
Gift of Léon Bing and Oreste F. Pucciani, 1988 1988.74.1a–f

PAGE 157:
Evening Gown
House of Givenchy, French, founded 1952; Hubert de Givenchy,
French, b. 1927, designer
Silk, feathers, ca. 1968
Gift of Mrs. Claus Von Bülow, 1971 1971.79.4

PAGE 159:
Evening Dress
Halston (Roy Halston Frowick), American, 1932–1990
Cotton, rayon, sequins, ca. 1974
Gift of Jane Holzer, 1980 1980.586.25

PAGE 160:
Statuette of a Veiled and Masked Dancer
Greek, 3rd–2nd century BC
Bronze, H. 8¹¹⁄₁₆ in.
Bequest of Walter C. Baker, 1971 1972.118.95

PAGE 161:
Evening Gown with Wrap
Halston (Roy Halston Frowick), American, 1932–1990
Synthetic, 1974
Gift of Hillie (Mrs. David) Mahoney, 1996 1996.498.2a,b

PAGE 163:
Evening Ensemble
Yves Saint Laurent, French, founded 1962; Yves Saint Laurent,
French (b. Algeria), 1936–2008, designer
Silk, Mylar glass, metallic thread, Fall/Winter 1976–77
Gift of Bernice Chrysler Garbisch, 1979 1979 329.6a–d

PAGES 164–65:
Evening Ensemble
Yves Saint Laurent, French, founded 1962; Yves Saint Laurent,
French (b. Algeria), 1936–2008, designer
Silk, metallic thread, beads, sequins, Spring/Summer 1980
Gift of Diana Vreeland, 1984 1984.607.28.a–c

PAGE 167:
Evening Ensemble
Madame Grès (Alix Barton), French, 1903–1993
Silk, early 1980s
Gift of Mary M. and William W. Wilson III, 1996 1996.128.1a–d

PAGE 169:
Dress
Comme des Garçons, Japanese, founded 1969; Rei Kawakubo,
Japanese, b. 1942, designer
Wool, 1983
Gift of Muriel Kallis Newman, 2003 2003.79.21

PAGES 170–71:
Dress
Geoffrey Beene, American, 1927–2004
Silk, wool, metallic, 1933–84
Gift of Geoffrey Beene, 2001 2001.393.49

PAGE 173:
Evening Gown
House of Patou, French, founded 1919; Christian Lacroix,
French, b. 1951, designer
Silk, 1987
Gift of Comtesse Thierry de Ganay, 1994 1994.278

PAGE 174:
Christian Lacroix at his 1988 Spring Line Launch, 1987
Photograph: WireImage

PAGES 174–75:
"Careme" Evening Ensemble
Christian Lacroix, French, b. 1951
Synthetic, silk, leather, Fall/Winter 1987–88
Gift of Mrs. William McCormick Blair Jr., 1989 1989.334.1a–e

PAGE 177:
Dress
House of Chanel, French, founded 1913; Karl Lagerfeld,
French (b. Germany), b. 1938, designer
Synthetic, Fall/Winter 1987–88
Gift of Thomas Shoemaker, in memory of Michael L. Cipriano,
1994 1994.161.1

PAGES 178–79:
Evening Ensemble
House of Chanel, French, founded 1913; Karl Lagerfeld,
French (b. Germany), b. 1938, designer
Silk, metal, ca. 1990
Gift of Mouna Ayoub, 1996 1996.129a–i

PAGE 180:
Christian Francis Roth fitting a model, 1989
Photograph: Time & Life Pictures/Getty Images

PAGE 181:
"Rothola" Crayon Dress
Christian Francis Roth, American, b. 1969
Wool, ca. 1990
Gift of Amy Fine Collins, 1994 1994.490.5

PAGE 182:
Marble Statue of a Woman
Greek, 2nd half of 4th century BC
Marble, H. 68⅛ in.
Gift of Mrs. Frederick F. Thompson, 1903 03.12 17

PAGE 183:
Evening Ensemble
Emanuel Ungaro, French, b. 1933
Silk, ca. 1990–92
Gift of Anne H. Bass, 1993 1993.345.15a–c

PAGES 184–85:
Naomi Campbell wearing Versace, Los Angeles, 1991
Photograph: Getty Images

Evening Gown
Gianni Versace, Italian, founded 1978; Gianni Versace, Italian, 1946–1997, designer
Silk, glass, Spring/Summer 1991
Gift of Gianni Versace, 1993 1993.52.4

PAGE 187:
Evening Dress
Gianni Versace, Italian, founded 1978; Gianni Versace, Italian, 1946–1997, designer
Silk, metal, Fall/Winter 1991–92
Gift of Gianni Versace, 1993 1993.52.2

PAGE 188:
Models wearing Miyake, Paris, 1993
Photograph: AFP/Getty Images

PAGE 189:
"Flying Saucer" Dress
Miyake Design Studio, Japanese, founded 1970; Issey Miyake, Japanese, b. 1938, designer
Polyester, Spring/Summer 1994
Gift of Issey Miyake, 1994 1994.603.1

PAGE 191:
"Staircase" Dress
Miyake Design Studio, Japanese, founded 1970; Issey Miyake, Japanese, b. 1938, designer
Synthetic, Fall/Winter 1994–95
Gift of Muriel Kallis Newman, 2005 2005.130.11

PAGE 192:
Gianni Versace at home, Miami, 1996
Photograph: Getty Images

PAGE 193:
Evening Gown
Gianni Versace, Italian, founded 1978; Gianni Versace, Italian, 1946–1997, designer
Silk, synthetic, Spring/Summer 1996
Gift of Donatella Versace, 1999 1999.328.4

PAGE 195:
Evening Ensemble
Gucci, Italian, founded 1906; Tom Ford, American, b. 1961, designer
Rayon, brass, leather, 1996–97
Gift of Gucci, 1999 1999.136.2a–d

PAGE 196:
John Galliano, Christian Dior Haute Couture Spring/Summer Collection, Paris, 2008
Photograph: WireImage

PAGE 197:
Dress
John Galliano, British (b. Gibraltar), b. 1960
Leather, Fall/Winter 1996–97
Gift of John Galliano S.A., 2005 2005.46

PAGES 198–99:
"Maria-Luisa (dite Coré)" Gown
House of Dior, French, founded 1947; John Galliano, British (b. Gibraltar), b. 1960, designer
Silk, synthetic, wool, metal, glass, Spring/Summer 1998
Gift of Christian Dior Couture Paris, 1999 1999.494a–h

PAGE 200:
Madonna and Donatella Versace, Los Angeles, 1998
Photograph: WireImage

PAGE 201:
Evening Gown
Gianni Versace, Italian, founded 1978; Donatella Versace, Italian, b. 1955, designer
Leather, Spring/Summer 1999
Gift of Donatella Versace, 1999 1999.137.2

PAGE 203:
Evening Gown
House of Dior, French, founded 1947; John Galliano, British (b. Gibraltar), b. 1960, designer
Silk, Spring/Summer 2000
Gift of Anne E. de la Renta, 2001 2001.397

PAGE 205:
"Airplane" Dress
Hussein Chalayan, British (b. Cyprus), b. 1970
Fiberglass, metal, cotton, synthetic, Spring/Summer 2000 (remade 2006)
Purchase, Friends of The Costume Institute Gifts, 2006
2006.251a–c

PAGE 207:
Wedding Dress
Yohji Yamamoto, Japanese, b. 1943
Cotton, nylon, silk, Spring/Summer 2000
Gift of Minori Shironishi, 2003 2003.573.8a,b

PAGE 208:
Dress
Gucci, Italian, founded 1906; Tom Ford, American, b. 1961, designer
Silk, Spring/Summer 2003
Gift of Gucci, 2003 2003.442

PAGES 210–11:
"Oyster" Dress
Alexander McQueen, British, 1969–2010
Silk, Spring/Summer 2003
Purchase, Gould Family Foundation Gift, in memory of Jo Copeland, 2003 2003.462

PAGES 212–13:
Dress
Yohji Yamamoto, Japanese, b. 1943
Silk, Spring/Summer 2005
Purchase, Friends of The Costume Institute Gifts, 2006 2006.37

PAGES 214–15:
"Propaganda" Dress
Vivienne Westwood, British, b. 1941
Silk satin, Fall/Winter 2005–06
Purchase, Friends of The Costume Institute Gifts, 2006
2006.197a–d

PAGE 215:
Ensemble
Vivienne Westwood, British, b. 1941, and Malcolm McLaren, British, 1946–2010
Cotton, metal, 1976
Purchase, Irene Lewisohn Bequest, 2004 2004.15a,b

PAGE 216:
"Creation" Ensemble
House of Dior, French, founded 1947; John Galliano, British (b. Gibraltar), b. 1960, designer
Silk, synthetic, cotton, wool, plastic, metal, leather, pearl, Fall/Winter 2005–06
Purchase, The Dorothy Strelsin Foundation Inc. Gift, 2006
2006.22a–d

PAGES 216–17:
Model wearing Galliano for Christian Dior Haute Couture Fall/Winter Collection, 2005–06
Photograph: Chris Moore, Catwalking

PAGES 218–19:
Models walk the runway, Christian Dior Haute Couture Spring/Summer Collection, Paris, 2009
Photograph: Getty Images